100 GREATEST MILITARY PHOTOGRAPHS

Robert J. Dalessandro

Erin R. Mahan

Jerry D. Morelock

100 GREATEST
MILITARY
PHOTOGRAPHS

www.whitman.com

If you enjoy the fascinating history and images in *100 Greatest Military Photographs*, you will also enjoy the other books in this collection, including *100 Greatest American Medals and Tokens*, *100 Greatest American Stamps*, and *100 Greatest U.S. Coins*. Other books in Whitman's library of American history and military titles include *World War II: Saving the Reality* (Rendell), *America's Money, America's Story* (Doty), *The Great War: A World War I Collector's Vault* (Dalessandro/Mahan), *One Thousand Nights at the Movies* (Bowers/Fuller-Seeley), the "U.S. Army in World War II" collection, and many more.

For a complete catalog of numismatic and historical reference books, supplies, and storage products, visit Whitman Publishing online at www.Whitman.com

The selection and descriptions of images do not reflect
the official position of the U.S. Department of Defense.

CONTENTS

ABOUT THE AUTHORS

GENERAL EDITORS

Robert J. Dalessandro, a retired army colonel, has written extensively on the American military experience. He is the current U.S. Army Chief of Military History at Fort McNair, Washington, D.C.

Erin R. Mahan, PhD, is the Chief Historian for the Office of the Secretary of Defense. A foreign policy / international relations specialist, she has published on a wide variety of topics, including arms control, WMD consequence management, NATO, and U.S.–French relations.

Colonel (retired) Jerry D. Morelock, PhD, is editor in chief of *Armchair General* magazine; he has published extensively on every facet of military history, but maintains a particular interest in the historiography of warfare through the medium of photography.

CONTRIBUTING AUTHORS

Frank F. Balle is a writer and freelance photographer specializing in military history.

Michael G. Knapp is Deputy Director, Museum Division, U.S. Army Center of Military History, Washington, D.C. He has published broadly on the Allied experience in World War I.

Christopher J. Semancik is Chief Curator of the United States Army. He has published and lectured on a broad range of historical subjects including the development of tactics, arms, and equipment.

Gretchen K. Witte is a writer with a background in World War I and 20th-century European history.

CREDITS AND ACKNOWLEDGMENTS

This work drew extensively from the photographic archives of the National Archives and Records Administration (NARA) of the United States, Washington, D.C., and College Park, Maryland; the Library of Congress (LOC), Washington, D.C.; the photographic archives of the U.S. Army Center of Military History, Washington, D.C.; and the photo archives of the U.S. Army Heritage and Education Center, Carlisle, Pennsylvania. Each of these organizations offered a treasure trove of materials that enriched this work. Their helpful staff members were always ready to provide professional advice and assistance. We extend our particular thanks to Siobhan Ausberry, Alan Bogan, Sara Forgey, John Paschal, Carrie Sullivan, James Tobias at the U.S. Army Center of Military History, Molly Bompane and Gus Keilers at the U.S. Army Heritage and Education Center, and Zachary Bathon of *Armchair General* magazine. Several individuals bettered this work by sharing their personal collections, particularly Dr. William Shultz, Gus Radle at Military Collector Shop, Drytown, Pennsylvania, and Erik Dorr, curator of the Gettysburg Museum of History. Our thanks go out to Don Troiani and the Military and Historical Image Bank for their support. Our appreciation goes to our families for bearing up under yet another project. Thanks to the extraordinary team at Whitman; your talents helped turn just another "great idea" into a superb book.

INTRODUCTION

"WORDS ARE NEVER ENOUGH"

Buna beach, New Guinea, February 1943: The bodies of three soldiers lie sprawled over a few yards of sand on an otherwise deserted wave-lapped tropical beach as World War II rages in the Pacific. A glance at the fallen soldiers' uniforms and equipment makes it immediately obvious that the dead men are U.S. soldiers (see No. 7). All of them remain frozen in the exact position they fell into when Japanese fire abruptly ended their young lives. Just a few hours later *Life* magazine photographer George Strock happened onto the scene, raised his camera, and snapped the shutter. When *Life* published Strock's photograph—with the stark but appropriate caption "Three dead Americans on the beach at Buna"—in its September 20, 1943, issue, the event was unprecedented. It was the first instance to that point in World War II that Office of War Information government censors had permitted the American public to see a graphic image of U.S. battlefield dead without the bodies being covered or in flag-draped coffins. Although for six months the censors had refused to allow *Life* to publish the photograph, they finally passed it after succumbing to pressure from President Franklin D. Roosevelt—who correctly judged that such a graphic, dramatic, and poignant image of the true cost of the war would shock an increasingly complacent American public into exerting greater support to the U.S. war effort. In a touching, full-page editorial on the photograph's facing page, *Life* explained its own compelling reason for publishing Strock's grim photo: "Words are never enough."

Indeed, for more than a century and a half the camera's unblinking eye has captured what "words are never enough" to fully nor even adequately describe, by preserving the often gut-wrenching images that record the drama, emotion, carnage, triumph, and tragedy of war. The editors of this book have carefully selected and gathered together within its pages the very best of the countless images depicting military forces and world conflict over the past 150 years. Viewed individually, each photograph in history's *100 Greatest Military Photographs* represents a specific instant in time, serving as an enduring legacy of the photographer's craft to be appreciated in its own right and judged on its own merits; taken together, however, these 100 Greatest provide a visual tour of military history from a point in time not long after Louis Daguerre's partner Joseph Nicéphore Niépce produced the first modern photograph at Saint-Loup-de-Varennes, France, in 1825, to today's 21st-century global conflicts.

History's first war photo is most likely the 1847 daguerreotype image of American general John E. Wool and his staff mounted on horseback in the streets of Saltillo, Mexico during the 1846–1848 Mexican-American War. Wool and his staff officers sit stiff and motionless in their saddles while a local dog, head turned toward the horsemen, shows them some casual canine interest.

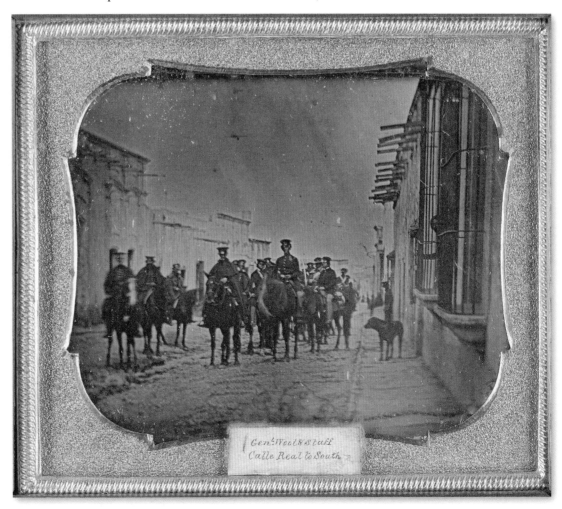

In what is probably the first wartime photograph, Brigadier General Wool and his staff paused for the photographer as they rode through the streets in Saltillo, Mexico, during the Mexican-American War of 1846 to 1848. (Yale Collection of Western Americana, Beinecke Rare Book and Manuscript Library)

Since early cameras and photographic technology were still primitive, awkward to transport, and hard to use outside of studios, it was extremely difficult for that era's photographers to move their bulky equipment and developing solution chemicals to the typically remote locations where military forces clashed. Yet, by the early 1850s, cameras and photograph processing had evolved sufficiently to allow photographers to more easily transport their equipment to a field environment in self-contained wagons—essentially traveling darkrooms. The 1853–1856 Crimean War, therefore, became the first widely photographed military confrontation. Several adventurous photographers covered the conflict, but Briton Roger Fenton, who took more than 300 photos during the war (in which Britain, France, and Turkey fought Imperial Russia on the Black Sea peninsula), is generally acknowledged as history's first widely known war photographer. Still, the cameras' long exposure time meant that the photos were either motionless landscapes or formally posed set-piece affairs showing officers and soldiers in their camps behind the lines—any movement by the subject produced only a ghost-like blur in the developed image. "Action" photographs required camera and photographic development technology not yet invented, and remained several generations in the future.

Fenton can also stake a claim to producing another first: the first fake battlefield photograph. He shamelessly gave his rather dreary and otherwise unremarkable 1855 Crimean War landscape photograph the dramatic title "Shadow of the Valley of Death" in an obvious attempt to commercially capitalize on Alfred, Lord Tennyson's hugely popular 1854 narrative poem "The Charge of the Light Brigade," glorifying the famously bungled British cavalry charge into the "valley of death" at Balaclava. However, Fenton's photograph actually shows a barren, behind-the-lines backwater area near Sevastopol—with some cannonballs scattered around for effect—miles away from Balaclava's real "valley of death." Since Fenton's time, "creative photography" has produced a number of famous war images that aren't what they seem to be, resulting in fakes or staged photographs vying with legitimate images of actual military conflict for the public's attention and critical renown. Such photographic fakery—intentionally or unintentionally passed off as authentic images of military action or its grisly aftermath—began almost as soon as the first photographers ventured onto battlefields, and over the ensuing years has been perpetrated on the unwary for commercial gain or propaganda purposes by some of history's most famous war photographers.

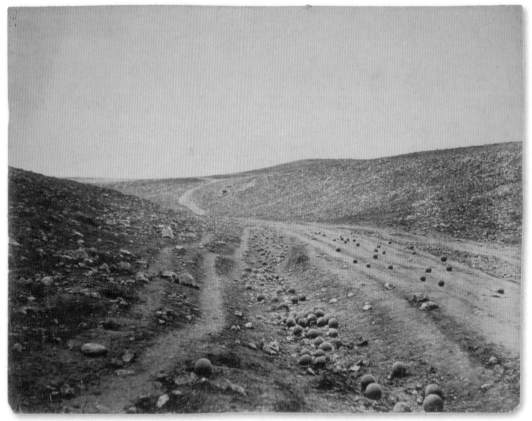

Roger Fenton accompanied British forces during the Crimean War of 1853 to 1856. Although Fenton titled this photo "Shadow of the Valley of Death," it shows a landscape miles away from where the ill-fated Light Brigade suffered horribly. Fenton scattered excessive numbers of cannonballs across the road to add to the dramatic effect. (LOC)

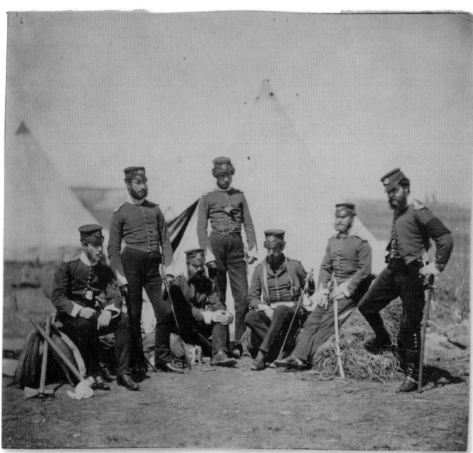

The officers of the 90th Regiment seem overly pensive in this photograph. (LOC)

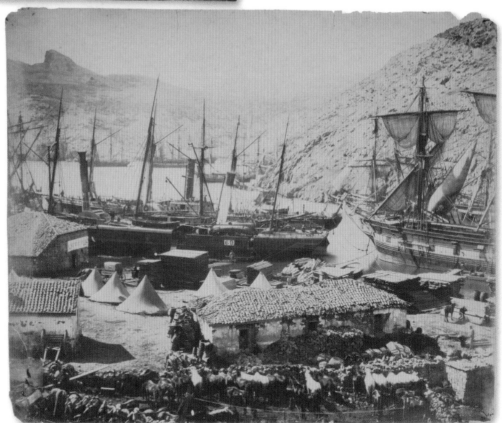

This view of Cossack Bay, Balaclava, suggests both the challenges of logistics and the chaos of war. (LOC)

Both officers and soldiers were always happy to pose for the camera. Here Major Burton and officers of the Fifth Dragoon Guards strike a martial pose. (LOC)

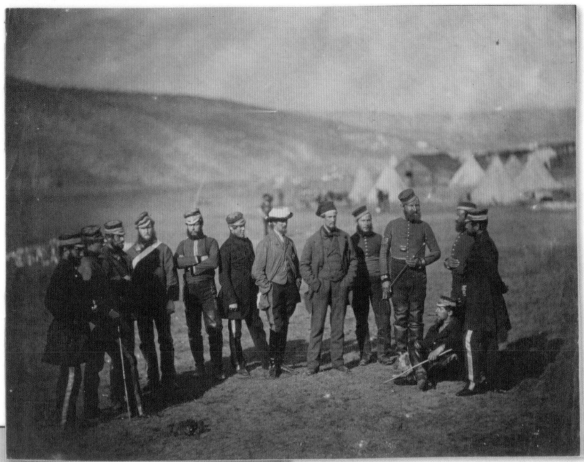

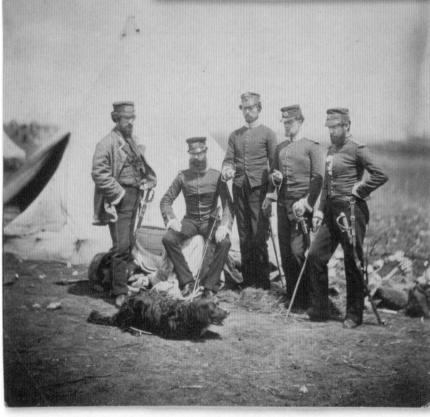

In this photograph, officers of the 57th Regiment stand in front of their camp with their regimental mascot. (LOC)

The 1861–1865 American Civil War marked the true beginning of what would evolve into combat photography. More precisely, it was the graphic photographic images of the horrific *aftermath* of combat action that piqued public interest and sparked a growing demand for photographs of military conflict. In fact, we know exactly what first prompted the public's desire for war photos that continues today. In the wake of America's bloodiest day, the September 17, 1862, Battle of Antietam, Mathew Brady Studio photographer Alexander Gardner lugged his camera and wagon-mounted portable darkroom equipment to Sharpsburg, Maryland, where Confederate general Robert E. Lee's Army of Northern Virginia had fought Union general George B.

McClellan's Army of the Potomac to a horrifically costly standstill. The fighting was over by the time Gardner arrived, but many of the battle's more than 1,500 Confederate dead remained unburied: some still in the positions they were in when they died, others laid out in long lines by Union army burial details. Gardner set up his camera and went to work. Curious crowds soon flocked to Brady's photo gallery to view Gardner's grisly photographs of dead Confederate soldiers—"shot to rags," in the era's vernacular—on the Antietam battlefield. Gardner's prescient remark that "As mementos of the fearful struggle . . . it is confidently hoped that it will possess an enduring interest" proved an understatement—since Gardner's time, war photos have horrified, inspired, disturbed, saddened, and ultimately fascinated us.

Encouraged by the tremendous public enthusiasm shown for his grim but riveting Battle of Antietam photographs, Gardner took his camera and traveling darkroom to more Civil War battlefields. Other intrepid cameramen followed his lead, producing

Brevet Major William A. Nichols, Second U.S. Artillery. A West Point graduate of the class of 1838, Nichols would rise to the rank of general officer during the Civil War. Here he is pictured after he received his brevet promotion to major for gallant conduct in the Battle of Molino Del Rey, Mexico, on September 8, 1847. (Courtesy Dr. William J. Shultz)

This unusual image, circa 1847, shows an unknown American light artillery second lieutenant in a highly adaptive field uniform during the Mexican campaign. He wears a nonregulation straw hat for comfort, while his frock coat is unbuttoned. He presents a striking contrast to the studio photograph of fellow artilleryman Major Nichols. Recent research suggests that the officer may be Thomas J. "Stonewall" Jackson. (Courtesy Dr. William J. Shultz)

countless images of the military forces on both sides, the far-flung battlefields they fought over, and the terrible scenes of death and destruction left in the battles' wakes. In July 1863, Gardner's own quest to show the public what "words are never enough" to describe took him to a small town in southern Pennsylvania to record the bloody aftermath of the Civil War's greatest battle— Gettysburg. From July 1 through July 3, 1863, 150,000 Union and Confederate soldiers had clashed across the fields and over the rolling hills in this otherwise peaceful Pennsylvania farm country—50,000 of them, one of every three soldiers engaged in the battle, fell dead or wounded before the battered but victorious Union troops defeated the Confederacy's last chance to win its independence outright on the battlefield. Again, Gardner's subjects were mainly the dead soldiers of both sides—many of the nearly 8,000 Union and Confederate soldiers killed during the battle's three horrific days of combat still littered the ground where the fiercest fighting had taken place. And again, his grisly photographs of bloated, blackened corpses, frozen in their death agonies, brought spellbound crowds flocking to the Brady studio.

Lieutenant Gordon Granger, U.S. Mounted Rifles, strikes a jaunty pose. Granger graduated in 1845 from West Point and would serve in the army until his death in 1876, by which time he had achieved the rank of major general. (Courtesy Dr. William J. Shultz)

Yet, like Fenton during the Crimean War, Gardner could not resist dramatizing some of the scenes that he photographed to increase his images' emotional impact on viewers. At Devil's Den, the fiercely contested boulder-strewn maze at the foot of Little Round Top, Gardner and his assistants Timothy O'Sullivan and James Gibson apparently dragged the body of a young Confederate soldier 40 yards from where the youth had fallen, posed the corpse behind a rock breastwork, added a rifle and other props, and marketed the resulting dramatically poignant image as "A Rebel Sharpshooter's Last Sleep, Devil's Den, Gettysburg, 1863." Despite Gardner's creation of the emotionally compelling, hauntingly evocative tableau, it became the fratricidal Battle of Gettysburg's most famous and enduring image. In fact, Gardner's staging of the photograph was not a unique or rare occurrence in an era when photography as an art form took precedence over its more practical function of accurately preserving images of events for the historical record. Indeed, enhancing Civil War photos for dramatic effect by moving bodies or by repositioning scattered weapons and equipment on or around a fallen soldier—even enlisting live soldiers to pose as dead ones—was not uncommon in battlefield photography's early era. And certainly Gardner would not be the last war photographer to harness the unique emotional impact of military photographs for artistic, commercial—and political—purposes.

The American Civil War represented the initial watershed for war photography. The compelling images taken by Gardner and his colleagues not only graphically and conclusively demonstrated that "words are never enough" to truly capture the soul of battle and its heartrending aftermath, but also began the process by which photography would eventually evolve into the preferred medium—the "record of choice"—for accurately documenting the progress of military conflicts worldwide. In the second half of the 19th century and the early 20th century, improved photographic technology allowed cameras to more closely follow the world's military forces, supplying a nearly insatiable demand by the burgeoning newspaper and periodical industries for photographs of military forces in training and at war. One of that era's most notable military images was taken July 3, 1898, during the Spanish-American War. Photographer William Dinwiddie arrived atop San Juan Hill outside Santiago, Cuba, less than a day after the American assault captured the heights—at a cost to the U.S. attackers of 205 dead and 1,200 wounded. Dinwiddie rounded up some of the several thousand U.S. regular and volunteer troops who had participated in seizing the heights from 800 Spanish defenders and quickly put his camera to work. His famous photograph of future American president Lieutenant Colonel Theodore "Teddy" Roosevelt surrounded by his "Rough Rider" troopers of the First Volunteer Cavalry Regiment and African-American soldiers of the 10th Cavalry Regiment became the ubiquitous, enduring, and defining public image of America's "Splendid Little War" (see No. 9).

The first truly modern military conflict covered by photographers was the 1904–1905 Russo-Japanese War in Manchuria, where the superbly disciplined forces of the dynamic rising Asian power, Japan, thrashed imperial Russia's ponderous, ill-led armies. The war's modernity was chiefly defined by the new horrors it introduced to the battlefield in what was a chilling preview of World War I's brutal combat (which would break out in Europe less than a decade later): highly accurate, magazine-fed rifles in the hands of all soldiers; deadly machine guns that quickly mowed down waves of advancing infantrymen; massive barrages by indirect artillery fire that pulverized opposing ranks; telephone and radio communications to more efficiently coordinate the armies' killing machines; soul-numbing trench warfare that prolonged battles and increased the misery that soldiers were forced to endure; and barbed wire, the modern battlefield's ubiquitous obstacle, which channeled hapless attackers into the deadly kill zones of opposing forces' overwhelming firepower.

Yet, photographic (and, increasingly, newsreel) coverage of world military forces immensely expanded during the 1914–1918 Great War, the 20th century's first cataclysmic conflict, which killed 15 million soldiers and civilians and caused the final collapse of the decrepit Russian, Austro-Hungarian, German, and Ottoman empires. World War I–era photographic technology made possible more compact and transportable cameras with faster shutter speeds capable of "freezing" soldiers who were moving at the pace of modern warfare; but true combat photography—cameramen risking wounds or death by accompanying soldiers during battle to capture images of combat as it happened—was still in the future. In fact, most photos purporting to show actual World War I combat don't: many claimed "combat action photos" show military forces during prewar field exercises, soldiers conducting training well behind the front lines, or even posed tableaus replicating "battle action" taken well after the fighting had ended. One of the most famous posed photos often mistaken as showing actual combat action purports to show a World War I poison-gas attack victim clutching his throat in his death agony at the moment he is apparently overcome by the deadly vapor. It is dramatic and compelling, but it is actually a posed photo of a training exercise staged by a U.S. Army chemical corps officer for American troops in a training course—no soldier was harmed in the making of the photograph. As in the American Civil War a half century earlier, Great War photographers' most popular subjects remained the ghastly images of death and destruction left in the wake of battles that starkly captured the ultimate horror of war.

World War I confirmed photography as the preferred medium for chronicling and documenting military forces and conflict. Beyond that, the photographs' unique ability to evoke powerful, visceral emotions was "enlisted" in the years between World Wars I and II to sway public opinion and generate popular support for various causes. Likely the most notorious interwar-period instance of using war photos for such propaganda purposes was the 1936–1939 Spanish Civil War, World War II's bloody prelude. Throughout the Spanish conflict both sides—Republican loyalists and Nationalist rebels—pioneered the use of war photos to create powerful propaganda intended to motivate their own followers and also to generate broad international political support for their competing causes. The most famous example, known as "The Falling Soldier," was taken September 5, 1936, by Robert Capa, considered by many to be the 20th century's greatest war photographer. Although Capa's iconic photograph apparently catches the exact instant that a Spanish Civil War Republican soldier is killed—Capa titled it "Loyalist Militiaman at the Moment of Death, Cerro Muriano"—evidence collected since 1975 strongly indicates that the event was staged for Capa's camera and the photo was taken at a completely different location that was then well away from the fighting front. However, even if the circumstances were as Capa claimed, the fact remains that

Photography allowed families to document important moments in their lives. Here the photographer, called "a daguerreon artist," captured a young midshipman along with his family in this daguerreotype from circa 1854. (Courtesy Dr. William J. Shultz)

"Falling Soldier" was widely used for purely propagandist purposes by Spanish Republican leaders. In the 1939–1945 global war that followed—World War II—both Axis dictatorships and the democracies that opposed them mobilized the powerful images produced by war photography as a vital part of sustaining their countries' war efforts.

World War II proved to be history's next defining watershed for military photographs, ushering in the modern era of combat photography as a virtual "army" of civilian cameramen, uniformed combat photographers, and war correspondents representing all of the war's belligerent nations descended on the global conflict's far-flung battlefields. Correspondents and war photographers—military and civilian—worked in every theater of World War II, from the frozen steppes of Russia through the rugged mountains of Italy to the Pacific's steaming jungles, documenting the war in three dimensions: on land, in the air, and at sea. Beginning with this war, photographers no longer simply recorded the aftermath of battles, but instead they became part of the action, risking life and limb dodging bullets and shells while accompanying front-line soldiers at the "sharp end" of combat.

During World War II, military and civilian war photographers huddled alongside assault troops in the first wave of vulnerable landing craft approaching enemy beaches under intense fire; they cowered in hastily dug foxholes enduring artillery barrages and risking instant vaporization from a well-placed shell; some felt the burning North African sand baking their feet through the soles of their combat boots while ever-present swarms of desert flies made eating and drinking virtually impossible and simply breathing a monumental effort; they slogged along, soaked to the skin in drenching rain, through ankle-deep mud as part of long, dreary columns of troops trudging slowly to the front; they endured oppressive Pacific heat and bitter Arctic cold standing exposed to the elements and, frequently, enemy fire on the pitching decks of naval combat ships and merchant vessels steaming to war over all of the world's oceans; many rode along with Air Force bomber crews, heavily bundled against the high altitude's freezing cold, buffeted by the nearby explosions of enemy flak artillery and feeling helpless when swarms of opposing fighter planes swooped in to rake their aircraft with a hail of bullets; and often in terror-filled moments they raced across open fields, zigzagging to avoid being "stitched" by chattering enemy machine guns while occasionally pausing briefly and at great risk to steady their cameras and snap a photograph. Many war photographers and correspondents paid the ultimate price for their courage, professionalism, and dedication to bringing history's greatest war "up close and personal" to their countries' home-front public.

World War II combat photographers of many nations operating around the globe produced some of the greatest military photographs in history. Notable among the legions of cameramen covering the war were the Soviet cameramen who endured the horrors of combat and the miseries of weather extremes alongside soldiers of the Red Army desperately battling Hitler's powerful Wehrmacht in the greatest clash of arms of World War II—the Eastern Front in northern, western, and southern Russia, stretching from the Arctic Ocean to the Black Sea. At least one million German soldiers and perhaps 25 million Russians died in the East Front war. Fifteen million of the Russian dead were civilians, representing fully 25 percent of the war's horrific 60 million worldwide civilian death toll. Unforgettable images taken by Soviet war photographers such as the brilliant Dmitri Baltermants and the highly talented Yevgeny Khaldei brought the agonizing realities of what the Soviets called the "Great Patriotic War" to Russia's long-suffering masses, and, importantly, their compelling photographs garnered enthusiastic international support for the Soviet war effort from the citizens of Russia's principal Western allies, Britain and the United States.

Nevertheless, the most famous Soviet photograph of World War II was staged. War photographer Khaldei perched high atop the war-ravaged German Reichstag building sitting amidst the rubble of conquered Berlin on May 2, 1945, and shot an iconic photo of the USSR flag being raised atop the famous symbol of Hitler's Germany. But even though Khaldei's stirring photograph superbly captures the indomitable spirit of courage, sacrifice, and incredible perseverance of the Red Army soldiers who triumphed over Nazi legions, the flag raising Khaldei photographed was an event staged specifically for his camera two days *after* Mikhail Minin and a small band of Red Army troops had fought their way through stubborn, last-ditch German defenders to the Reichstag's roof and actually raised the first flag. Even more fakery was added to Khaldei's staged photo by Soviet dictator Josef Stalin's ever-watchful censors, who demanded that several looted wristwatches clearly visible strapped onto the outstretched arm of the officer supporting the flag raiser be deleted. Despite the dubious pedigree of Khaldei's stirring flag-raising photo, however, there was nothing fake about the suffering, resilience, and ultimate triumph over Hitler's genocidal aggressors of Soviet soldiers and civilians.

Unforgettable images of the war taken by American photographers date from the very beginning of the United States' involvement in World War II, as cameramen snapped pictures and rolled movie cameras while Japanese bombs were falling on Pearl Harbor on December 7, 1941. The photograph by an unknown photographer of the stricken battleship USS *Arizona*—its hull sunk below the harbor's waters, the ship's superstructure knocked askew by explosions, and clouds of oily black smoke pouring from its remains (see No. 3)—seared the shock of the infamous sneak attack into the American public's national consciousness and helped establish and then sustain "Remember Pearl Harbor!" as the nation's battle cry in the Pacific war. As U.S. fighting forces on land, in the air, and at sea fought around the world, Americans on the home front were given unprecedented "front row seats" to

An unidentified dragoon lieutenant and his beaming bride pose for a studio daguerreotype on their wedding day, circa 1850. (Military History Institute)

attack, they accompanied the waves of invasion troops as they landed in the face of a blizzard of enemy fire from Normandy's German defenders. Within hours of the first U.S. soldier setting foot on the Normandy beachhead on D-Day, Americans safe at home viewed the historic invasion from the awe-inspiring perspective of soldiers exiting a landing craft "Into the Jaws of Death" under enemy fire, through the breathtaking photograph taken by U.S. Coast Guard Chief Photographer's Mate Robert F. Sargent (see page 132).

Also there on D-Day was *Life* magazine photographer Robert Capa. While dodging intense German fire, Capa was among those cameramen snapping pictures on Omaha Beach, one of the Allies' five Normandy invasion beaches, as he came ashore in the second attack wave with the First U.S. Infantry Division's 16th Infantry Regiment. As Capa took photographs of the men wading ashore and moving across the sand under intense enemy fire, the regiment he landed with lost 1,000 soldiers dead and wounded seizing the stoutly defended beach—about one-fourth of the total U.S. casualties suffered at "Bloody Omaha" that momentous day. Unfortunately, a technical

view battle action as it unfolded in the global theaters of war through the efforts of photographers and newsreel cameramen recording images of the conflict as it happened, where it happened, and regardless of the great personal risk involved in capturing the dramatic images.

American photographers recorded all aspects of the land, sea, and air war fought by U.S. military forces as they moved inexorably over the long, bloody roads toward the Axis capitals of Rome, Berlin, and Tokyo to win final victory over fascism, Nazism, and Japanese imperialism. Yet, of all the thousands of days that comprised the 1939–1945 war, one clearly stands out: D-Day, June 6, 1944. The culmination of years of unprecedented planning, preparation, training, and logistical wizardry, all done under a carefully crafted and strictly maintained blanket of secrecy, the Allied invasion of Hitler's "Fortress Europe" was the most monumental effort of the war—indeed, it has been hailed as the most complicated human endeavor ever undertaken before the computer age. War photographers not only documented in photos and on film the meticulous Allied preparations for the historic cross-channel

accident in the subsequent photo-development processing in *Life* magazine's London facility ruined many of the 106 images that Capa had risked his life to capture. Only eleven of his historic D-Day photographs survived, and most of those "Magnificent Eleven" appear out of focus due to the faulty processing. When *Life* published some of Capa's D-Day photographs in its June 19, 1944, issue, editors claimed that Capa's "slightly out of focus" pictures were caused by the cameraman's hands shaking with excitement and fear; Capa, who prior to D-Day had already seen his share of combat action covering the Spanish Civil War, Japan's invasion of China, and World War II in the Mediterranean Theater, always bristled at the claim, denying that he was shaking with fear as he raced around Omaha Beach taking the photographs and sharing the risks of American soldiers in desperate combat. Indeed, Capa's courageous dedication to his profession, in spite of the deadly risks he willingly endured, was tragically confirmed May 25, 1954—Capa died that day, camera in hand, when he stepped on a land mine in Thai Binh, Vietnam, while covering the First Indochina War.

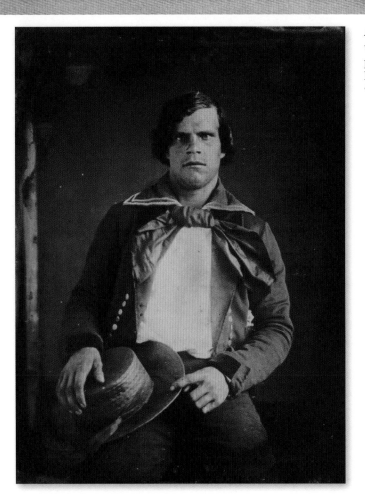

An unknown sailor posed for this wonderfully tinted photograph circa 1850. As photographers perfected their craft, they often added features like color tinting to increase the realism to the "struck image." (Courtesy Dr. William J. Shultz)

One American World War II photograph, however, stands above all others. Rejected as a military photographer by the U.S. Army for "poor eyesight," Joe Rosenthal went to war anyway as a civilian cameraman for the Associated Press news service. His iconic, Pulitzer Prize–winning photo of the Iwo Jima flag raising atop Mt. Suribachi, February 23, 1945, is the greatest military photograph ever taken (see No. 1). When U.S. Marines Michael Strank, Harlon Block, Franklin Sousley, Ira Hayes, and Rene Gagnon, and Navy corpsman John Bradley, began to raise a larger, more visible American flag atop Suribachi—looming at more than 500 feet, the highest point on the island—to replace a smaller one originally put in place, Rosenthal recalled simply that "I swung my camera and shot the scene." In a stark testament to the drama Rosenthal captured in his photograph and in grim validation of the horrific combat required to capture Iwo Jima from Japanese defenders willing to fight to the death, three of the flag raisers—Strank, Block, and Sousley—became some of the nearly 7,000 marines and sailors who were killed during the battle. Less than eighteen hours after Rosenthal took the photograph hundreds of newspapers all across America had received from Associated Press's wire service what AP photo editor John Bodkin had immediately recognized as "one for all time!" Indeed, a telling comment by one American official who was there to witness it emphasizes the significance of the event itself and, by extension, the overwhelmingly stirring photograph that immortalized it. Observing the flag raising from a boat carrying him to the invasion beach, U.S. Navy Secretary James V. Forrestal claimed that "the raising of that flag on Suribachi means a Marine Corps for the next 500 years." Thanks to Rosenthal's magnificent photograph, likely the most frequently seen, most often reproduced military photo of all time, Forrestal's prediction seems assured.

World War II war photographers set the pattern and established the standards for covering military forces and conflicts "up close and personal" for all of those who have since followed in their groundbreaking footsteps. Yet the "Good War" of World War II, in which the obvious and undeniable evils of genocidal Axis aggression were ultimately vanquished, gave way to more troubling, less clearly defined conflicts beginning in the postwar era. Overshadowing the first decades of this era was a nearly half century–long (1946–1991) military, diplomatic, political, economic, and cultural confrontation waged by the two superpowers that emerged from the chaos of World War II: the democratic United States and the communist Soviet Union. Egregiously misnamed the "Cold War" since the military forces of the U.S. and the USSR never directly fought each other (kept in check by the "balance of terror" established by the Atomic Age's threat of mutual nuclear annihilation), the struggle of the two ideologically opposed nations and their allies to win over the "hearts and minds" of populations around the world to their competing political systems and vastly different ways of life nevertheless created the conditions and established the deadly parameters in which millions were killed in countless bloody conflicts. Military photographs began to reflect—or, more accurately, to *record*—the inherent ambiguity of a world in which "good vs. evil" was far from clearly defined.

With the USSR committed to expanding its communist system beyond its own borders and those of its fellow communist nations, and the United States and its allies equally dedicated to "containing" the spread of communism, Cold War competition not only required the U.S. to maintain a global presence of its armed forces' land, sea, and air components, it eventually embroiled the American military in two costly undeclared wars in Asia: the Korean and Vietnam wars. War photographers—increasingly, civilian cameramen representing independent news services that did not feel obliged to present exclusively an "American" point of

view—extensively covered both conflicts. The disturbing and troubling images that they sent back home had a profound impact on their vast public audience, which had already begun to question U.S. motives and methods in wars whose purpose they only vaguely understood.

Photographs of military forces fighting America's 1950–1953 "limited war" in Korea ("limited" in the sense that the fighting was deliberately confined to the Korean Peninsula and only conventional, not nuclear, weapons were used) focused mainly on

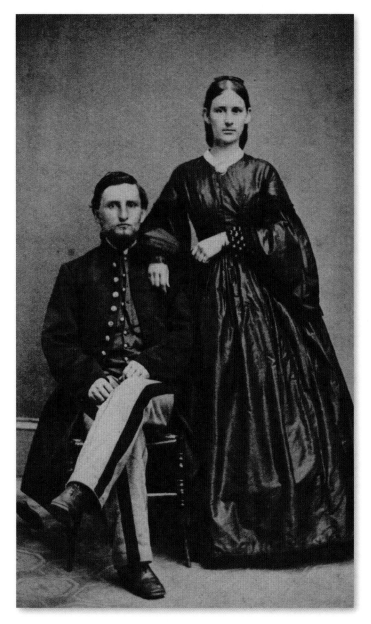

Wartime photography was not limited to the field. In this Albion, New York, carte de visite, Sergeant John B. Jones and his wife Lovilla sit for the photographer. The carte de visite revolutionized mid-19th-century photography, allowing the production of multiple images from one exposure. (Private collection)

capturing the agonizing experience of combat as reflected in the faces of those who endured it. One of the most notable and telling examples of such Korean War photographs is the one taken by famed *Life* magazine photographer David Douglas Duncan of war-weary Captain Ike Fenton, Baker Company, First Battalion, Fifth Marines (No. 2). Duncan's photograph shows the nearly unbearable strain of combat on Fenton's face at the moment he receives more bad news—his first sergeant has just been killed and his company has run out of ammunition—while desperately fighting the invading North Korean army along the Naktong River near Pusan in September 1950. The look on Fenton's face is one of the most profound statements on war ever photographed.

Although the tide of the Korean War turned in America's favor in the wake of General Douglas MacArthur's brilliant "end run" amphibious invasion at Inchon, September 15, 1950, it shifted yet again two months later when the massive military intervention by the rising Asian communist power, China, sent the U.S.–led United Nations forces reeling back in retreat. Finally, in July 1953, instead of the unambiguous total victory America had won in World War II, the costly and inconclusive Korean War fighting produced only an uneasy armed truce. The communist takeover of democratic South Korea had been prevented—communism in Asia had been "contained"—but when the bitter fighting ended with the opposing sides once again facing off along the conflict's prewar border, the Korean War sacrifice of 37,000 Americans killed seemed to many to have achieved only a bloody, disappointing stalemate. And the images taken by the war's photographers overwhelmingly reflected the pain, frustration, agony, despair, and confusion of those who had fought it. War photography had reached another watershed. The stirring triumphalism of World War II, captured so magnificently in Rosenthal's Iwo Jima flag-raising photograph, was replaced during the Korean War by uneasy, troubling feelings of ambiguity and nagging uncertainty, as exemplified in Duncan's telling image of Marine Captain Fenton's haunting expression of agonized despair.

A decade after the Korean War fighting ended, America's Cold War effort to contain communism prompted yet another, even more costly, U.S. military intervention in an Asian conflict—and produced a revolution in war photography. Like the Korean War, the Vietnam War again featured a communist "north," supported by China and the USSR, that was fiercely determined to conquer a democratic "south" championed by the United States. Unlike the Korean War, however, this American effort to contain the spread of communism in Asia ultimately failed. The decade-long American military intervention in Vietnam—during which U.S. military strength serving "in country" reached a peak of a half million troops in 1969—received blanket coverage by civilian and military war photographers as well as by a new phenomenon recording and reporting the war: television cameras. Hailed as history's first "televised war," the conflict in Vietnam became a

persistent, ever-present fixture on Americans' TV screens and in the pages of their newspapers and periodicals. Stark "here and now" television footage and grim combat photographs gave the American public unprecedented access to the Southeast Asian military struggle; but the saturation of war images seemed to do little to clarify in the public's mind what *exactly* was happening and, more importantly, *why*. U.S. government official spokesmen might claim that America was "winning"—noting thousands of tons of bombs dropped on North Vietnam and citing one-sided body counts of enemy dead to prove it—yet the war dragged on, the North Vietnamese stubbornly persevered, and, significantly, the ghastly images of military and civilian death and suffering continued to haunt television screens and to crowd the pages of print media. By the end of 1967, grave doubts about a final "victory" in Vietnam had already been raised. In January 1968, shocking war photographs and television footage of a horrific combat action that began that month not only seemed to confirm those doubts, but also evoked a public reaction in America that profoundly influenced the outcome of the war.

The 1968 Tet Offensive—an all-out effort by 500,000 North Vietnamese regulars and Viet Cong guerrillas that suddenly struck cities and military bases throughout South Vietnam and continued for months—ended in a disastrously costly battlefield failure for the communists. The decisive North Vietnamese military defeat, however, ultimately turned out to be irrelevant. Dramatic photographs and television footage showing desperate, harried U.S. and South Vietnamese troops fighting and dying in the streets of major cities such as Hue and Danang, including the capital city, Saigon (Viet Cong sappers even penetrated the U.S. Embassy grounds), left the American public almost literally shell-shocked. The powerful images of death and agony in a conflict that America was supposed to be winning brought to the people back home by war photographers and TV cameramen, helped turn public opinion against the war. And one ghastly photograph, more than any other of the grim images produced by the Tet Offensive, became the defining symbol of the entire war's cruelty, horror, and futility. On a Saigon street on February 1, 1968, as the confusing and deadly battle for control of the capital raged throughout the city, Associated Press photojournalist Eddie Adams snapped a photo of Saigon police chief Nguyen Ngoc Loan summarily executing Viet Cong terrorist Nguyen Van Lem. Adams's Pulitzer Prize–winning photograph shocked and horrified the world, becoming overnight an iconic antiwar image that more than any other single picture turned ordinary Americans against the war. Although Adams, who covered 13 wars and won more than 500 awards, later expressed his remorse over taking it—he called Saigon police chief Loan "a hero in a just cause"—the horror depicted in his famous war photograph remains undeniable and, ultimately, emotionally overpowering in its stark visual impact of the callous brutality that seemed to define the

Vietnam War. Direct U.S. military involvement in the Vietnam War continued for five more bloody years—eventually American forces' death toll reached 58,000, while millions of Vietnamese died—but, due in large measure to the terrible images sent home by war photographers and television cameramen, the American public's commitment to the war essentially evaporated in the wake of Tet 1968. Two years after the last U.S. troops departed Vietnam in 1973, South Vietnam fell to a massive communist offensive. Fittingly, the dramatic photograph of triumphant North Vietnamese tanks crashing through the gates of the South Vietnamese government palace grounds in Saigon on April 30, 1975, has become the defining and enduring image of the final communist victory.

Even though America failed to contain communism in Southeast Asia and the global superpower confrontation dragged on for another decade and a half, the catastrophic collapse of the USSR in December 1991 brought ultimate Cold War victory to the United States and its allies. However, the end of the Cold War did not mean the end of war, and there have continued to be a plethora of military conflicts erupting worldwide that have kept legions of war photographers and television cameramen fully employed in recording them.

The 1991 Gulf War became another extensively photographed and widely televised war as American and international audiences around the world watched the conflict unfold literally as it happened. Although another "army" of civilian and military war photographers and cameramen was mobilized to cover the war between the U.S.-led coalition and dictator Saddam Hussein's Iraqi forces, a bitter controversy arose over how that coverage was "managed" by American officials—a controversy that still simmers today. Unlike the freer, largely unrestricted access granted to war photographers and reporters in World War II, Korea, and Vietnam, the U.S. military's strict control of media access to American forces and combat operations in the Gulf War became a controversial issue, inevitably raising indignant claims by the media of unwarranted government censorship. Indeed, since many senior American military leaders in the Gulf War had come of age during the Vietnam War, it is understandable that they would want to avoid any repetition of what they perceived as the public-relations disaster that occurred in 1968 in the wake of the Tet Offensive, when horrific images of the battlefield chaos of that desperate fighting produced the false impression in the minds of the American public that Tet was a stunning U.S. military defeat. But war photographers and news reporters operating within a free and open society and representing organizations that are fiercely independent of government control understandably balked at any restrictions that could threaten their ability to capture uncensored images documenting the true face and brutal cost of war. The critical question—and one whose answer remains contentious and elusive—is this: how can balance be achieved

between the armed forces leadership's legitimate concern with maintaining the security of unfolding military operations and the war photographers' and news reporters' equally compelling responsibility to accurately and truthfully record the conduct and outcome of those operations?

America's most recent military conflicts have not only produced additional compelling, poignant, and enduring images of war, but they have also tested that elusive quest for balance between military security and war photographers' freedom of access. As the terrorist attacks on September 11, 2001—"9/11"—horrifically demonstrated, the world remains an exceedingly dangerous place, with stateless terrorists as America's new, fanatically committed foe replacing the organized military forces of enemy countries typically faced in past wars. The 9/11 attacks prompted a wide-ranging U.S. military response by land, air, and sea forces that once again sent the country's troops—who were once again accompanied by swarms of American and international war photographers and news reporters—to distant combat zones. American troops who fought in the Iraq War and subsequent occupation

(2003–2011) and those who continue today fighting in Afghanistan have been joined by military and civilian combat photographers as well as accredited journalists and camera crews. The sacrifice of American troops in these struggles against terrorists and those who support and sustain them is a testament to their courage and commitment to their vital profession; the efforts of war photographers to record and document all aspects of those military conflicts, despite the risk involved, is likewise a testament to the dedication and professionalism of the war photographers whose equally vital role ensures that the troops' sacrifice is not in vain.

Today, war photographers circle the globe, covering the seemingly endless proliferation of strife, guerrilla wars, terrorist attacks, revolutions, and numerous ongoing conflicts. Moreover, the Internet and social-network web sites now provide a new global audience for war photographers, who can post their images online for hundreds of millions to see what "words are never enough" to describe.

Jerry Morelock

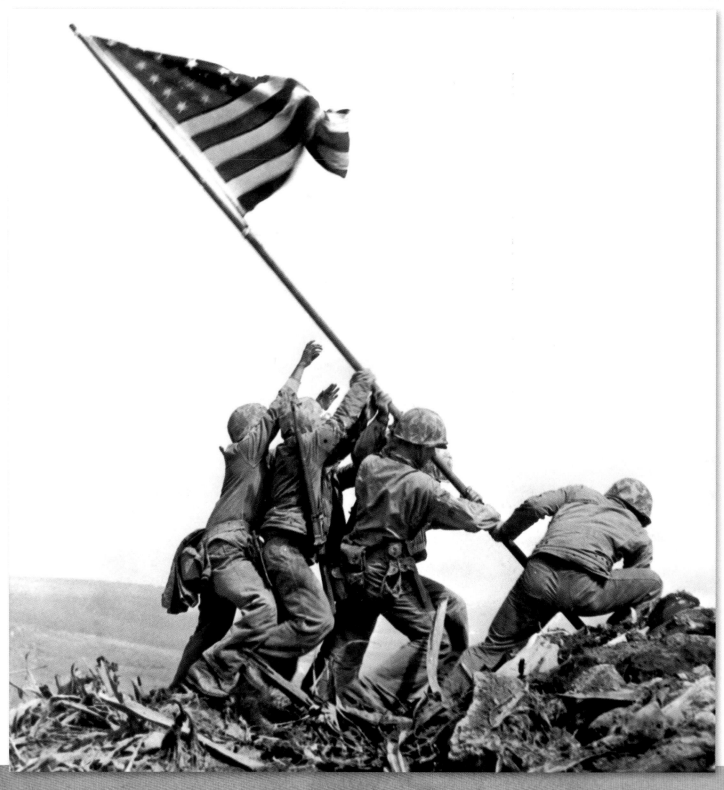

Flag raising on Iwo Jima. February 23, 1945. Joe Rosenthal, Associated Press. (Left to Right: Ira Hayes, USMC; Franklin Sousley, USMC; Michael Strank, USMC; John Bradley, USN; Rene Gagnon, USMC; and Harlon Block, USMC). Strank (March 1), Block (March 1), and Sousley (March 21) were later killed in the battle.

History's greatest military photograph *almost* didn't get taken. When five U.S. marines and a navy corpsman began raising a larger American flag atop Iwo Jima's highest point—Mount Suribachi—to replace a smaller one erected earlier, Associated Press photographer Joe Rosenthal had only seconds to react. Rosenthal had arrived atop the 528-foot height, which provided a commanding view of the island—just as the larger flag was being attached to a Japanese water pipe. Setting his Speed Graphic camera down, Rosenthal was piling rocks for a better photo vantage point when he noticed movement out of the corner of his eye—the flag was going up! Grabbing his camera, Rosenthal had no time to even look through the viewfinder—he quickly swung his camera around and snapped the shutter. He later said he had no idea what his camera had actually captured. Only after his film had been sent to Guam and developed was it recognized, in the words of AP photo editor John Bodkin, as "one for all time."

In fact, Rosenthal's initial ignorance of the historic image he had captured inadvertently sparked controversy when claims were made that his photo was staged after the fact specifically for his camera shot. On Guam a few days later, Rosenthal was asked if he had posed the photo. Still ignorant of the significance of his flag-raising photograph and incorrectly assuming that the questioner was asking about a later group photo in which Rosenthal had indeed posed the flag raisers and other Marines, Rosenthal answered, "Sure." His "admission" even prompted detractors to demand that the Pulitzer Prize awarded the photo be revoked. However, once he came to understand the confusion regarding the photographs, Rosenthal quickly denied the "staged photo" claims. Fortunately, color movie film shot by marine combat cameraman Sergeant Bill Genaust (killed on Iwo Jima on March 4, 1945) from nearly the same angle as Rosenthal's photograph confirmed that the flag raising was genuine and not staged merely for Rosenthal's camera.

President Franklin D. Roosevelt, recognizing the powerful impact the photo would have on the American public, directed its use as the symbol of the country's seventh war bond drive. An artistic color recreation of the photo appeared on 3.5 million posters with the appropriate motto "Now, All Together." That bond drive, which included a stateside tour by flag raisers Gagnon, Hayes, and Bradley, raised $26.3 billion. Rosenthal's photo was used on the U.S. three-cent stamp issued in July 1945 and was the basis for Felix de Weldon's massive Marine Corps War Memorial sculpture in Arlington, Virginia.

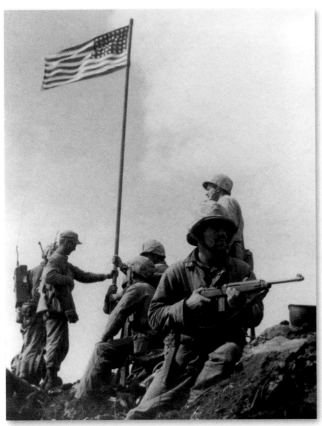

The original, smaller flag first raised atop Mount Suribachi. The larger flag, captured in Joe Rosenthal's famous photograph, soon replaced it. (NARA)

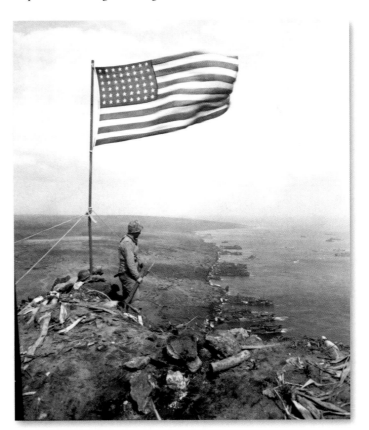

From the crest of Mount Suribachi, the Stars and Stripes waves in triumph over Iwo Jima after U.S. Marines fought their way inch by inch up its steep lava-encrusted slopes. (NARA)

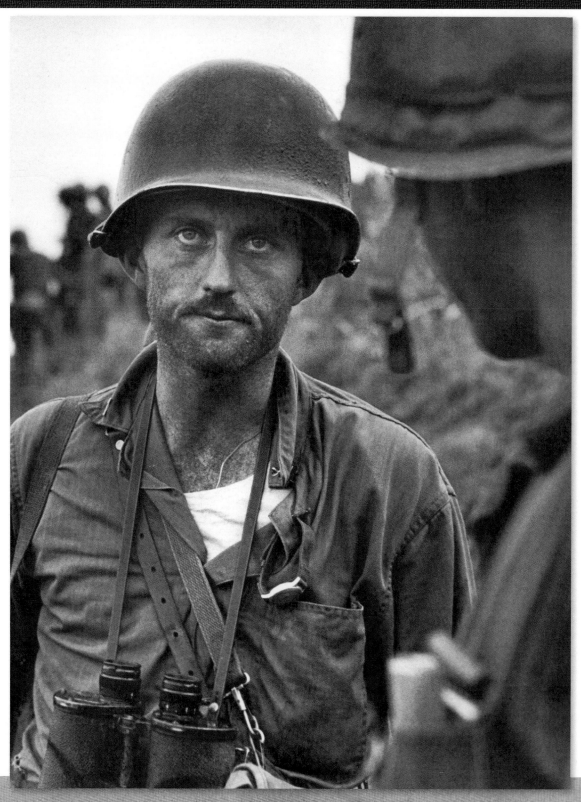

Captain Francis "Ike" Fenton's "thousand-yard stare" as he learns he is out of ammo. Naktong River Perimeter near Pusan, Korea, 1950. Captain Fenton, Company B, Fifth Marines by photojournalist David Douglas Duncan. One of 20 images in a photo essay by Duncan titled "This Is War" published in the September 18, 1950, issue of *Life* magazine.

The Cold War turned hot in June 1950 when Soviet-sponsored Communist North Korea launched a surprise attack across the 38th parallel against democratic South Korea (Republic of Korea or ROK). With ROK forces fleeing south, in July U.S. president Harry S. Truman sent American ground forces to intervene, but the U.S. task force was quickly overrun. By September, Communist spearheads had advanced to Korea's southeastern tip, where American soldiers and marines, along with ROK troops, held a tenuous line along the Naktong River near Pusan. Failure to hold the Naktong perimeter would force a U.S.–ROK evacuation—and the Communists would win the Korean War.

At this crucial stage, famed photojournalist David Douglas Duncan cabled his *Life* editors from Tokyo that he planned to send a "timeless, dateless, nameless, wordless story which says very simply quietly 'This is War.'" For 36 hours starting September 4, 1950, Duncan joined Company B, Fifth Marines, in desperate combat along the hard-pressed Naktong River line. Under Duncan's "This Is War" headline *Life* published his 20 photographs, adding only a short introduction, minimal photo captions, and a brief explanation to readers of the stark situation prompting marine captain Ike Fenton's haunting expression. *Life* described the desperate combat Fenton's marines faced: "During the Red counterattack in the rain . . . there were moments when it seemed as though all [Fenton's] men would die fixed in their positions on the precious ridge. Far ahead of the other advancing Marine units, Company B had its flanks exposed. The Reds pummeled it from the sides with heavy mortar barrages, then counterattacked time and again. As in so many battles, the modern accoutrements of war went wrong. Rain denied Captain Fenton air support, and communications failed. Supply of ammunition became dangerously low—it was replenished in the nick of time—and all around him Fenton saw his men stumbling from the firing line, bleeding with their wounds, to huddle under the defilade of the hill. For a night and a day the thinning line held. Suddenly, the Red attack ceased, and the action had been won by that eternally fundamental principle of war—men against men. The Marines had proved themselves better fighters than the North Koreans who outnumbered them. Later, as ammunition

came forward, Captain Fenton and what was left of B Company ground away at other ridges that rose like fishbacks between them and the Naktong River."

The Naktong line held. On September 15, 1950, General Douglas MacArthur's brilliant Inchon invasion sent the North Korean army fleeing back north across the 38th parallel.

This painting by combat artist Tom Lea pictured the "1,000-yard stare" during combat in 1944. (Courtesy U.S. Army)

The surprise attack on Pearl Harbor was planned and conducted by the Imperial Japanese Navy's air forces against the U.S. naval base at Pearl Harbor in the U.S. Territory of Hawaii on the morning of December 7, 1941 (December 8 in Japan). The attack was intended as a preventive action in order to keep the U.S. Pacific Fleet from interfering with military operations that Japan was planning in Southeast Asia against the overseas territories of the United Kingdom, the Netherlands, and the United States.

Japanese fighters, bombers, and torpedo planes attacked in two waves, launched from six aircraft carriers. All eight U.S. Navy battleships at Pearl Harbor were damaged and four were sunk. Of these eight, two were raised and four were repaired, returning six battleships to service later in the war. The Japanese also sank or

damaged three cruisers, three destroyers, an anti-aircraft training ship, and one minelayer. The attack destroyed 188 U.S. aircraft; 2,402 Americans were killed and 1,282 wounded. The power station, shipyard, fuel and torpedo storage facilities, submarine piers, and headquarters building—home of the intelligence section with cryptographic capability to break Japanese naval signals code—were not attacked. Japanese losses were light: 29 aircraft and five midget submarines lost, and 65 servicemen killed or wounded. One of the Japanese sailors on a midget submarine was captured.

Fortunately for the U.S. Navy, the aircraft carriers were not present during the attack; had they been present and damaged, the Pacific Fleet's ability to conduct offensive operations would have been crippled for at least a year. The elimination of the battleships left the U.S. Navy with no choice but to rely on its aircraft carri-

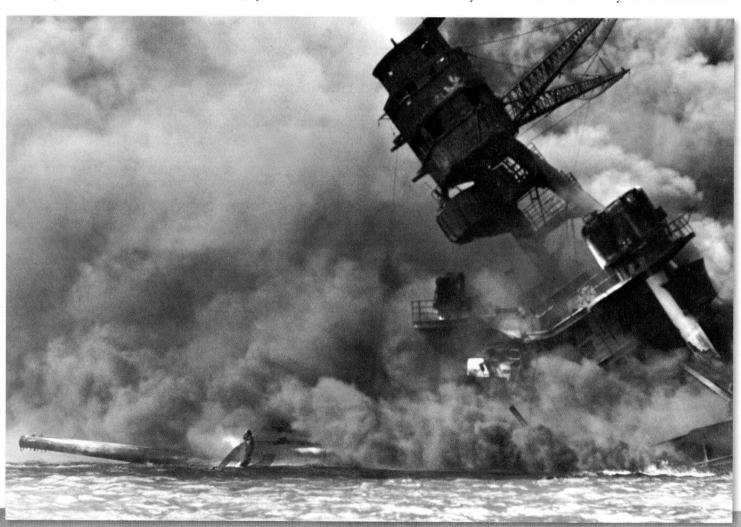

This is perhaps the most iconic photograph of the attack on Pearl Harbor. The foremast and turret number two of the USS *Arizona*, BB-39, burn after a torpedo exploded in the forward magazine.

3

ers and submarines—the very weapons with which the U.S. Navy halted and eventually reversed the Japanese advance. A major flaw of Japanese strategic thinking was a belief that the ultimate Pacific battle would be fought by battleships. In spite of their success at Pearl Harbor, Japanese planners did not foresee the dominating role of carrier-based airpower in future naval operations.

Admiral Hara Tadaichi summed up the Japanese result by saying, "We won a great tactical victory at Pearl Harbor and thereby lost the war."

The attack came as a profound shock to the American people and led directly to the American entry into the war. Domestic support for isolationism all but disappeared, and the following day (December 8) the United States declared war on Japan. Subsequent operations by the United States prompted Germany and Italy to declare war on the United States on December 11, which the United States reciprocated the same day.

There were numerous historical precedents for unannounced military action by Japan; the lack of any formal warning, however, particularly while negotiations were still apparently ongoing, led President Franklin D. Roosevelt to proclaim December 7, 1941, "a date which will live in infamy."

Pearl Harbor on December 7, 1941: the USS *West Virginia* aflame. (NARA)

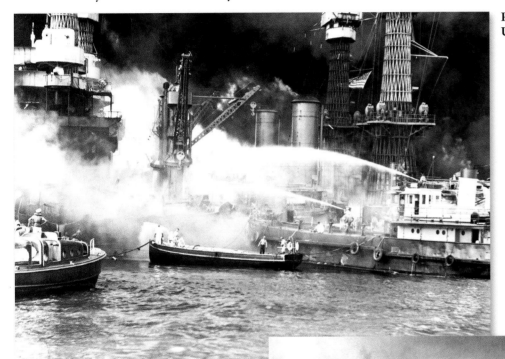

A burned B-17C aircraft rests near hangar five, Hickham Field, December 7, 1941. (NARA)

WORLD WAR I GUN CREW

One of the most publicized images of American infantry in combat from the Great War, this snapshot shows troops advancing in a nightmare landscape. The image reportedly shows men of the United States Army's 23rd Infantry Regiment of the famed Second Infantry Division firing a French-made P 37 mm gun, model of 1916. Designed in France by Puteaux, this weapon was intended to provide direct frontline artillery fire against machine gun positions and other hardened strong points. Equipped with a telescopic sight and with an effective range of 1,600 yards, it could be used as a large sniper rifle to place shells through small openings in machine gun pillboxes. It also was provided with an antipersonnel round to break up enemy troop concentrations and could deliver 25 rounds per minute with a trained crew.

When the United States joined the Allied cause in the war against Germany in April 1917, it did not possess a large army by European standards. Although the United States was a highly industrialized nation building weapons under contract for other countries, the U.S. Army had not kept up with modern developments in the weapons needed to wage trench warfare. Outside of providing a large number of men equipped with quality rifles, the army lacked everything from trench boots and helmets to machine guns, trench mortars, grenades, chemical weapons, aircraft, tanks, and the latest in artillery. It was estimated at best that it would take at least a year to equip a million-man force with American-made weapons of all the various types, which constituted a delay that the Allies knew would cost them the war. So it was agreed in

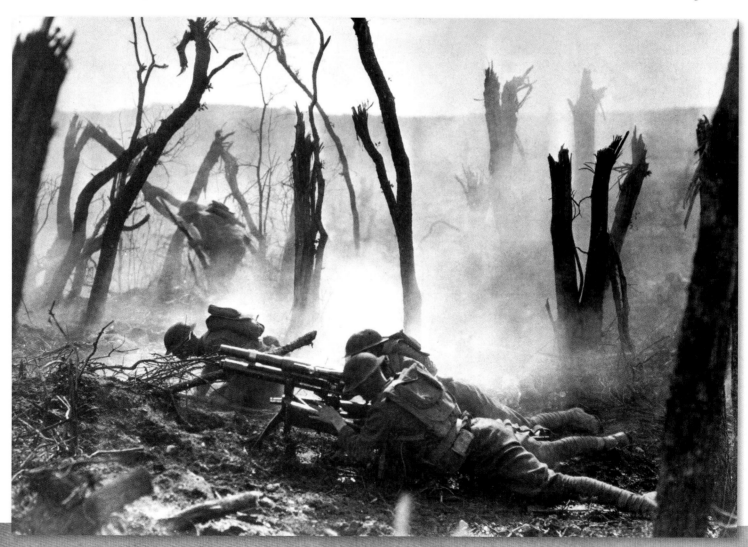

Gun crew from Regimental Headquarters Company, 23rd Infantry, firing a 37 mm gun during an advance against German entrenched positions, 1918. (Army)

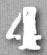

order to speed an army to the front that America would send her men with their rifles, and the Allied nations of Europe would provide the modern weapons to equip it.

Although this photograph is one of the most widely recognized images of American troops in combat and is often attributed to a unit of the Second Infantry Division in action around Belleau Wood, the location, unit, and date are obscure. The regimental reports filed by both the 23rd Infantry and the Ninth Infantry describe the use of 37 mm guns of this type during the engagement. The shattered woods in the image match the conditions resulting from the artillery bombardment that destroyed the woods of the Bois des Rochets around Hill 204 near Vaux, and also match drawings made by eyewitnesses of the assault on the hill.

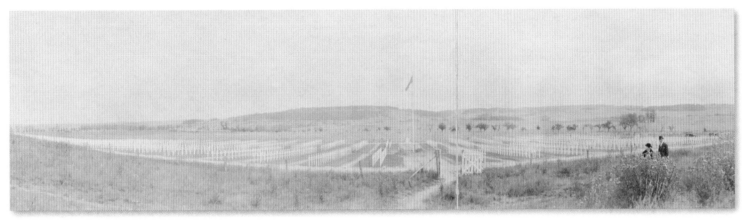

This panoramic photograph shows the American cemetery at Belleau Wood, France, where over 2,000 American soldiers and marines who gave their lives in the victory at Chateau Thierry and Belleau Wood sleep the last sleep. (LOC)

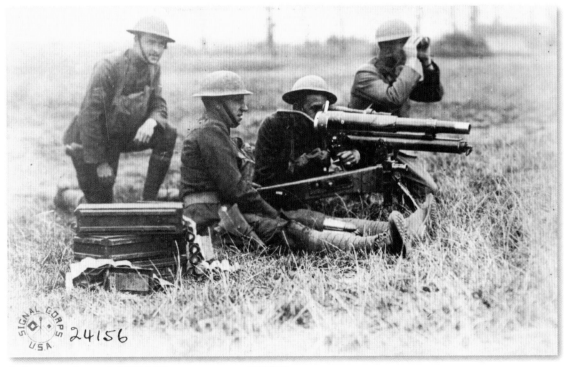

A close-up of a model 1916 37 mm gun crew. (NARA)

GENERAL DWIGHT EISENHOWER AND PARATROOPERS

On February 12, 1944, the Supreme Allied Commander in Europe, General Dwight D. "Ike" Eisenhower, received a cable from the British-American Combined Chiefs of Staff giving him a daunting mission: "You will enter the continent of Europe and, in conjunction with the other United Nations, undertake operations aimed at the heart of Germany and the destruction of her armed forces." On June 6, 1944, Ike's forces—ground, air, and naval units of America, Britain, Canada, and a dozen other Allied nations—began to "enter the continent of Europe" by invading the beaches of Normandy, France. Designated Operation Overlord, history's greatest amphibious invasion would ever after be known simply as "D-Day."

Eisenhower's Operation Overlord plan for the Normandy invasion took an army of staff planners more than 14 months to develop and detailed the specific actions and split-second timing of all Allied forces involved in the operation. These included

General Dwight D. Eisenhower gives the order of the day—"Full victory—nothing else"—to paratroopers of the 101st "Screaming Eagle" Airborne Division in England just before they board their airplanes to participate in the first assault in the invasion of the continent of Europe. June 5, 1944. (Army)

160,000 Allied ground troops; nearly 7,000 naval vessels of all types to transport troops and equipment across the English Channel, and to provide naval gunfire support at the beaches; and more than 4,000 war planes to cover the invasion fleet and the landings, bomb German strongpoints near the beaches, and interdict enemy attempts to move reinforcements from assembly areas in other parts of France to counterattack the Allied beach footholds.

In addition to Overlord's other forces, the Allied plan included massive airborne drops—24,000 U.S. and British paratroopers and glider-borne troops would be dropped behind German lines the night of June 5 to 6 to help pave the way for the beach assaults. Planners predicted that the paratroopers would suffer extremely heavy casualties during the drops and throughout the time that the sky soldiers would have to fight on their own until contact could be established with the main invasion force moving inland from the beachheads. Ike was fully aware of the dire predictions regarding his paratroopers' fate. Therefore, in the hours before the massive invasion that he had set in motion began, Eisenhower visited groups of American paratroopers, perhaps as much to soothe his own conscience about sending some of them to their deaths as to motivate and inspire the men for their highly dangerous mission. On the afternoon of June 5, shortly before they boarded transport aircraft for their historic mission, men of the U.S. 101st "Screaming Eagle" Airborne Division welcomed a high-ranking visitor—General Ike Eisenhower.

The Allied airborne drops did prove to be costly, but the paratroopers and glider troops also achieved great success, paving the way for one of World War II's greatest victories.

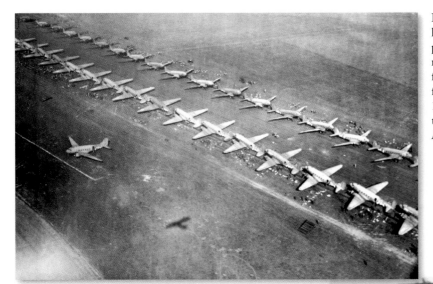

In another airborne operation, long twin lines of C-47 transport planes are loaded with men and equipment at an airfield from which they took off for Holland on September 17, 1944. The C-47s carried paratroopers of the First Airborne Army. (NARA)

Parachutes open overhead as waves of paratroopers land in Holland for Operation Market Garden. (NARA)

BURIAL PARTY AT COLD HARBOR

After taking command of the Union armies, General Ulysses S. Grant quickly launched a series of attacks against the Confederate troops guarding Richmond. Realizing he was fighting a war of attrition, Grant aimed to force General Robert E. Lee to fight. With the Union's superior numbers, Grant knew that each battle would bring relatively more destruction to Lee's forces. Grant's Wilderness Campaign initiated a series of hard-fought battles followed by a sidle to the east in an attempt to get between Lee's army and Richmond.

On May 5, 1864, as Grant led his army across the Rapidan River, Lee attacked. Although Lee's forces were outnumbered nearly two to one, Lee's speedy attack caught Grant off guard. While Grant recovered, the heavy woods where the fighting raged nullified much of Grant's advantage in men and artillery. After two days of bloodshed, Grant broke off the Battle of the Wilderness and began a series of sidling moves to the east looking for a more favorable place to attack. After attacking at Spotsylvania and North Anna, he arrived at Cold Harbor.

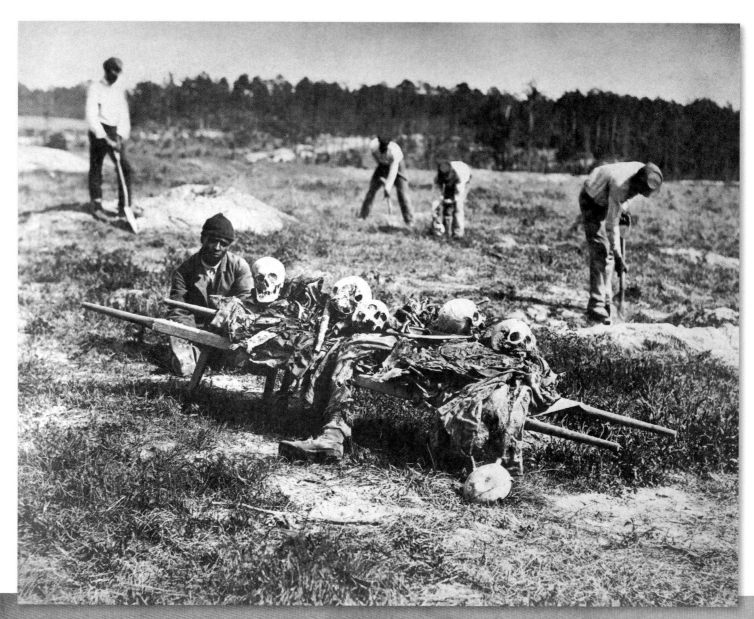

Burial party at Cold Harbor. Taken by John Reekie in April 1865, the image shows a group of African Americans burying the remains of Union troops killed nearly a year earlier at Cold Harbor, Virginia.

By May 31, what began as a cavalry skirmish around Cold Harbor had turned into a full-blown battle as infantry from both sides joined the fighting. For the next three days, neither side yielded any ground in the repeated attacks. On June 3, Grant, with all his forces on the field, made his last attack. Lee's forces, having had time to entrench, were prepared. In the early morning the Union troops rose and attacked the Confederate line. Within minutes 7,000 Union soldiers lay dead, few having reached the Confederate line. By noon, Grant called off the attack.

Grant called off the attack but did not leave the battlefield. As the corpses rotted in the sun amidst the cries of the mostly Union wounded, Grant's and Lee's troops remained in their positions, subject to snipers, artillery fire, and the stench of corpses. On June 5, Grant asked Lee for a mutual cessation of hostilities in order to bury the dead and collect the wounded. Lee, not having any wounded between the lines and wanting to force Grant to admit defeat, demurred. Two more similar exchanges followed, but not until June 7 did Grant finally capitulate and come out with a flag of truce. However, by then only a handful of wounded remained, the rest having either made their way back to the Union lines or perished.

While Grant regretted the losses at Cold Harbor, he did not relent. He would make the next move towards Petersburg, where he would eventually wear down Lee's army. However, he would do so without the soldier who wrote in his diary on June 2, the night before the battle, "June 3. Cold Harbor. I was killed."

The identity badge of George Upton, Eighth Connecticut Volunteers, who died of his wounds at Cold Harbor, Virginia, in 1864. By the time of the Battle of Cold Harbor, soldiers understood the grim reality of war and often privately purchased identity tags to ensure that their remains were identifiable after death. (Military and Historical Image Bank)

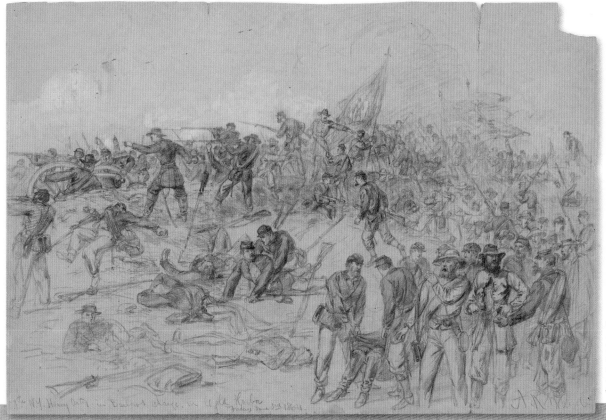

The Seventh New York Heavy Artillery in Barlow's charge near Cold Harbor, Friday, June 3, 1864. (LOC)

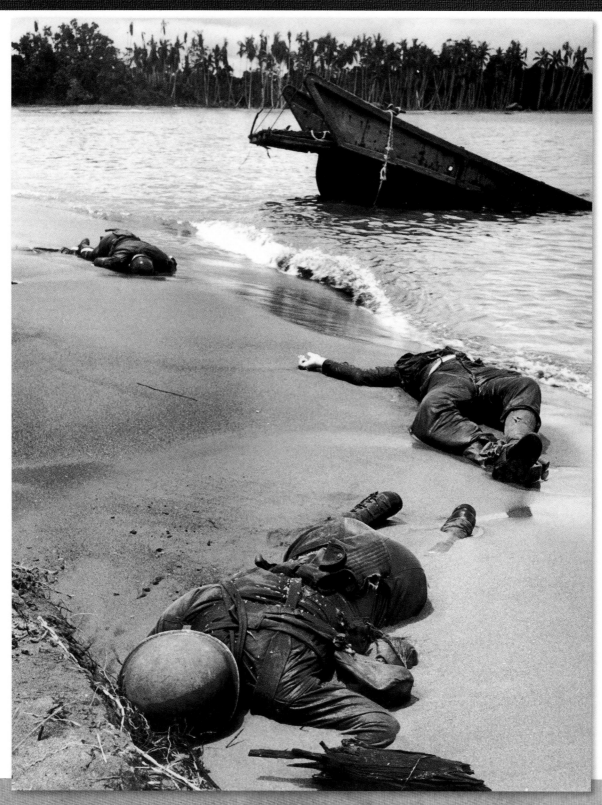

Three dead Americans on the beach at Buna, New Guinea, in February 1943. This is the first image cleared for publication during World War II by official government censors to depict U.S. troops dead on the battlefield. By George Strock, published in the *Life* magazine issue of September 20, 1943.

By 1943, Allied forces led by the United States, Britain, and the Soviet Union were on the offensive worldwide against Nazi Germany, fascist Italy, and Imperial Japan. In the Pacific, Americans had finally secured Guadalcanal, while General Douglas MacArthur's American and Australian troops won a foothold on New Guinea's northern coastline after a fierce battle against Japanese defenders at Buna-Gona. This enclave would serve as the jumping-off point for MacArthur's brilliant campaign that "hopped" along New Guinea's northern coast and led to his 1944–1945 reconquest of the Philippines. MacArthur's strategy of bypassing Japanese strongpoints kept his forces' casualties low compared to losses in other commands—yet a price in blood inevitably had to be paid. In February 1943, *Life* photographer George Strock discovered three American soldiers who had paid that price. Cut down by a hidden Japanese machine gun some hours before, they lay dead on the tide-swept sand of Buna beach, where Strock clicked his camera's shutter and captured the scene.

Life's request that the U.S. Office of War Information censors clear Strock's photograph for publication was denied. No photograph showing American dead on the battlefield had yet been cleared for publication. Six months of resistance were finally ended when President Franklin D. Roosevelt intervened. FDR felt that seeing the war's stark realities would infuse new vigor into the American public's flagging homefront war effort. In its September 20, 1943, issue, *Life* published Strock's brutally grim image as a full-page photograph.

Life accompanied Strock's photograph with a page-long essay explaining the magazine's reason for publishing the disturbing image of dead U.S. soldiers. Under the headline "Three Americans—Where These Boys Fell, A Part of Freedom Fell: We Must Resurrect It In Their Name," the editors explained: "The reason is that words are never enough. The eye sees. The mind knows. The heart feels. But the words do not exist to make us see, or know, or feel what it is like, what actually happens. The words are never right. . . . And the reason we print it now is that, last week, President Roosevelt and Elmer Davis and the War Department decided that the American people ought to be able to see their own boys as they fall in battle; to come directly and without words into the presence of their own dead. And so here it is. This is the reality that lies behind the names that come to rest at last on monuments in the leafy squares of busy American towns. Here is the picture we meet upon a battlefield of the war."

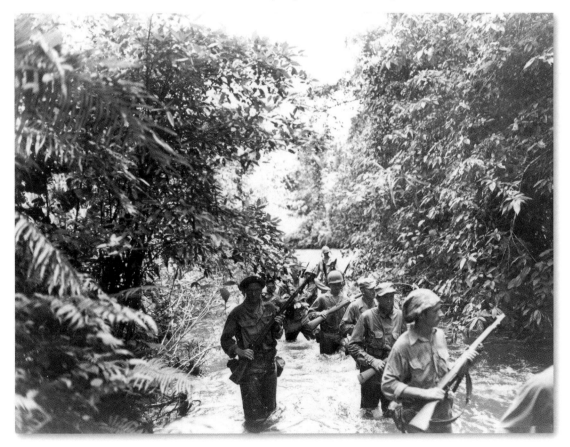

A U.S. Marine Patrol moves up a jungle stream under cover of dense foliage in New Guinea. The Japanese proved highly adept at waging jungle warfare, making combat a nightmarish ordeal for American soldiers and marines fighting on countless Pacific islands. (NARA)

P resident Lyndon B. Johnson sent the first major contingent of American ground troops to intervene in the Vietnam War in March 1965, when he dispatched Marines to Danang. Within a year, combat against communist North Vietnamese Army (NVA) regulars and Viet Cong (VC) insurgents had greatly escalated. In 1969, U.S. troop strength peaked at over 500,000 serving in Vietnam. More than 58,000 Americans would die before American involvement in the Vietnam War ended with the departure of the last troop contingent in 1973. In April 1975, two years after the last American troops left, the North Vietnamese overran South Vietnam, uniting Vietnam under communist rule.

Long before the war's end in 1975, *Life* photojournalist Larry Burrows covered fierce combat south of the Demilitarized Zone

(DMZ) separating communist North Vietnam from democratic South Vietnam. During August through October of 1966, battalions of 4th, 5th, 7th, 9th, and 12th Marines conducted Operation Prairie to block NVA infiltration routes through the DMZ and clear enemy troops from the region south of it. The fighting was bitter and prolonged—much like America's decade-long involvement in the Vietnam War itself—and marines found that the rugged terrain was as formidable a foe as their NVA and VC enemies. *Life* magazine quoted one marine participant's telling comment likening the Vietnam terrain to some of the most miserable conditions in the Marines' previous wars: "'Mountains like Korea, jungles like Guadalcanal,' grumbled one veteran." When the operation ended near the close of October 1966, marines had suffered over 1,000 wounded and 200 killed in action. Communist

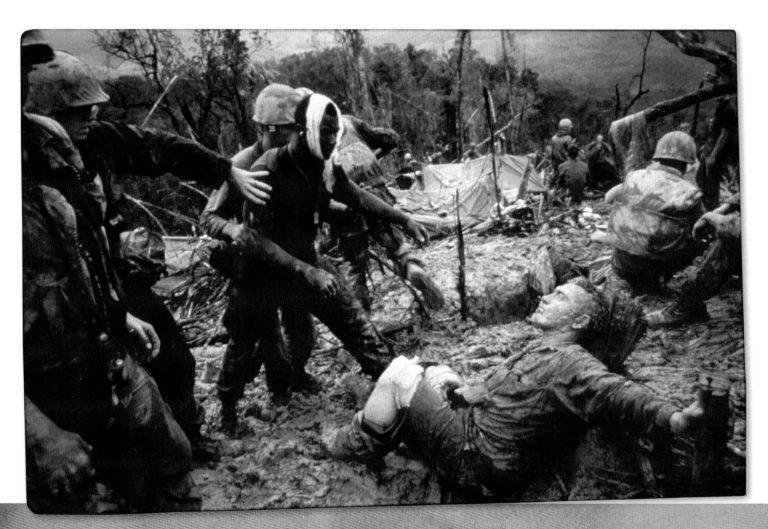

American first-aid center south of the Demilitarized Zone (DMZ), Republic of Vietnam, where wounded marines were treated before being helped to helicopter air-evacuation points, 1966. By Larry Burrows. One in a series of photographs of marine combat, several of which were published in the October 28, 1966, issue of *Life* magazine.

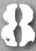

losses were much heavier, but the bloody body counts of enemy dead would prove to do little to lessen North Vietnam's determination to persevere in the war.

In its issue of October 28, 1966, *Life* published several of Burrows's photographs of marines in Operation Prairie under the headline "Marines Blunt the Invasion From the North." Unlike the stirring images war photographers took to rally the American public during World War II, Burrows's pictures most often featured subjects who reflected the agonizing misery endured by those who bore the burden of combat. His photograph of wounded marines at a primitive aid station hacked out of a jungle clearing south of the DMZ is typical—Burrows captured none of the war's "glory," only its pain and suffering.

At age 16, the English-born Burrows had joined *Life*'s London bureau, and he became best known for his photographs of American involvement in the Vietnam War, produced from 1962 until his February 10, 1971, death in Laos. That day Burrows and three other photojournalists died when their helicopter was shot down.

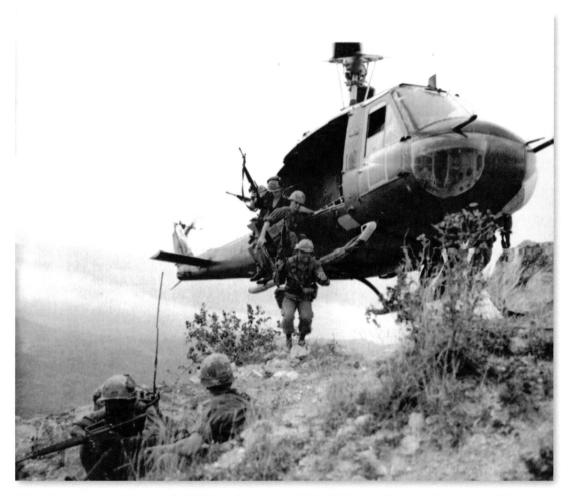

U.S. soldiers of the First Cavalry Division leap from a UH-1D Huey helicopter after being airlifted to a position near Chu Lai while conducting Operation Oregon in 1967. Helicopters also proved vital life-savers, quickly evacuating wounded troops to aid stations. (NARA)

"TEDDY'S COLTS"

Here we have an image that made a presidency and defined a nation. Few images capture the spirit of the moment as does William Dinwiddie's enduring photograph of one of the most celebrated units and dominant personalities of the Spanish-American War: Theodore Roosevelt and his "Rough Riders." The Rough Riders, officially designated the First United States Volunteer Cavalry, was composed of hand-picked volunteers selected from among the best cowboys and wealthy adventurers in the nation. The composition of the unit symbolized the United States at the end of the 19th century with its complex and evolving population of Western frontiersmen, Native Americans, and wealthy Easterners.

In the center stands the stuff of legend, Lieutenant Colonel Theodore Roosevelt, who was already a household word in the

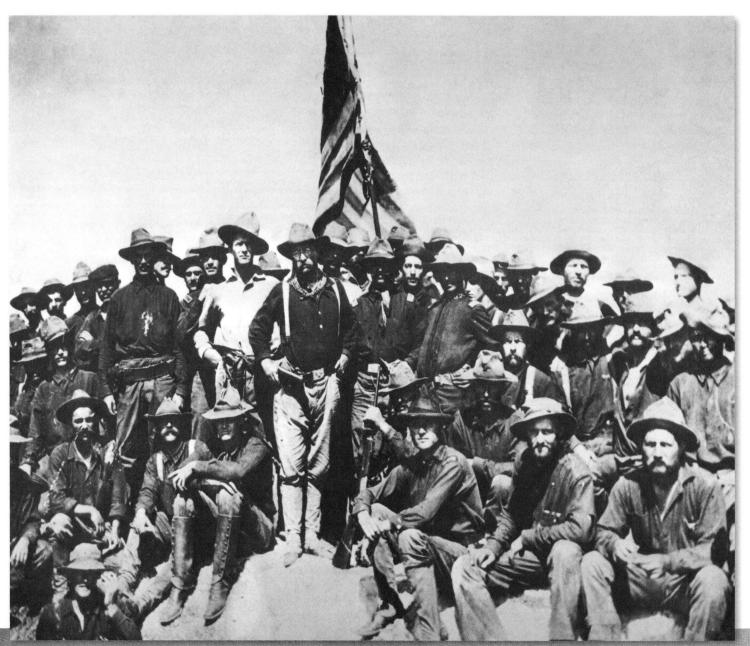

Colonel Theodore Roosevelt and his Rough Riders, "Teddy's colts," at the top of the hill they captured in the Battle of San Juan Hill, in 1898. Photographer: William Dinwiddie.

United States, having served as the police commissioner of New York City and the assistant secretary of the navy. Organized on May 1 in the American Southwest, the unit was in action in Cuba at Las Guasimas on June 24, just 55 days after Roosevelt and his friend Colonel Leonard Wood raised the regiment. Due to lack of ships, only 8 of the original 12 companies of troopers were able to go to Cuba—and they had to leave their horses behind in Florida, which forced them to conduct operations on foot.

William Dinwiddie, the photographer, was on assignment in Cuba to cover the war and provided images to various newspapers, including the *New York Herald*, *Truth*, and *Harper's Weekly*. The engagement on the San Juan Heights (or San Juan de Majares) actually saw the Rough Riders participate in two distinct charges on July 1, 1898. The first was on a position that would become known as Kettle Hill, due to a large sugar refining kettle found in one of the out buildings; the second, which came a few minutes later, was on the block house on top of San Juan Hill. This photograph shows Roosevelt at center stage flanked by members of the Rough Riders and was taken several days after the event. Within a few months Roosevelt would be elected governor of the State of New York, and in 1900 he was nominated to serve as vice president under William McKinley. In 1901 President McKinley was assassinated, propelling Theodore Roosevelt at age 42 into the White House as president of the United States of America.

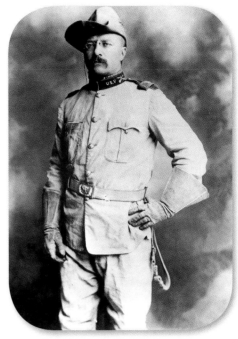

Colonel Theodore Roosevelt, First Cavalry, U.S.V. (NARA)

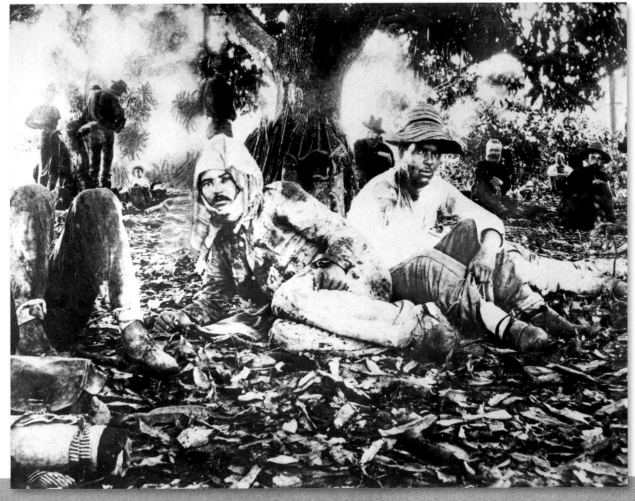

Wounded Spanish prisoners at Brigade Hospital on San Juan Hill, Cuba, July 3, 1898. (NARA)

More than 400,000 Union and Confederate soldiers became prisoners during the Civil War. In the early years of the war, both sides exchanged and paroled their prisoners. However, in the latter stages of the war, this practice ceased, largely due to the Union's unwillingness to release prisoners whom they knew they would have to fight again. For the soldiers who remained imprisoned, the last two years of the war became years of misery.

Initially, the armies housed prisoners in old forts, barracks, and buildings surrounded by fencing. As the prisoner count swelled, open stockades became common, such as the one at Andersonville. Southern authorities rimmed Andersonville's 30 acres with a double row of fencing. The space between the fencing served as a "dead zone," so called because guards would shoot anyone near it.

Prison diets, initially consisting of pickled beef, salt pork, rice, beans, and corn meal, did little to sate appetites even when pro-

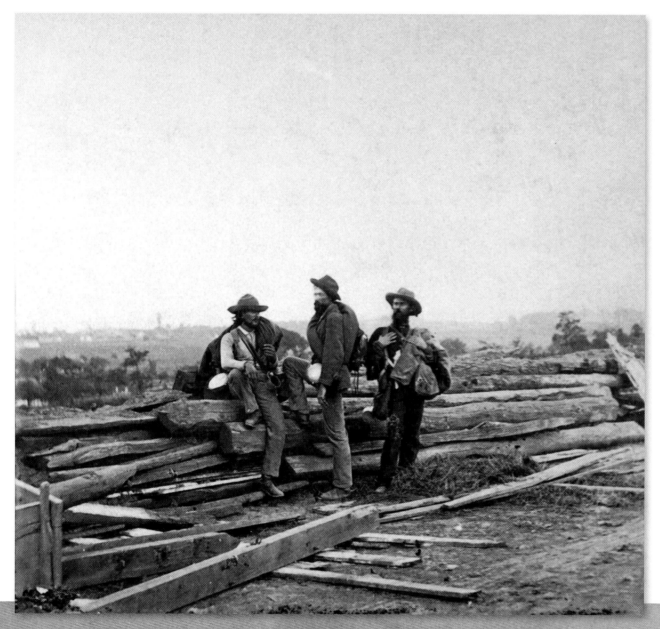

Confederate prisoners on Seminary Ridge at Gettysburg, July 1863. Photographer: Alexander Gardner. (Army)

vided in sufficient quantity. As the war progressed, and particularly in southern prisons, food became scarce, for both the jailed and the jailers. Augmenting the diet with caught rats or other critters did little more than provide base entertainment.

As a result of the poor diet, scurvy and dysentery became routine. Lack of water led to dehydration, while the poor quality of what water was available, combined with a lack of sanitation, led to typhoid and cholera. Close quarters allowed diseases such as smallpox to flourish, and the backwater locations of many of the prisons led to outbreaks of malaria. The abysmal sanitary conditions meant that any small sore or wound remained susceptible to infection and gangrene, and the infected limb in turn subject to amputation.

In addition to the physical hardship, prisoners struggled to cope with mental tribulations as well. With little to do and often less to look forward to, depression was a constant threat. However, as with any prisoner of war camp, men did what they could to make life bearable. Some prisons had their own newspapers, libraries, and societies dedicated to such activities as debate and theater. However, no other pastime provided as much escape from the daily horrors as planning and attempting to escape. While tunneling was by far the most common and most time-consuming method, some prisoners feigned illness or death. In some northern prisons, a few of the inmates darkened their skin with charcoal and walked out with the African American servants. Despite the odds against them and the harsh punishment that awaited them if caught, prisoners remained undeterred in their efforts to escape.

While Southern prisons such as Andersonville in Georgia and Libby Prison in Richmond became infamous after the war for the squalor the prisoners endured, Union prisons offered equally shameful conditions. Lack of food, medical supplies, and adequate shelter fostered conditions that made every day a struggle to survive. Only death or escape gave the inmates relief from the cesspool in which they lived. With 50,000 men dying in the prisons during the war, death proved the more likely outcome.

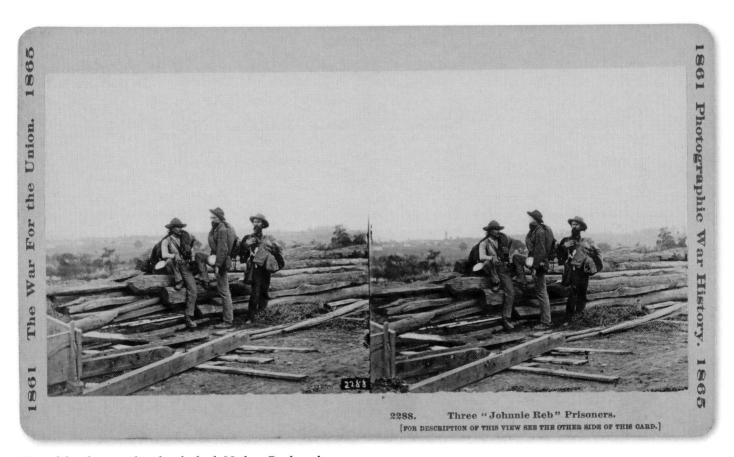

Most of the photographs taken by both Mathew Brady and Alexander Gardner were available to the public as stereoviews so that the observer could "step into" the scene. (LOC)

FORT SUMTER

In the early morning of April 12, 1862, Confederate batteries around Charleston Harbor began their bombardment of Fort Sumter. After 34 hours, with provisions nearly exhausted, the commander of Fort Sumter, Major Robert Anderson, surrendered the fort to Confederate General P.G.T. Beauregard and prepared for its evacuation. The evacuation of Fort Sumter capped a nearly month-long chess match between President Abraham Lincoln and his Southern rival, Jefferson Davis.

Shortly after South Carolina announced its secession from the Union, Major Anderson moved his men from Fort Moultrie into the heavier Fort Sumter. South Carolina protested the move of Federal troops to Fort Sumter, proclaiming it a violation of South Carolina's sovereignty. When President James Buchanan sent an unarmed steamer under a British flag to resupply and reinforce Fort Sumter, South Carolina troops fired on the steamer, causing her to turn back.

When Lincoln took office on March 1, 1862, he recognized that the Confederate states could not allow the border states to maintain their neutrality for long and saw Fort Sumter as the ideal place to force a confrontation. Jefferson Davis, having declared the Federal presence at Fort Sumter a violation of Southern sovereignty, would have to fight or back down. Since many in the Confederacy saw an action against Fort Sumter as a means to sway the border states to join them, a fight was almost guaranteed.

On April 6, Lincoln signed the order dispatching a naval expedition to resupply Fort Sumter. He notified the Confederate states of his intent, knowing it would force the Confederacy to either back off or fire the first shot. Meanwhile, Davis ordered Beauregard to take any action necessary to prevent the resupply

The Confederate flag flying over Fort Sumter on April 14, 1861, two days after the Confederate shelling. Attributed to Alma A. Pelot, this is one of the few photographs of the war taken by a Southern photographer. (NARA)

of the fort. At midnight on April 12, Beauregard sent a delegation under a flag of truce to ask Anderson to surrender. Anderson replied that without additional supplies, he would evacuate the fort by April 15, but until then would hold fast. However, with the Union relief expedition sitting just outside Charleston Harbor, Beauregard had little choice but to commence hostilities.

As dawn broke on April 15 and the Confederate flag flew over Fort Sumter, Anderson's garrison made its way north to a heroes' welcome. Meanwhile, the South hailed Beauregard as the champion of their sovereignty. Lincoln and Davis began preparations for the fight each knew lay ahead, and photographers came from Charleston to photograph the aftermath of the first battle of the war.

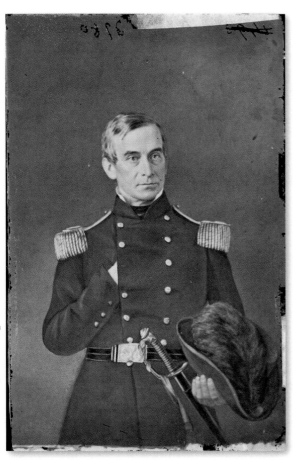

Major Robert Anderson commanded Fort Sumter in April 1861. He later surrendered the fort to the victorious Confederates. (LOC)

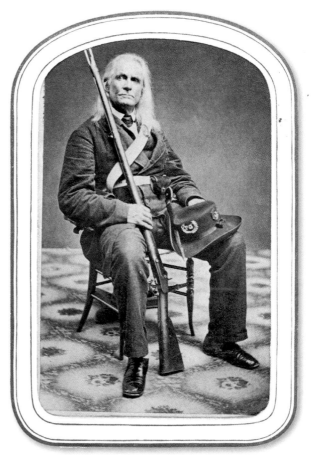

Edmund Ruffin purportedly fired the first shot of the Civil War at Fort Sumter. He was so distraught by the Confederate defeat that he killed himself at the close of the war. (NARA)

BALLOON *INTREPID* AT SEVEN PINES

In March 1862, General George B. McClellan landed troops on the Virginia Peninsula as part of an effort to flank the Confederate army. By the middle of May 1862, McClellan's forces had pushed the Confederates under General Joe Johnston back into the defensive fortifications of Richmond. McClellan's forces stood within six miles of the Confederate capital and prepared to lay siege to its defenses.

McClellan had two-thirds of his army north of the Chickahominy River. The remaining third, the Third and Fourth Corps, under General Erasmus D. Keyes and General Samuel P. Heintzelman respectively, stood south of the swollen Chickahominy, leaving them vulnerable to a Confederate counterattack if McClellan's remaining corps could not bridge the river. Johnston recognized the opportunity McClellan's divided force presented and moved to take advantage of it. He planned to strike at Seven Pines, a crossroads, which would allow him to bring the majority of his army to bear down onto Keyes's Third Corps. After defeating Keyes, he would then turn to attack Heintzelman.

On May 31, as Johnston prepared to attack, Professor Thaddeus Lowe, head of the Union army Balloon Corps, lifted off in the balloon *Intrepid* from his base at Gaines Farm north of the Chickahominy. Tethered to the ground and outfitted with a telegraph, the *Intrepid* allowed Lowe to relay information on Confederate troop movements occurring in front of Keyes's Third Corps at Seven Pines.

Armed with the information from Lowe, McClellan ordered General Edwin Sumner's Second Corps to cross the river in support of Keyes. They arrived just in time to solidify Keyes's crumbling right flank, and the Confederate attack faltered. The Confederates renewed their attack the next morning, but they made little progress against a reinforced Union line and broke off their attack before noon.

The Battle of Seven Pines marked the high point for the Union offensive against Richmond. By the end of July, Confederate forces, now under General Robert E. Lee, who had assumed command after a shell injured Johnston, would push the Union army back across the James River and into the outskirts of Washington.

Seven Pines marked the high point for Lowe's Balloon Corps as well. McClellan had used the Balloon corps extensively during his campaign on the Peninsula, but Lowe contracted malaria near the end of the campaign. During his month-long recovery, the Army quartermaster requisitioned Lowe's equipment; by the time Lowe negotiated his way through the political and military red tape to get it back,

McClellan no longer commanded the Army of the Potomac. Not until the Battle of Fredericksburg in December 1862 did Lowe again take part in any action. However, a reduction in pay, as well as disparaging reports regarding the effectiveness of his Balloon Corps, caused Lowe to tender his resignation in May 1863. By August that year, the Army disbanded the Balloon Corps altogether.

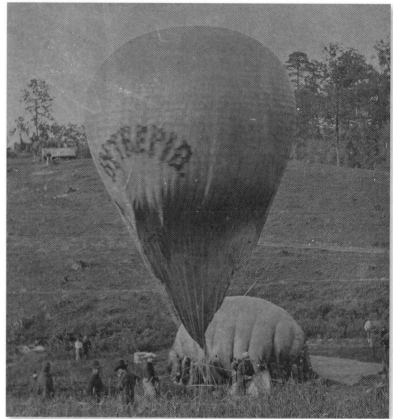

Fair Oaks, Virginia. Professor Thaddeus S. Lowe replenishing the balloon *Intrepid* from the balloon *Constitution*. (LOC)

Professor Thaddeus S. Lowe. (LOC)

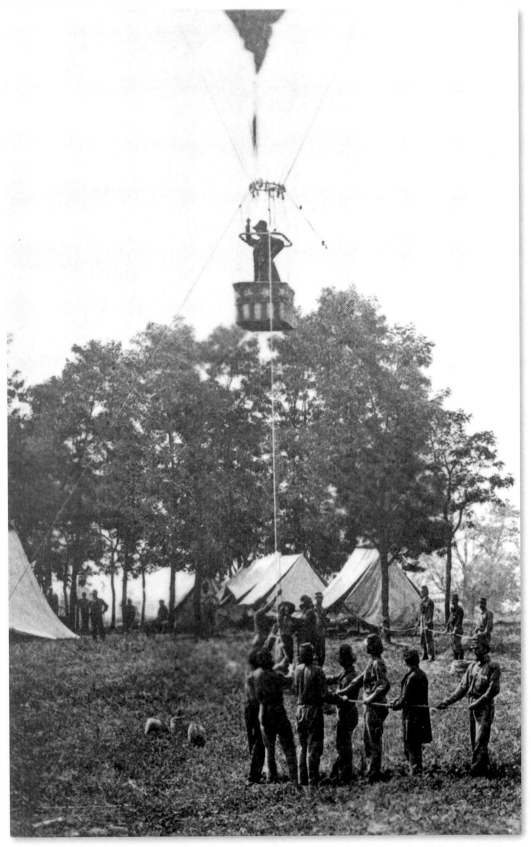

Thaddeus Lowe in the balloon *Intrepid* at the Battle of Seven Pines in Virginia. Taken by Mathew Brady circa May 31, 1862. (NARA)

GENERAL ROBERT E. LEE

Son of Revolutionary war hero Henry "Lighthorse Harry" Lee and husband of Martha Washington's great-granddaughter, Robert E. Lee faced a difficult decision on the eve of Virginia's secession. As late as March 28, 1861, Lee accepted a colonelcy in the Federal army. On April 18, he turned down an offer to command the defenses of Washington, D.C., knowing he might have to attack his home state in the process. When Virginia finally seceded on April 20, Lee resigned his commission with the U.S. Army and offered his services to the Confederacy.

Lee spent his early years in the war commanding Confederate forces in Virginia but soon took command of the coastal defense of South Carolina and Georgia. His early encounters with Federal forces yielded mixed results, but Confederate President Jefferson Davis nonetheless appointed him as his military adviser, after which he began improving the defenses around Richmond.

Not until June 1862, when he took command of the Army of Northern Virginia, did Lee command an army in the field. While criticized in the press for his perceived lack of aggressiveness, Lee's subsequent actions at the Seven Days' Battle and at the Second Battle of Bull Run quickly quieted his critics.

In late 1862, Lee orchestrated a campaign that took the battle to the Northern states. Launched in conjunction with similar campaigns in the west, Lee's campaign looked to bring much needed supplies to his army as well as gain a significant victory on Northern soil. He moved his troops quickly through Maryland in the early stage of the campaign; the Union army put up little resistance after its defeat at the Second Battle of Bull Run. However, as parts of Lee's army crossed eastward over the Shenandoah Mountains, they ran into the mass of the Union army at Antietam. While Lee did not lose at Antietam, the beating his army took forced him to retreat to Virginia. He still managed to procure the needed supplies as well as score a decisive victory at Fredericksburg as he retired further South.

After another victory at Chancellorsville, Lee began another campaign into the Northern states. In early July 1863, Lee met Union forces under General George Meade at Gettysburg, Pennsylvania. Lee gained an advantage after the first two days of fighting. However, on the third day, a failed frontal assault brought the battle to an end. Having suffered upward of 28,000 casualties, Lee again pulled his forces back to his home soil of Virginia.

The loss at Gettysburg prompted Lee to submit his resignation, which President Davis declined. Gettysburg, in particular Pickett's failed charge on the third day, symbolized the high-water mark for the Confederacy and also in many ways for Lee. While he would fight for another two years, the Confederacy now fought a purely defensive battle as the Union army, particularly after General Ulysses Grant took command, began placing constant pressure on Lee and his army that ended with Lee's surrender at Appomattox.

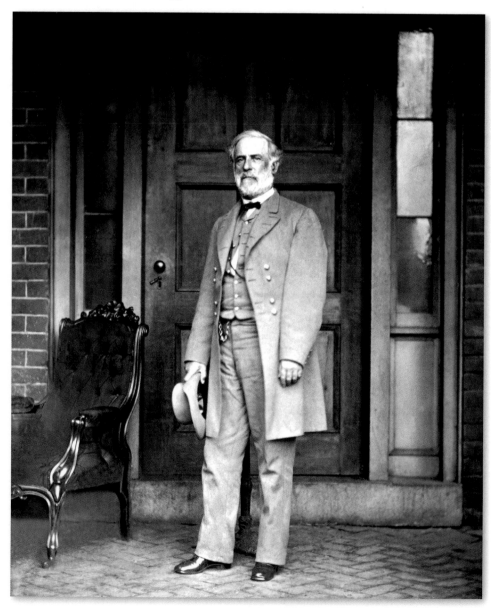

Robert E. Lee standing on the back porch of his Richmond home several days after his surrender at Appomattox Court House. Taken by Mathew Brady on April 16, 1865. (NARA)

SIEGE OF YORKTOWN

In March 1862, Union General George B. McClellan began an offensive campaign on the Virginia Peninsula that he had prepared for since he had taken over the army more than six months earlier. While he originally planned to land his troops in Urbanna, Virginia, to outflank the Confederate army positioned outside Washington, the Confederate army's withdrawal back toward Richmond forced McClellan to change his landing point to Fort Monroe farther down the coast and to outflank the Confederate army by marching on Richmond from the southeast.

Once Confederate General Robert E. Lee became aware of McClellan's intent, he moved to fortify the peninsula. Lee ordered General John B. Magruder to defend a line near Yorktown along the Warwick River. At Yorktown, Magruder dug into the old British entrenchments left over from the Revolutionary War, extending them down to the Warwick until the river formed a moat around the earthworks. Magruder also dammed various parts of the river, creating a quagmire behind which he mustered his troops and maneuvered them in a display of force.

Although McClellan had successfully landed his troops on the peninsula, weather, logistical problems, and McClellan's paranoia slowed his advance. Rain had started to fall, turning the usually solid, sandy roads into muddy thoroughfares. Adding to the difficulty presented by the washed-out roads, McClellan had maps that were all but useless. Finally, Magruder's theatrical display of sabre rattling caused McClellan to fear he faced a much larger force than his 120,000 troops could handle. With all this weighing on him, McClellan's advance slowed to a crawl before he even made any significant contact with the Confederate line at Yorktown.

McClellan did have confidence in his superior artillery, and with that began building siege works of such magnitude he would describe them in a telegraph to Lincoln as "gigantic." Throughout April, McClellan built 15 10-gun batteries of 13-inch coastal mortars, each capable of hurling a 200-pound shell up to two miles around the defenses of Yorktown. These large mortars were ideally suited to break the Confederate defenses as they could send a plunging fire into the fortifications. As Union artillerists based their aim on calculations rather than line of sight, they could fire coastal mortars from deep within their own trenches, offering them the added benefit of firing from a protected position. Satisfied, McClellan planned to rely on his artillery to do the work of removing the Confederates from the Yorktown entrenchments.

Though McClellan built impressive siege works, his taking of Yorktown proved anticlimactic. Seeing the preparations Union troops had made, General Joe Johnston, commanding the Confederate forces on the peninsula, quietly removed his troops from the Yorktown line and back to a second line prepared at Williamsburg. Yorktown fell to McClellan with hardly a shot fired and almost no shelling from the massive coastal mortars.

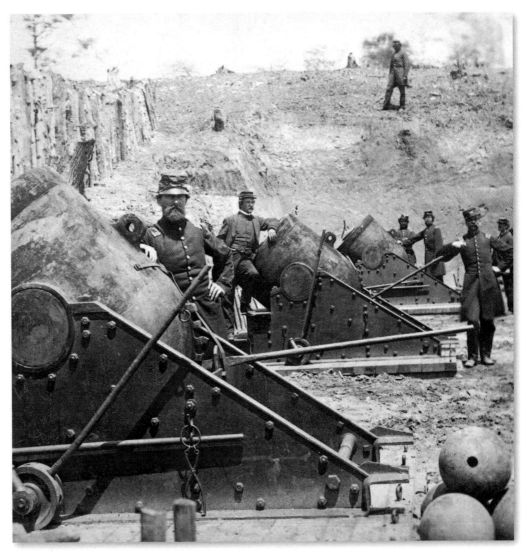

Officers of a battery of 13-inch seacoast mortars at Yorktown. The 200-pound shell could do significant damage to an enemy's earthworks. Taken in May 1862 by James Gibson. (NARA)

LINCOLN AT ANTIETAM

On September 22, 1862, President Abraham Lincoln issued the precursor to the Emancipation Proclamation. It put the Confederacy on notice that he would proclaim all slaves free as of January 1, 1863. Lincoln also gave the Confederate states and slaveholders a chance to rejoin the Union and offered to compensate them for any loss of "property" if they did. However, he knew the proclamation had no teeth unless the Union army succeeded in driving the Confederate invaders back across the Mason-Dixon line and Union troops advanced into the Southern states.

On October 1, 1863, Lincoln visited General George B. McClellan at Antietam. Lincoln had already dispatched Generals Buell, Pope, and McDowell, none of whom had satisfied his desire for more aggressive action. While McClellan had won a critical victory at Antietam and had won the devotion of the Army of the Potomac, he too lacked the offensive spirit Lincoln wanted in his generals. Lincoln's patience with McClellan's prevarications had worn thin, and he intended to prod him into action. Over the next three days, Lincoln took stock of the troops and their leadership. He urged McClellan to resume pursuit of Lee, but McClellan showed little enthusiasm for it. Lincoln left Antietam on October 4 with the realization of two things: McClellan would prove difficult to move, and the Army of the Potomac's deep loyalty to their general would make his removal a delicate task.

On his return to Washington, Lincoln immediately ordered McClellan to attack across the Potomac and give battle to Lee's battered army. McClellan sent back an evasive, lackluster reply. For the next month, Lincoln continued to push McClellan, and

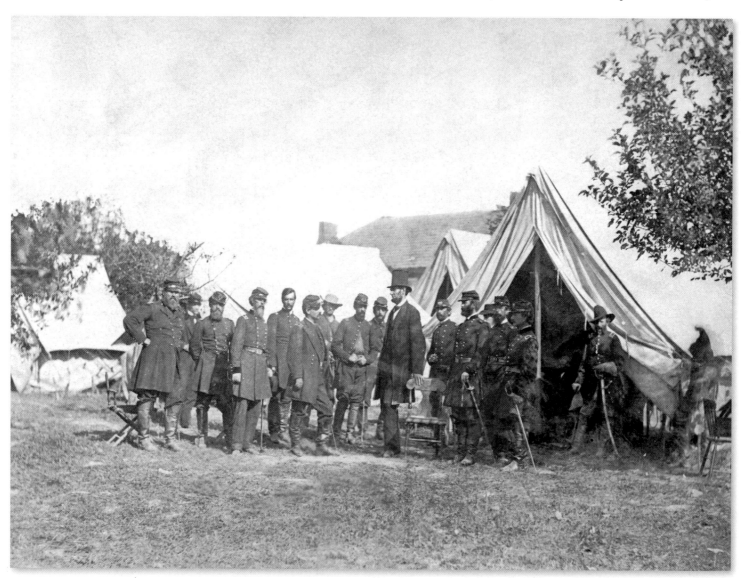

President Lincoln visiting General George B. McClellan and his staff in Sharpsburg, Maryland, after the Battle of Antietam on Oct 3, 1862. Photographer: Alexander Gardner. (NARA)

while stopping short of an outright order, his tone became ever more caustic. By November 5, the day after the midterm elections, Lincoln's patience with McClellan ran out and he drew up the orders for his removal.

Having removed McClellan, Lincoln now had his three chosen commanders in place: Generals Burnside, Rosecrans, and Grant. With these three he planned to take the fight into the Southern states, with emphasis on Richmond, Chattanooga, and Vicksburg. Lincoln knew full well that once those three bastions of the South fell, the whole of the Confederacy would follow.

Alexander Gardner, who photographed Lincoln's meeting with McClellan at Antietam, lost his position with McClellan's dismissal. He had held an honorary captain's rank on McClellan's staff, a position he received as a result of Lincoln's agreement to have the war photographically documented. That role as chief army photographer diminished when McClellan left. Gardner became increasingly frustrated with Mathew Brady, for whom he worked, as Brady would publish Gardner's work under his own name. Gardner would eventually break with Brady, but he would continue to photograph the war, most notably at Fredericksburg, Gettysburg, and Petersburg.

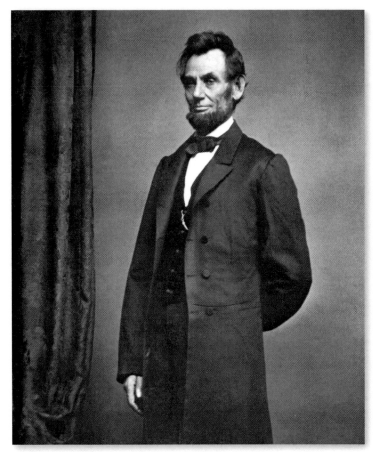

This Mathew Brady photograph of President Lincoln was taken in 1864 and shows a war-weary president. (NARA)

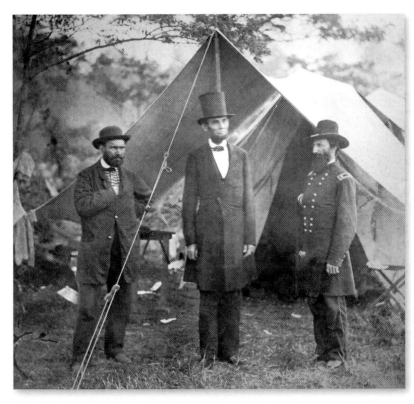

Major Allan Pinkerton, President Lincoln, and Major General John A. McClernand, Antietam, Maryland. (NARA)

ANTIETAM BRIDGE

After his victory at the Second Battle of Bull Run, Robert E. Lee continued his offensive into Maryland. Although General Lee captured Harper's Ferry, the Army of the Potomac under General George B. McClellan managed to stave off his offensive at South Mountain, Maryland, on September 14. Unlike previous battles, McClellan continued his pursuit of the Confederate troops, forcing Lee to take up a defensive position around the town of Sharpsburg, Maryland, and setting the stage for the Battle of Antietam.

The town of Sharpsburg lay within the bends of the Potomac. The ridges around the eastern outskirts of the town provided natural defenses, especially against attacks coming from across Antietam Creek, which had few fords and fewer bridges spanning its 50-foot width.

On the morning of September 16, McClellan's troops encountered the Confederate positions. Unaware of the numerical superiority he had over Lee, McClellan chose to delay his attack until the next day when the bulk of his army would arrive and allow him to attack three sections of the Confederate line simultaneously. The delay proved costly.

The Union attack began early on the morning of September 17, with General Joe Hooker's First Corps advancing down the Hagerstown Turnpike. The Confederate troops under General Stonewall Jackson had taken up positions in woods and a cornfield that lay on either side of the turnpike. The early stages of the battle showed promise for the Union troops, and the Confederate

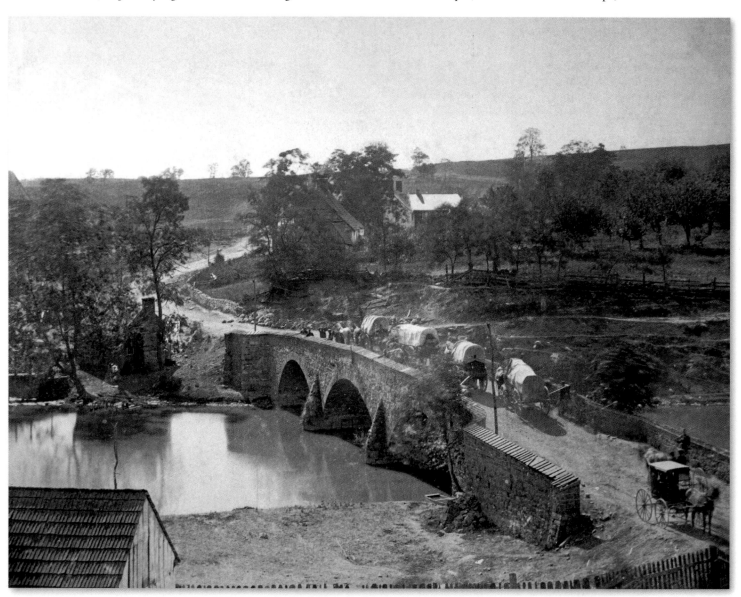

Antietam Bridge. One of 70 photographs taken by Alexander Gardner days after the Battle of Antietam in September 1862. The bridge saw a short, spirited fight during the battle. (NARA)

lines nearly broke. By 7 a.m. Confederate reinforcements had arrived from Harper's Ferry, and Jackson's lines stabilized. By 10 a.m., the Union attack in this sector died out, and Lee's left flank remained secure. However, carnage reigned, and both sides suffered a combined total of 13,000 casualties in the first five hours of the battle.

By midday, the main fury of the fighting lay in the middle of the Confederate line. Called the "Bloody Lane," the fighting along this 800-yard stretch resulted in nearly 5,600 casualties. Here, too, the Confederate lines nearly broke, but timely reinforcements as well as McClellan's reluctance to engage more of his reserve troops allowed the Confederates to hold the line.

South of the Boonsboro Road, Union General Ambrose Burnside attacked the Confederate forces guarding Rohrbach's Bridge, later renamed Burnside's Bridge. Having moved much of his force north of the Boonsboro Road, Lee had just 3,000 men south of the Boonsboro Road, of which only 400 guarded Rohrbach's Bridge. Those 400 men, led by Brigadier General Robert Toombs, faced the bulk of the 12,000 men under Burnside; however, they held the bridge for nearly three hours. Only when ammunition began to run low did Toombs surrender the bridge. Despite losing the bridge, they bought Lee valuable time, as General A.P. Hill had arrived from Harper's Ferry to bolster Lee's defense.

As dusk arrived the battlefield grew quiet. Lee prepared his troops to defend the Union assault that would most certainly come at sunrise. However, having suffered more than 12,000 casualties, McClellan had no intention of resuming the attack and instead contented himself with holding what ground he had gained. Realizing that McClellan would not pursue, and having suffered 10,000 casualties of his own, Lee began to withdraw from his positions back behind the Potomac and made for the safety of Virginia.

Over the next few days, Alexander Gardner took nearly 75 pictures in and around Antietam, including many of both the Antietam and Rohrbach bridges, the latter of which had played such a pivotal role in the outcome of the battle. The serene landscape belies the ferocity of the fighting that occurred in the area just days before; in all likelihood, this juxtaposition caught Gardner's eye after the carnage he had witnessed.

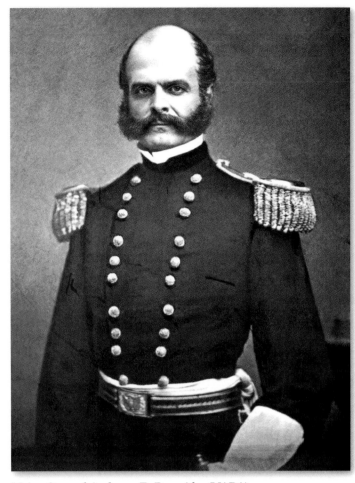

Major General Ambrose E. Burnside. (NARA)

Soldiers of the 51st Pennsylvania Volunteers storm across the stone bridge at the battle of Antietam, Maryland, 1862; painting by Don Troiani. (Military and Historical Image Bank)

FREDERICKSBURG, VIRGINIA

After the Battle of Antietam, as Robert E. Lee's army retreated back to Virginia by way of the Shenandoah Valley, Union General Ambrose Burnside, commanding the Army of the Potomac, attempted to cut Lee's army off from an undefended Richmond. Lee, recognizing that Burnside would cross the Rappahannock River before his troops could get to Fredericksburg, originally planned to set up a defensive line at the North Anna River. However, various impediments kept Burnside from reaching the Fredericksburg crossing in time, allowing Lee to take up a strong defensive position on the heights south of the city.

On December 11, Burnside began moving his troops across the Rappahannock. Confederate sharpshooters under General William Barksdale delayed the crossing. Not until dusk, after a lengthy Union artillery bombardment destroyed much of the city, did Burnside's troops enter Fredericksburg. However, the difficulties were only just beginning for the Union troops.

On the morning of December 13, Union troops began their attacks on the Confederate positions. South of Fredericksburg, the attacks made some headway as troops under General George Meade made a small break in the Confederate line. However, Meade could not hold his positions for long. General Thomas "Stonewall" Jackson's counterattack broke the Union assault and began to push them back toward the river. Union artillery fire, along with the arrival of fresh Union troops, halted Jackson's counterattack.

The Union attack clearly had problems south of Fredericksburg; at Maryes Heights, just behind the city, it turned into a disaster. A sunken road and a stone wall ran alongside the Plank Road, which led out of the city. Here, covered by artillery that bristled along Maryes Heights, Confederate troops set up their defensive line. To make their attack on the sunken road, Union troops had to cross an open field under Confederate artillery fire before forming into columns to navigate the bridges that spanned a small canal. Only then, once across the canal, could they gain some shelter from a small bluff before making their final charge.

Around noon, as the morning fog began to lift, the first Union troops under General Nathan Kimball made their charge. As they got to within 100 yards of the stone wall along the Plank Road, the Confederate defenders rose up and fired. The first Confederate volley ripped into the Union attackers, and subsequent volleys followed as the defenders rotated through their lines, each coming to the wall, firing, and then falling back for the next wave. Kimball's brigade suffered 25 percent casualties, including Kimball himself. The Union troops only made it to within 40 yards of the Confederate line.

In all, Union troops made a total of 14 separate charges at Maryes Heights, each ending as dismally as the one before. At 6 p.m. the last charge came to its grisly end. Two days later, having dealt with the dead and wounded, Burnside retreated from the field, with both his campaign and his command finished.

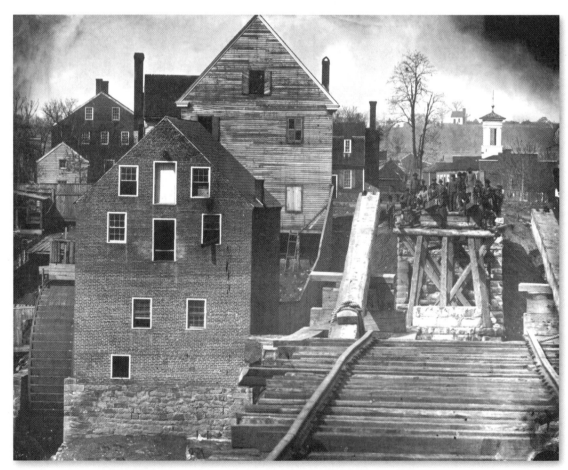

Confederates at Fredericksburg as seen from across the Rappahannock. Taken by Mathew Brady after the Union withdrawal circa December 15, 1863. (NARA)

U.S.S. *MONITOR* AT HAMPTON ROADS

On March 8, 1862, the Confederate Navy's ironclad CSS *Virginia* (called the *Merrimack* by the Union) steamed into Hampton Roads intent on attacking the five Union vessels stationed there. In short order the *Merrimack* sunk the USS *Congress* and *Cumberland*, while the frigates USS *St. Lawrence*, *Roanoke*, and *Minnesota* ran aground during the battle. By the time the *Merrimack* left Hampton Roads, the U.S. Navy had suffered the worst loss it would know until World War II. While some members of Lincoln's cabinet panicked at the thought of the *Merrimack* sailing on Washington, Navy Secretary Gideon Welles reassured them the *Merrimack* could not sail up the Potomac; the Union also had its own ironclad already en route to counter any further attacks by the *Merrimack.*

The invention of engineer John Ericsson, the USS *Monitor* looked like what one Confederate described as a "cheesebox on a raft." It consisted of a revolving turret armored with nine inches of steel plate and armed with two 11-inch Dahlgren guns. The turret, along with a pilot house, sat on top of a hull that barely broke the waterline.

By March 9, the *Monitor* had arrived at Hampton Roads. Having barely survived a heavy sea on her tow down from the Brooklyn Dockyards, the *Monitor* took up station behind the grounded *Minnesota* and waited for dawn and the arrival of the *Merrimack.*

As the *Merrimack* steamed toward the *Minnesota*, intent on finishing what the outgoing tide had prevented the night before, the *Monitor* came out from behind the *Minnesota*. For the next several hours, the two ironclads battled. Under the command of Lieutenant John Worden, the more maneuverable *Monitor* circled the *Merrimack*. The *Monitor* fired shell after shell into the heavier ironclad's armor plate, all the while absorbing the *Merri-*

mack's own retaliatory fire. Inside both ironclads, sailors bled from their ears as the sound of the shells reverberated off the steel plate and the discharge of cannons echoed within their steel chambers.

Lieutenant Catesby ap Roger Jones, commander of the *Merrimack*, recognized that his shells were making little impact and attempted to ram the *Monitor*, but the smaller ironclad proved too elusive. As the fighting continued, a shell struck the *Monitor*'s pilot house, injuring Lieutenant Worden. With her commander injured, the *Monitor* turned away from the battle to regroup. Lieutenant Jones, thinking the *Monitor* had withdrawn and facing a falling tide, made for Norfolk.

The ironclads would not face each other again, yet both would suffer their demise by the end of the year. The Confederacy burned the *Merrimack* when they abandoned Norfolk, and the *Monitor* sank in a heavy sea while repositioning to Beaufort, North Carolina. However, both had proved their worth and ushered in a new era for naval warfare around the world.

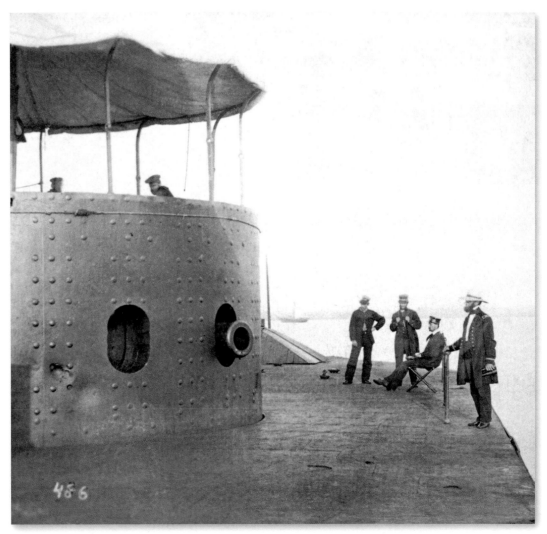

Original *Monitor* shortly after her battle with the *Merrimack*. Dents from the *Merrimack*'s shells are visible on the *Monitor*'s turrets. Taken by James Gibson on July 9, 1862. (NARA)

DECK OF THE GUNBOAT *HUNCHBACK*

Built in 1852, the USS *Hunchback*, a steam-powered side-wheel gunboat, spent her first eight years as a ferry in New York City. With the outbreak of the Civil War, the U.S. Navy purchased *Hunchback* in December 1861 and converted her for military use. Such repurposing of civilian ships allowed the U.S. Navy to quickly bring ships into service to meet the needs of the blockade against the Southern states as well as provide mobile artillery support to armies campaigning along riverfronts.

The *Hunchback*'s shallow draft and relatively high speed made her ideally suited for both roles. The 179-foot ferry's conversion included the addition of three nine-inch guns, a 100-pound parrot rifle, and armor plating around the fore and aft decks, which provided the gun crews with some protection from small arms fire.

By January 1862, the *Hunchback* had joined the U.S. Navy's North Atlantic Blockading Squadron, where she participated in the attack on Roanoke Island and contributed to the fall of the Confederate-held Fort Barrow. After the attack on Fort Barrow, the *Hunchback* moved up the Chowan River, where she carried troops and provided heavy artillery support for the attack on New Bern.

An officer leaning on one of the gunboat USS *Hunchback*'s heavy guns.
Taken on the James River by Mathew Brady, circa 1864 or 1865. (NARA)

In October 1862, the *Hunchback* participated in the Joint Expedition Against Franklin. As the *Hunchback* and her sister ships made their way up the Blackwater River toward the Confederate forces gathering at Franklin, a barricade of felled trees prevented further advance. The ships faced withering fire from Confederate troops along the riverbank. As the gunboats waited for Union infantry support, the Confederates felled trees to their rear in an attempt to prevent their escape. Lacking the infantry support to conclude the attack, the *Hunchback* and sister ships made their way back down the river, easily running the hastily constructed Confederate blockade.

Over the next few months the *Hunchback* would see further action in the Albemarle Sound, most notably at Hamilton, Fort Anderson, and Washington, North Carolina. In early 1864 the *Hunchback* went to Baltimore for repair and refit, her two years of nearly constant action having finally taken their toll.

By May 1864, the *Hunchback* was back in action on the James River. She towed the ironclad USS *Saugus* up the James, shelled Confederate troops, and carried dispatches for the army. Before she was decommissioned in June 1865, the *Hunchback* had one more tour of duty in Albemarle Sound. Once decommissioned, the *Hunchback* returned to service as a New York City ferry, renamed *General Grant*. She would remain in this capacity until 1880, when she was retired and scrapped.

Two sailors pose with a gun on the deck of U.S. gunboat *Hunchback*. (LOC)

Correspondent Alford R. Waud's drawing of a Union gunboat. (LOC)

REBEL SHARPSHOOTER AT GETTYSBURG

"I hated sharpshooters, both Confederate and Union and I was always glad to see them killed," wrote a Union artillerist. Many soldiers likely echoed his sentiment. Sharpshooters made life miserable for both sides, especially when armies had entrenched. Never immune from the crack of a distant rifle, men would have to crawl or zigzag from their lines to get basic necessities. The simple act of looking over the trench at the enemy could ring a death knell.

At the start of the war, Hiram Berdan, one of the top marksmen in the country, set out to recruit two regiments of riflemen for the Union army. To join Berdan's regiments, recruits had to place 10 shots within five inches of a bull's-eye at 200 yards. Once in the regiment, Berdan drilled the troops religiously, both in skirmish tactics and in marksmanship. Berdan outfitted his troops in green uniforms for camouflage and armed them with the Sharps rifle, which allowed them to fire at more than twice the rate of the standard infantryman.

Berdan's troops often acted as true light infantry at the onset of a battle, deploying into a broad skirmish line ahead of the regular infantry and laying down a withering fire. Once fully

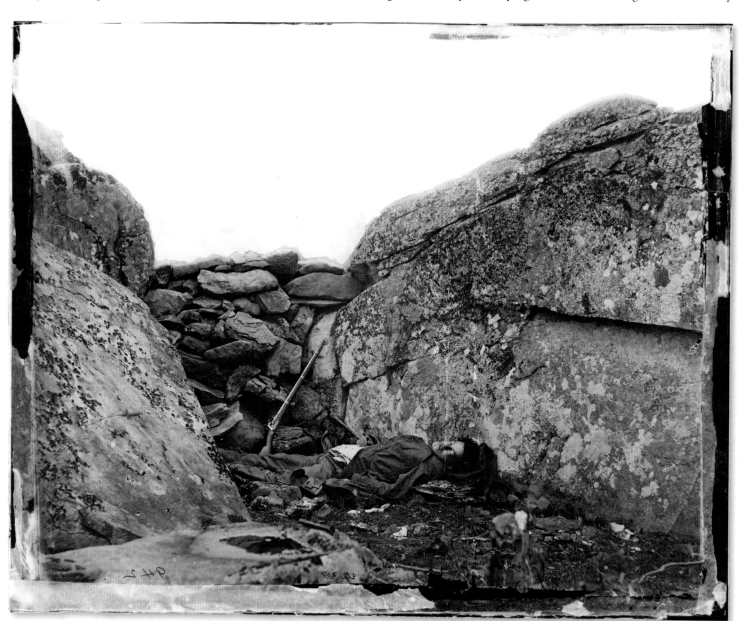

"Home of a Rebel Sharpshooter, Gettysburg," taken by Alexander Gardner days after the Battle of Gettysburg, 1863. Controversy over "staging the scene" surrounds the composition of this image. (NARA)

engaged, they broke into smaller units and began their deadly task of picking off Confederate officers and artillerymen.

While the Confederates had their own versions of Berdan's units, most of their sharpshooters belonged to a regular unit. Armed with the best match rifle they could scrounge, often the English Whitworth, Confederate sharpshooters regularly remained in the rear until opportunities arose for them to begin their work. Once engaged, they largely worked independently of the rest of their unit.

At Gettysburg, particularly in and above Devil's Den, an area ideal for sharpshooters, Confederate marksmen positioned themselves in the boulders, trees, and crevices that dominated the area. Their fire took a significant toll on the Union troops. Not until Union forces unleashed the counter-fire from its sharp-

shooters and artillery did the Confederate marksmen's fire begin to fade.

While sharpshooters proved particularly deadly, they were not immune from enemy fire. Although they often positioned themselves well away from the heart of the battle, once the enemy discovered the telltale puff of smoke, sharpshooters drew an inordinate amount of counter-fire. Not only did they become targets of their counterparts, but artillery searched out their positions mercilessly.

Though highly skilled, independent, and tough, sharpshooters suffered from the nature of their duty. In a letter, a Union sharpshooter described seeing a Confederate in his crosshairs and wrote, "The above impression struck me as being as near murder as anything I could think of in connection with the army."

The same spot on the battlefield today. (LOC)

Gardner moved this dead Confederate from this position to create the more famous image pictured opposite. (LOC)

ORANGE & ALEXANDRIA RAILROAD

At the start of the Civil War, it was apparent to leaders on both sides that they would rely heavily on railroads in order to effectively supply the armies they put in the field. After General Joe Johnston used the Manassas Gap Railroad to move Confederate reinforcements from Shenandoah Valley in time to join the First Battle of Bull Run, the first large-scale battle of the war, they became even more aware of the railroads' importance.

While the Confederates moved first to take advantage of the opportunities railroads afforded, the Union army would ultimately use the railroads to their fullest potential, largely due to the guidance of engineer Herman Haupt. A year after the outbreak of the war, Secretary of War Edwin M. Stanton, recognizing the knot that existing supply channels had made, created a department responsible for constructing and operating the military railroads and appointed Haupt to run it.

Haupt moved quickly to repair broken rail lines around Washington. He laid telegraph lines along the rail lines to improve communications and trained and armed a staff responsible for

The engine Firefly stopping along the Orange & Alexandria railroad on one of the hastily constructed bridges made of "corn stalks and beanpoles." Taken in 1863 by Mathew Brady. (NARA)

maintenance and defense of the railroads, a staff that included frontier woodsmen, skilled craftsmen, and freed slaves. The repair of bridges and rail lines became routine for Haupt's department as Confederate cavalry constantly strove to disrupt the Union army's supply line by destroying bridges and rail track. Haupt's men could build temporary bridges, often within a day of their destruction. Made of timber, these bridges caught the eye of Lincoln, who proclaimed, "That man Haupt has built a bridge four hundred feet long and one hundred feet high, across Potomac Creek, on which loaded trains are passing every hour, and upon my word, gentlemen, there is nothing in it but cornstalks and beanpoles."

With its hub in Alexandria, the Orange & Alexandria Railroad was the main supply line for the Union army campaigning in Virginia. Chartered in 1848, the Orange & Alexandria effectively connected Alexandria and Richmond. Haupt would augment this vital line with a second north-south line when he repaired the Richmond, Fredericksburg, and Potomac Railroad. To support this, he rebuilt the wharf at Aquia Landing and moved rolling stock by barge to the new hub, effectively creating a second north-south line from Alexandria.

The Orange & Alexandria became the most contested railway line of the war. The constant fighting over the Orange & Alexandria eventually left it in shambles. After the war, the Baltimore & Ohio Railroad took over the Orange & Alexandria, repairing the damage and merging it with the Manassas Gap Railroad to form the Orange, Alexandria, and Manassas Railroad.

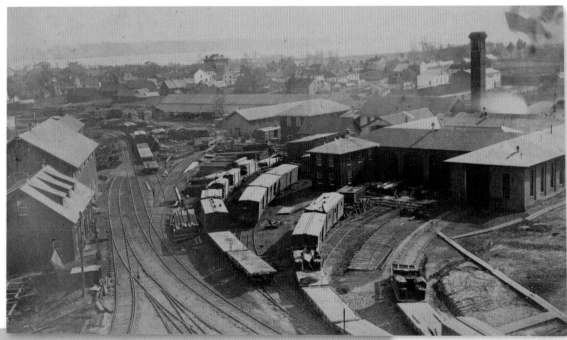

Bird's-eye view of machine shops, with the east yard of Orange & Alexandria Railroad, Alexandria, Virginia. (LOC)

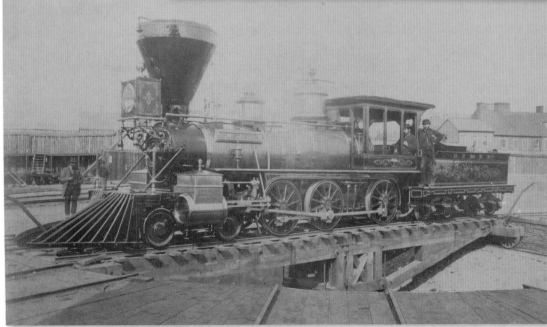

Engine E.M. Stanton, Alexandria, Virginia, July 1864. (LOC)

MARIE TEPE

In June 1861, Bernhard Tepe enlisted in the 27th Pennsylvania Zouaves as a private. Against his objections, Bernhard's wife, Marie, accompanied him and became the unit's *vivandière*. Of French origin, vivandières played a role akin to regimental "den mother," alternately acting as cook, sutler, laundress, and nurse. Marie Tepe's initial role as vivandière with the 27th Pennsylvania Zouaves did not last long. Before the end of 1861, her husband had stolen $1,600 from her. Thereafter, "French" Marie left the unit, disowned her husband, and headed back home.

She did not stay home for long. She soon joined the 114th Pennsylvania Zouaves, also known as Collis's Zouaves, and would serve that unit with distinction for the duration of the war. Tepe dressed in the red pantaloons, blue blouse, and sash of her unit but exchanged the traditional fez for a bonnet and augmented her uniform with a red skirt. Armed with a 1.5-gallon keg, from which she would dispense either water or whiskey, and a .44 Remington pistol, Tepe moved through the front lines to treat the wounded. Not content to stay at the rear of the fighting, she received a wound at Fredericksburg.

In the Battle of Chancellorsville, Tepe's bravery earned her a nomination for Kearney's Cross, a decoration for meritorious service and something that only one other woman, the vivandière Annie Etheridge, had received. Similar to other members of the 114th, Tepe would not wear the medal, claiming such adornment dishonored those who showed similar courage on the battlefield but lacked the luck to receive its nomination.

Marie Tepe stayed with the 114th until August 1864. She had met her second husband, Corporal Richard Leonard, during the Peninsula campaign, and when his three-year enlistment expired, she too left the service. By the time Tepe left the 114th, the entire army recognized her name, image, and ever-present keg.

Marie Tepe was not the only vivandière of the Civil War. Vivandières served on both sides of the conflict, often receiving the same pay and benefits as the enlisted men and, in the case of Kady Brownell, discharge papers from the army. While their roles did not officially include fighting, they were often armed. Vivandière Sarah Taylor often carried sword, rifle, and pistols; Annie Etheridge, a brace of pistols; and Kady Brownell, who at New Bern carried her regiment's colors into battle, a rifle and sword. With vivandières' closeness to their regiments, one cannot help but think that they might have fired a shot or two in defense of them.

114th Pennsylvania Volunteers (Collis's Zouaves) circa 1862 to 1863, by Don Troiani. (Military and Historical Image Bank)

Zouaves wore unique uniforms. This is a jacket of the 114th Pennsylvania Volunteers (Collis's Zouaves). (Military and Historical Image Bank)

Marie Tepe in her Zouave uniform, decorated with medals, with her ever-present keg and sidearm. Attributed to Charles and Isaac Tyson, circa 1863. (NARA)

CLARA BARTON

At the outbreak of the Civil War, Clara Barton worked as a recording clerk in the U.S. Patent Office. As the first wounded Union soldiers from a Massachusetts regiment arrived into Washington after a skirmish in Baltimore, Barton began collecting and distributing relief supplies. Not affiliated with any existing outside organization, she learned how to procure, house, and distribute the supplies she needed. In addition to bringing them food, water, and clean linens and clothes, she would often just spend time with them as they convalesced. It was a far cry from her work as a clerk in a patent office.

As the war continued, Barton became more involved in getting needed medical supplies closer to the battlefield. Not content to follow behind the army, Barton often moved her supplies and wagons nearer the vanguard so she could reach the battlefield as soon as possible. When she appeared at a field hospital with her supplies, a surgeon noted: "I thought that night if heaven ever sent out a[n] . . . angel, she must be one—her assistance was so timely." The "Angel of the Battlefield" was born.

Barton would follow the army through much of the war, including some its bloodiest battles: Antietam, Fredericksburg, Petersburg, and Cold Harbor. Not content to stay near the rear of the battle, she would move as close to the front as possible to relieve the wounded. She moved so far forward that in one instance a bullet pierced her sleeve and killed a soldier she tended to.

Away from the battlefield, Barton did not rest. She petitioned the government to provide more and better supplies for the wounded. At Fredericksburg, after seeing that Southern homes stood empty while wounded soldiers remained outside without shelter, she petitioned Senator Henry Wilson to investigate the matter. After his inquiry corroborated Barton's assessment, Wilson opened the homes to the wounded soldiers.

After the war, and armed with a note from President Lincoln, Barton established the Office of Correspondence, which worked with the "Friends of the Missing Men of the U.S. Army" to locate missing soldiers. Through this enterprise, Barton and her staff located 22,000 men. Her work culminated in identifying and marking the graves of the thousands who died at the Confederate prison in Andersonville, Georgia. It became one of the first national cemeteries.

After the war, Barton traveled to Europe, where friends introduced her to the Red Cross movement. As the Franco-Prussian War broke out in 1870, Barton did what she had done in the American Civil War, following the Red Cross to the front lines to deliver aid. On her return, she actively worked to create the American Red Cross and influenced the United States' signing of the Geneva Convention. She

A small Civil War surgical case used by Surgeon Hills of the 27th Connecticut Volunteers. (Military and Historical Image Bank)

This photograph shows two uniformed men standing before the entrance of a building bearing the name of the Clara Barton Ambulance Corps above the door and the insignia of the National First Aid Association of America on either side; the man with the sword may be Roscoe Wells, Clara Barton's assistant and commander of the ambulance corps. (LOC)

would remain at the head of the American Red Cross until 1904, when she resigned at the age of 82.

Clara Barton died in 1912. Even as she neared the end of her life, she continued to fight for those in need, including women suffragists. In a letter to "her soldiers," as she affectionately called those she cared for during the Civil War, she wrote: "When you were weak and I was strong, I toiled for you. Now you are strong and I am weak. Because of my work for you, I ask your aid. I ask the ballot for myself and my sex. As I stood by you, pray you stand by me and mine."

Clara Barton, founder of the American Red Cross, in Washington, D.C., at the height of her "Angel of the Battlefield" fame. Taken by Mathew Brady in 1865. (NARA)

GENERAL ULYSSES S. GRANT AT COLD HARBOR

At the start of the Civil War, Ulysses S. Grant worked in his father's tannery in Galena, Illinois, the last in a series of odd jobs after his resignation from the regular army in 1854. One of only 50 captains in the regular army, he resigned amid rumors of intemperance and a discordant relationship with his commanding officer. When President Lincoln made the call for volunteers in April 1861, the citizens of Galena asked Grant to lead the recruitment effort.

Grant recruited and trained volunteers for the first few months of the war. Not until June 1861 did Grant receive a field command, with the rank of colonel, to lead a regiment of Illinois volunteers. He took command of the Military District of Cairo, Illinois, by the end of August.

From his base in Cairo, Grant—now reporting directly to General Henry Halleck, who would soon become the General-in-Chief of the Union army—launched successful attacks on Confederate-held Forts Belmont, Henry, and Donelson. The attack on Fort Donelson made him a celebrity in the North when his terms— "No terms except unconditional and immediate surrender"—led to his moniker, "Unconditional Surrender" Grant. Despite ongoing rumors of heavy drinking, Grant's victories brought him a promotion to major general. Grant now commanded the 50,000 men of the Army of the Tennessee.

On April 6, 1862, Grant's army faced Confederate forces under General Albert Sidney Johnston and General P.G.T. Beauregard at the Battle of Shiloh. The two-day battle yielded more than 23,000 casualties, by far the most of the war to date. Halleck questioned Grant's leadership and temporarily relieved him of command of the Army of the Tennessee. Grant contemplated resignation; General William T. Sherman, however, who had experienced similar scrutiny, convinced him to remain in the army. Lincoln, alarmed at the outcome of the battle, sent War Department observer Charles Dana to interview Grant. On Dana's return to Washington, Lincoln reinstated Grant to command of the Army of the Tennessee.

Capturing Vicksburg, Mississippi, became Grant's next objective. Grant's campaign against the fortified city began in December 1862. It would take until July 1863 for Vicksburg to fall. In the aftermath, Grant again received criticism for some of his decisions, and again came accusations of drunkenness. Once more, Lincoln sent Dana to investigate and to watch Grant. Dana became close friends with Grant and made light of his drinking. Lincoln found the charges baseless, later commenting that "if it makes fighting men like Grant, then find out what he drinks, and send my other commanders a case!"

With the fall of Vicksburg, Grant now commanded the entire western theater. His fame increased after the Battle of Chattanooga, and Lincoln put him in overall command of the Union army. When Grant took charge of the eastern theater as well, General Robert E. Lee remarked, "Grant is not a retreating man. Gentlemen, the Army of the Potomac has a head."

The dress frock coat of Lieutenant General U.S. Grant from about 1866. West Point Museum Collection. (Military and Historical Image Bank)

(Opposite) Ulysses S. Grant taken in front of his headquarters at Cold Harbor, Virginia, in late June, 1864, by Mathew Brady. (NARA)

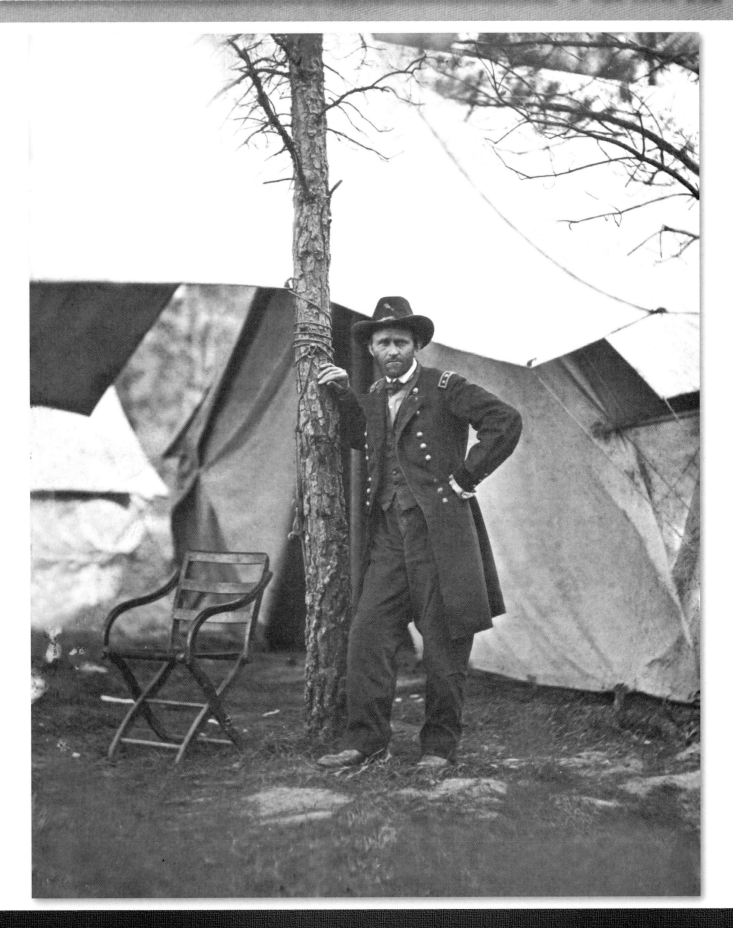

WOUNDED ZOUAVE

The French army created the first Zouave units in the 1830s. Originally of Berber descent, the Zouaves fought for the French in the Algerian desert. As their prowess gained recognition over the next 20 years, they became increasingly composed of Frenchmen. By 1852, Napoleon III made them part of his regular army. During the Crimean War, they became renowned as elite light infantry regiments due to their exploits at Alma, Balaclava, Sebastopol, and Malakoff. Observing the Zouaves during the Crimean War, Captain (later General) George B. McClellan called them the finest light infantry Europe could produce. Their style of dress—bright baggy pants, short waistcoats, and oriental headgear (see page 52)—only added to their legend.

Back in the United States, a Chicago militia unit under Elmer Ellsworth would add greatly to the popularity and allure of the Zouave in America. A rising star in the militia, Ellsworth studied law in Lincoln's Springfield practice and became a lifelong friend of the future president. He became enamored with Zouave tactics and battlefield drill and set up his own handpicked militia unit based on Zouave principles. In the years before the war, his unit, replete in their gaudy uniforms, toured the country and challenged other local militia to drill competition. Their 20-city tour made the unit and their young commander famous.

When the call for volunteers went out in 1861, many regiments, both Federal and Confederate, adopted the Zouave name and attire. In the early battles of the war, many even adopted the light infantry tactics that made the original Zouaves famous, often advancing at the double-quick and firing from either kneeling or prone positions. Ellsworth himself, having traveled with Lincoln to Washington, raised the New York 111th "Fire Zouaves," composed largely of Manhattan's volunteer firemen. Though Ellsworth would not see much of the war (he was killed in his unit's first action as they crossed into Alexandria in May 1861), Zouave units would fight in every major battle.

While many of the Zouave units served with distinction, they were not the elite units of their French namesake. As the war progressed, the Zouaves increasingly blended in with regular units. It became too costly to maintain their unique uniforms, and tactically, most generals did not use light infantry as specialized fighting units. By the war's end, many Zouave units were Zouave in name only.

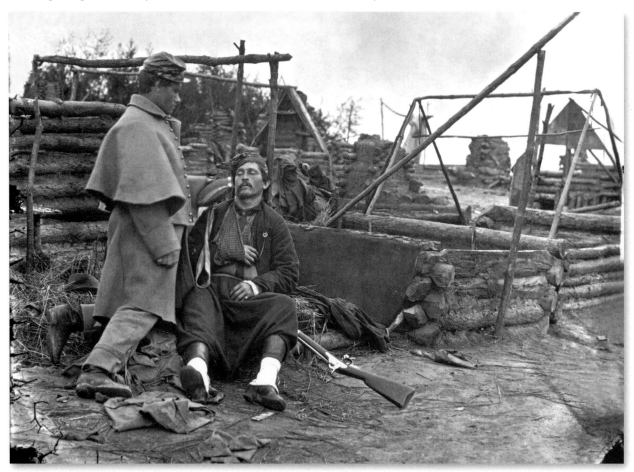

A wounded Zouave resting in a deserted camp tended to by a soldier in "regular" uniform. Taken by Mathew Brady circa 1863. (NARA)

"A HARVEST OF DEATH," GETTYSBURG

On June 30, 1863, Confederate General Henry Heth sent a brigade from Cashtown, Pennsylvania, toward Gettysburg in search of a supply of shoes that an earlier brigade had overlooked. Before the lead brigade could reach Gettysburg, they spied a detachment of Union cavalry just west of the town. Rather than force the issue, brigade leader General Johnston Pettigrew, mindful of General Lee's admonishment to not engage the enemy in a fight, withdrew. Confederate General A.P. Hill, upon hearing Pettigrew's report of Union cavalry in the area, declared, "The only force at Gettysburg is cavalry." Assured that no infantry backed the Union cavalry, General Heth marched in force down the Chambersburg Pike the next day to "get those shoes."

Unfortunately for Heth, General John Buford commanded the Union cavalry that stood in the way of his shoes. Armed with new Spencer carbines that could fire five times faster than traditional infantry muskets, Buford's troops presented a formidable barrier. They also had the advantage of choosing the ground for their defense, McPherson's Ridge, located behind a small creek, Willoughby Run.

Buford's troops held for hour. They had fallen back near the crest of McPherson's Ridge and were approaching the limits of their endurance when General John F. Reynolds's First Corps arrived, led by the vaunted Iron Brigade. Now facing a full infantry brigade, Heth's troops fell back.

On the north side of Gettysburg, the Confederate attack had more success. Here, Union troops ran into Confederate forces marching down the Harrisburg and Mummasburg roads. The pressure of the attack coming down from two directions broke the Union infantry and threatened to make the entire Union position at Gettysburg untenable. Union troops streamed through the town in retreat. Only their positions on Culp's Hill and Cemetery Hill, two natural strongholds that they had already strengthened by felling trees and digging entrenchments, prevented the collapse of the Union right.

After nearly a day of fighting, both sides settled into the positions they would hold over the next two days. The Union troops held a strong position on the ridges just south of Gettysburg. Overlooking the Union defenses from their positions across the way, Confederate General James Longstreet suggested the Confederates move left of their current positions and interpose themselves between the Union army and Washington. General Robert E. Lee demurred and continued with his planned attack. His fighting spirit up, Lee declared he would either "whip them or they are going to whip me."

The Battle of Gettysburg culminated on July 3 with Pickett's Charge, where 12,500 Confederates charged across three-quarters of a mile of open ground to the Union lines. Only half returned.

In all, both sides suffered nearly 51,000 casualties, with nearly 8,000 dead lying on the battlefield in the summer heat. At the start of the battle three days earlier, Buford had remarked to Reynolds, "The devil's to pay." He could not have known just how true those words would ring.

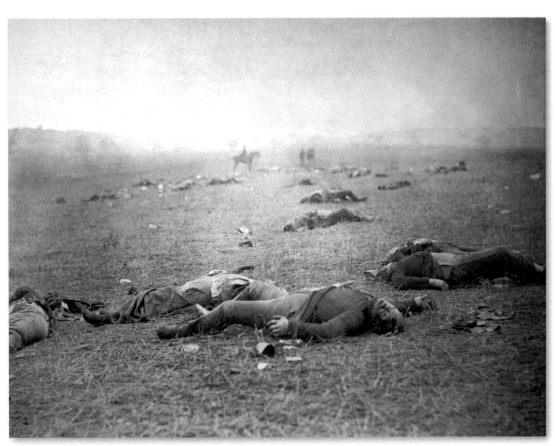

"A Harvest of Death," taken by Timothy O'Sullivan days after the Battle of Gettysburg, circa July 5, 1863. The bodies festered for weeks after the battle, leaving a stench for miles around the town. (NARA)

RUINS OF ATLANTA

Under orders from General Ulysses S. Grant to move against General Joe Johnston's army and to damage the South's ability to continue the war, General William T. Sherman began planning how he would achieve Grant's order.

While he had a two-to-one superiority in manpower, the rocky terrain around Dalton, Georgia, nullified much of Sherman's advantage. Unable to move Johnston out of Dalton by a frontal assault, Sherman sent a portion of his army south, under General James B. McPherson, to cut Johnston off from his supplies in Atlanta. In early May 1864, with McPherson behind Johnston's lines, Sherman began the attacks that would culminate with the destruction of Atlanta.

Sherman strove to get around Johnston's flank and cut off his access to Atlanta. However, with each of Sherman's assaults, Johnston fell back and set up a new line of positions, all the while moving ever closer to Atlanta. As Johnston retreated back across the Chattahoochee River, Jefferson Davis and the authorities in Richmond grew ever more concerned for Atlanta's security. On July 17, as Sherman's troops crossed the Chattahoochee, Davis relieved Johnston of command and replaced him with General John B. Hood. Hood would not only stand and fight, he would also attack. While Hood's strategy appealed to the politicians in Richmond, it also played into Sherman's hands.

Three days after taking command, and hoping to catch Sherman's forces astride the Peachtree Creek, Hood attacked. However, Sherman had most of his fighting force across the creek in

Atlanta in ruins after Sherman departed on his "March to the Sea." Only 400 buildings remained untouched. Taken by George Barnard in November 1864. (NARA)

time to rebuff the attack. Hood fell back on the entrenchments ringing Atlanta, hoping to draw the Union troops closer and to outflank them around Decatur. Two days later, Hood made his second attack on the Union forces. Again Sherman fended off the attack and Hood retreated back to the defenses of Atlanta. Hood's third and final attack west of Atlanta suffered the same fate as the first two.

After rebuffing all three of Hood's attacks, Sherman brought up heavy siege guns from Chattanooga and shelled the city. He made a counterclockwise wheeling move around the southern end of Atlanta to cut the Macon & Western Railway, the only supply line remaining for Hood's troops. Facing the combination of artillery siege and encircling movement, Hood had no choice but to leave Atlanta, lest he lose his entire army. On September 3, with Atlanta devoid of Confederate troops, a delegation of Atlanta's civic leaders surrendered the city.

Sherman set up his headquarters in Atlanta and for the next two months chased Hood's army and prepared for his march to Savannah. As he left Atlanta with his army on November 14, he burned all but 400 of Atlanta's buildings to the ground, setting the precedent for the 60-mile-wide swath of destruction known as the March to the Sea.

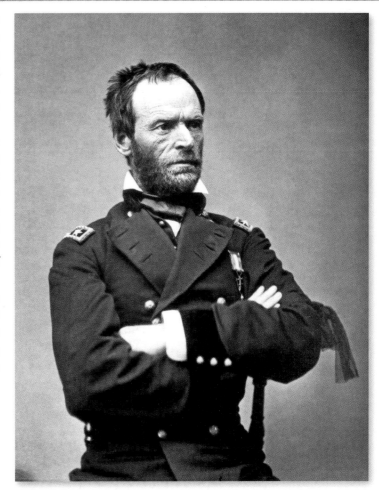

Major General William Tecumseh Sherman's name became synonymous with destruction. (NARA)

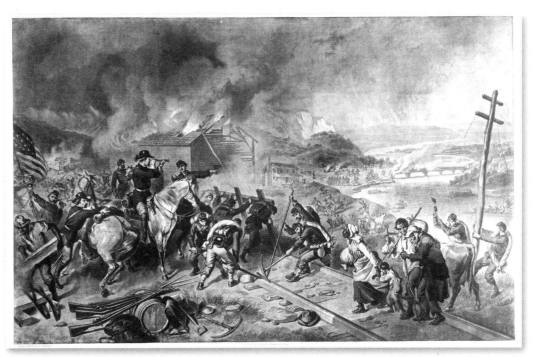

F.O.C. Darley's print of Sherman's march to the sea depicts Sherman's men destroying the railroads in Georgia. (LOC)

RUINS OF RICHMOND

By early April 1865, with his positions at Petersburg and Richmond made untenable by Grant's forces, General Robert E. Lee advised President Jefferson Davis that he would need to move his army out of Richmond. As Davis and the cabinet prepared to leave the city, Confederate General John Breckenridge readied the city for the army's evacuation, setting fire to the magazines, armory, and supply warehouses along with the bridges surrounding the city.

The Confederacy's capital had changed significantly during the war. The population had grown nearly fourfold throughout the war years, much of it due to the influx of refugees from the countryside. Along with the population increase came the less desirable element that often flourished during times of war. Gambling dens and bordellos—along with juvenile gangs committing petty larceny and assault—flourished in the underpoliced city. Tight quarters, made tighter with an influx of soldiers, led to a housing crunch as well as the spread of disease, including a smallpox epidemic. The swelling population added to the shortage of food, causing inflation to run rampant. Small-scale riots broke out, but the threat of military reprisal checked any large-scale rioting.

While the city struggled to cope with the inflow of people, it also grew into a significant industrial center, largely due to the presence and growth of the Tredegar Iron Works. The iron

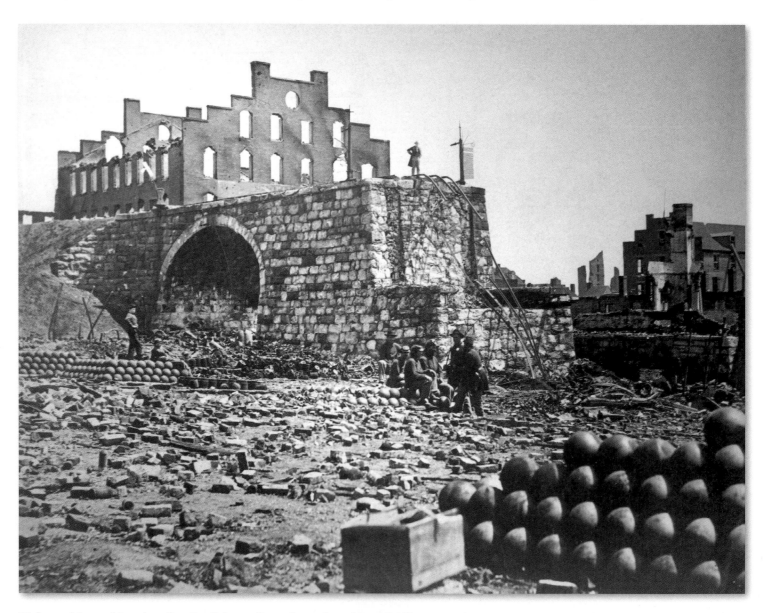

Richmond Arsenal in ruins after Confederate forces burned anything of military value as they evacuated. Taken by Alexander Gardner, April 1865. (NARA)

works had produced arms and armor since its founding in 1837. However, with the start of the war, its production increased dramatically; the company manufactured everything required for the Confederate war effort, from heavy artillery pieces and locomotives to buttons for uniforms.

In addition to becoming the manufacturing hub of the South, Richmond also boasted the Confederacy's largest hospital, Chimborazo. Chimborazo treated upward of 75,000 soldiers during the course of the war and had the lowest mortality rate of any hospital in the country.

Throughout the war, city officials feared Confederate troops might destroy anything deemed valuable before the city fell into Union hands. Though the Confederates had defended the city and staved off any previous threat, on April 2, 1865, the city officials' fears of destruction became reality as the Confederate army evacuated and set fire to the city. Fires at the manufacturing plants and warehouses, coupled with explosions on navy vessels, lit up the night sky. As General Breckenridge crossed the last remaining bridge out of Richmond, he looked at the engineer in charge and said, "All over. Goodbye. Blow her to hell."

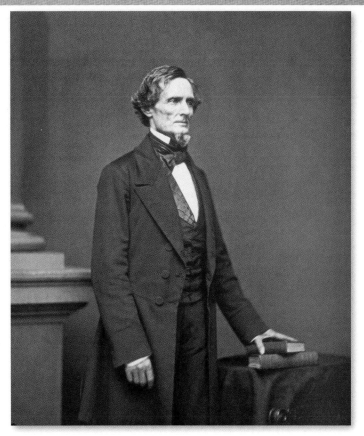

President of the Confederacy Jefferson Davis established his capitol in Richmond, Virginia. (LOC)

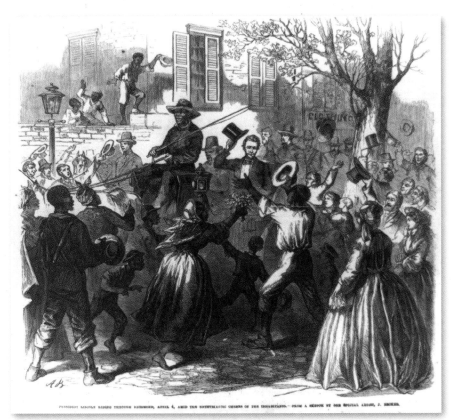

Frank Leslie's Illustrated Newspaper published this view of President Lincoln riding through Richmond amid the enthusiastic cheers of the inhabitants. (LOC)

CITY POINT

In June 1864, the Union army under General Ulysses S. Grant had begun to encircle the Confederate troops at Petersburg, Virginia. Confederate General Robert E. Lee did not bring his troops out of the Petersburg fortifications as Grant had hoped, so Grant began to prepare for a long siege. City Point became the hub for all Union activity that led to the Petersburg front as well as Grant's headquarters.

Situated above the James and Appomattox rivers, City Point provided an ideal site to build the port that would be used to shuttle men and materiel to the Petersburg front. In short order, Union General Rufus Ingalls, Grant's chief quartermaster, replaced the decrepit docks with eight new wharves that stretched in some places up to 500 feet into the river. When completed, the wharves could unload up to 25 ships a day. In addition to the docks, Ingalls built an intricate system of rail lines that allowed ships to offload directly to rail cars. The rail lines stretched all the way to the front lines, making resupply of the troops an efficient process.

To house the massive amount of supplies required to support the Petersburg siege, Ingalls built more than 280 buildings covering more than 100,000 square feet of space. In addition to the storage created for war materiel, the commissary had its own storage and wharves. The commissary could store 16,000 tons of food for soldiers and another 17,000 tons for horses.

City Point also housed a medical facility unlike anything else seen to that date. The Union army had seven hospitals at City Point; the largest, Depot Field Hospital, could care for 10,000 patients. Like the commissary, the hospital had its own supplies and depots, further adding to the overall size of City Point.

While City Point remained isolated from the fighting that took place at Petersburg, it was not completely immune from Confederate attempts to disrupt its operations. On August 9, 1864, John Maxwell, a Confederate saboteur, exploded a barge that contained 30,000 artillery shells and 75,000 small arms munitions. The resulting explosion destroyed the wharf, and the quartermaster would require nine days to get the supply depot back to full operational capacity. A Confederate fleet made a second attempt to disrupt operations at City Point in January 1865, but they could not get close enough to inflict any serious damage.

The depot at City Point became the model for in-country supply operations for the U.S. military in subsequent years. However, in 1864 the mass of supplies assembled at City Point to support military operations was unprecedented. More than anyone else, Grant recognized that the industrial might of the North would win the war. He only had to put the army in a position to leverage that might.

Brigadier General John A. Rawlins, General Grant's Chief of Staff, with his wife and child at the door of their quarters at City Point, Virginia. (LOC)

Tents of the City Point, Virginia, General Hospital. (LOC)

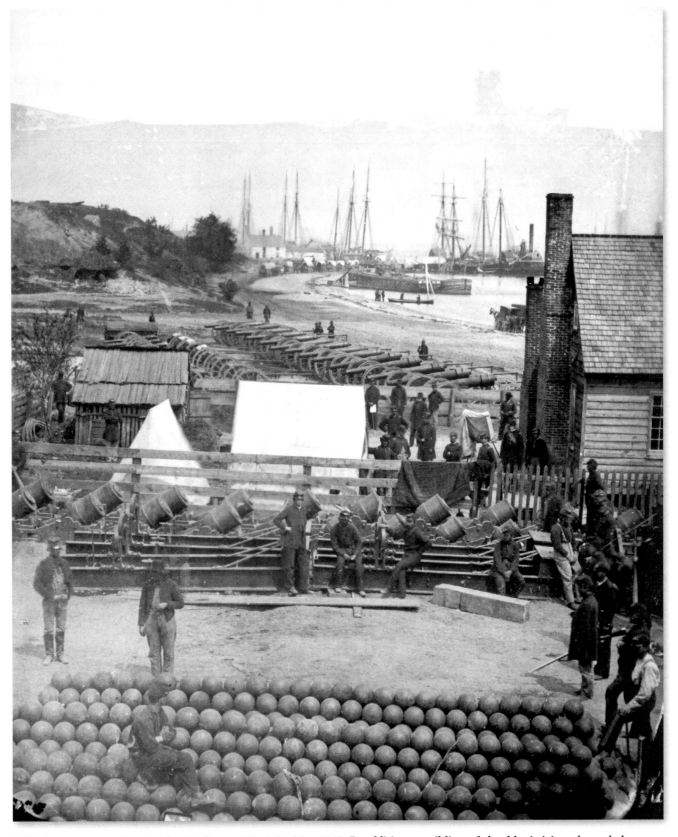

Military stores near the wharf at Yorktown, Virginia, May 1862. In addition to rail lines, federal logisticians depended heavily on transport of supplies by ship. Military cargo vessels would remain in the queue for days waiting to unload their stores on the York River at Yorktown and on the James River at City Point. (NARA)

TRENCHES AT PETERSBURG

The Siege of Petersburg was the culmination of a nearly six-week attempt by the Army of the Potomac, under General Ulysses S. Grant, to outflank General Robert E. Lee's Confederate forces and capture Richmond. Starting on May 5, 1864, with the Battle of the Wilderness, Grant's continued campaign down the coast included some of the bloodiest battles of the war. After the Battle of the Wilderness, the two forces clashed at Spotsylvania, North Anna, and Cold Harbor before Grant made the assault on Petersburg on June 14.

That day, Union troops, now south of the James River, attacked the eastern fortifications of Petersburg. While the 50,000 Union troops faced less than 20,000 Confederates, the scale and effectiveness of the defensive entrenchments coupled with the piecemeal attacks allowed the Confederates to hold their line long enough for Lee's reinforcements to arrive and solidify their defensive positions.

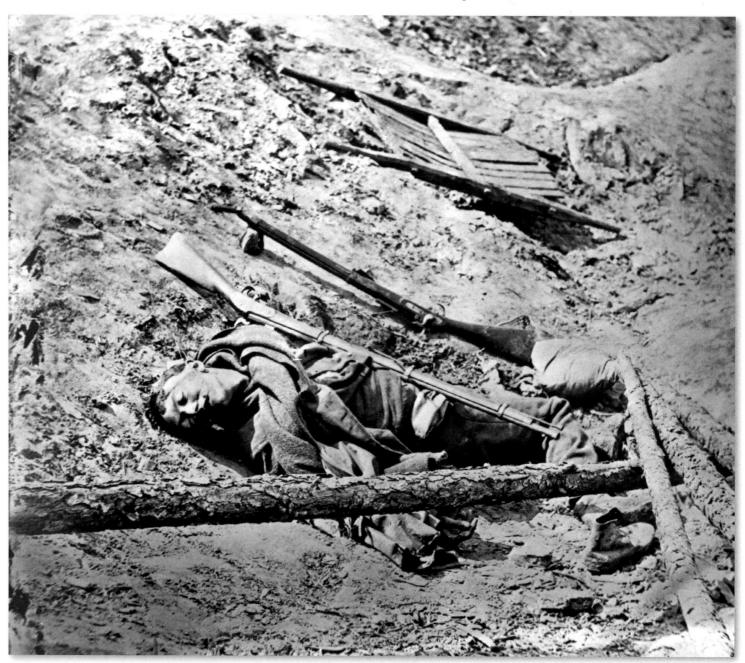

Foreshadowing what was to come nearly 50 years later in WWI, trench battles predominated at the Battle of Petersburg. Taken April 3, 1865, by Thomas Roche. (NARA)

Lee had repulsed Grant's initial attacks, but Grant did not give up. Over the next eight months, Grant would launch a series of attacks against the Petersburg defenses. Having learned at Cold Harbor that headlong assaults against entrenched troops would only serve to lengthen his casualty rolls, Grant largely targeted the railroads that led to Petersburg as well as the Confederate flanks, with one notable exception: the Battle of the Crater.

By the end of June, as Grant's troops began to settle into their own trenches, Lieutenant Colonel Henry Pleasants, a mining engineer, proposed the digging of a mine-shaft under the Confederate lines which he planned to subsequently explode to create a breech the infantry could exploit. While Grant allowed the activity, he had little faith in it. However, despite Grant's lack of confidence in the plan and a general lack of supplies for the project, Colonel Pleasants continued his work and by July 17 had built a 500-foot tunnel that ended 50 feet beneath a Confederate battery. After a failed infantry attack at Deep Bottom, Grant decided to use the mine to kick start an attack.

On July 30, having filled the mine with 8,000 pounds of explosives, the Union forces set them off. The resulting explosion created a crater nearly 150 feet in diameter and 30 feet deep. It killed nearly 300 Confederate troops and effectively breached the Confederate line. The first wave of Union troops to reach the breach went straight into the crater rather than around it, hoping it would provide them some cover from Confederate fire. A second wave of Union troops moved forward, the United States Colored Troops, and, facing increased Southern resistance on their flanks, joined the initial force in the crater. Rather than provide cover, however, the crater hemmed the troops in and allowed the Confederates to lob mortar shells as well as enfilade a withering fire, described by some as a "turkey shoot."

As Grant held his lines, Generals William T. Sherman and Philip Sheridan narrowed in on the Confederate forces. With every mile they moved closer to Grant, the noose continued to tighten around Lee's forces, eventually making the defense of Petersburg untenable.

Captain William K Crossfield, Company C, Sixth New Hampshire Volunteers, was killed July 30, 1864, at the Battle of the Crater in Petersburg, Virginia. (Military and Historical Image Bank)

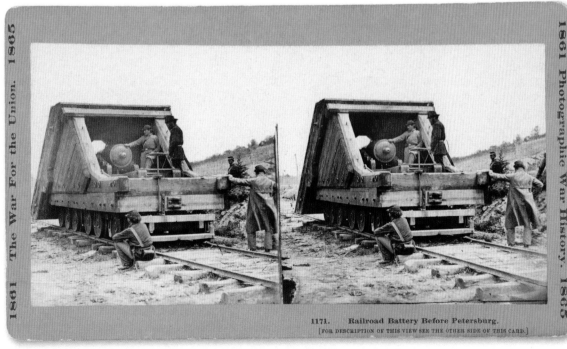

1171. Railroad Battery Before Petersburg.
[FOR DESCRIPTION OF THIS VIEW SEE THE OTHER SIDE OF THIS CARD.]

A railroad battery before Petersburg. Grant tried every method available to break the Petersburg defenses. (LOC)

HANGING OF THE LINCOLN CONSPIRATORS

On April 14, 1865, five days after General Robert E. Lee and his Army of Northern Virginia surrendered to General Ulysses S. Grant at Appomattox, actor and Confederate sympathizer John Wilkes Booth made his way into President Lincoln's box at Ford's Theatre in Washington, D.C., and shot the president in the head as he sat watching a play with his family.

As doctors in the audience tended to Lincoln, Booth escaped from the theater, breaking his leg as he jumped from the balcony. He made his way over the Potomac River to Garrett's Farm in Virginia, where members of the 16th New York Cavalry found him on April 26. When Booth refused to come out of the barn, the troops set fire to it. As he emerged brandishing a rifle, a soldier shot him dead.

Booth had not acted alone. His coconspirators included Lewis Powell, George Atzerodt, David Herold, Michael O'Laughlin,

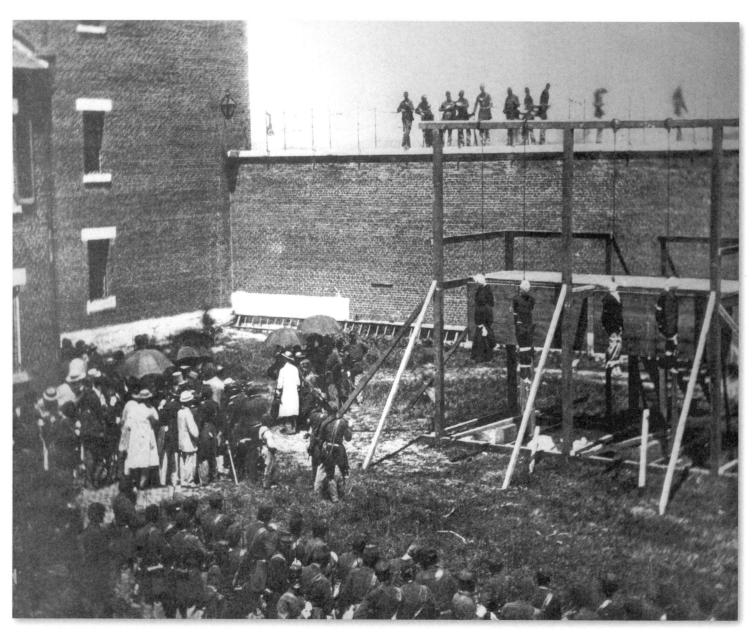

Hanging of the conspirators in Lincoln's assassination. The hanging marked the U.S. government's first execution of a woman, Mary Surratt. Taken on July 7, 1865, by Alexander Gardner. (NARA)

and John Surratt. The plan called not only for the attack on Lincoln but for simultaneous attacks on Vice President Andrew Johnson, General Ulysses S. Grant, and Secretary of State William Seward.

Lewis Powell attempted to murder William Seward at Seward's home. Powell managed to enter Seward's residence and stab the secretary of state in the face, but he blundered the attempt as Seward's family and aides reacted to the intrusion and fought Powell off.

George Atzerodt meanwhile planned to murder Vice President Johnson while both stayed at the Kirkwood House in Washington, D.C. Atzerodt lost his nerve while waiting for Johnson at the hotel bar, got drunk, and aborted the plan.

As for Grant, Booth had expected him at the play with Lincoln. However, Grant's wife declined the invitation earlier in the day, and the couple boarded a train for their home in Philadelphia. O'Laughlin boarded the train as well; however, no attack occurred as the Grants sat in a locked car guarded by porters.

In the wake of the assassination, the government rounded up anyone who'd had even the slightest contact with Booth or Herold. The government narrowed down its list of suspects to eight people: Powell, Atzerodt, Herold, O'Laughlin, Samuel Mudd (the doctor who set Booth's leg), Edmund Spangler (a stage hand at Ford's Theatre), Samuel Arnold (a conspirator in an earlier plot to kidnap Lincoln), and Mary Surratt (owner of the boarding house where the conspirators met and mother of suspect John Surratt, who had escaped to Canada).

The government tried the eight suspects in a military tribunal with a nine-member commission. The trial lasted seven weeks, and nearly 400 witnesses testified. In the end, the tribunal sentenced four of the suspects to death—Powell, Atzerodt, Herold, and Mary Surratt—and incarcerated the other four. Evidence against Surratt appears largely circumstantial other than her ownership of the boarding house. Nevertheless, on July 5, 1865, President Andrew Johnson signed her death warrant, stating she "kept the nest that hatched the egg." Despite pleas for clemency on Surratt's behalf, Johnson did not stay her execution. Two days later, Mary Surratt, Lewis Powell, George Atzerodt, and David Herold hung in the gallows of the Old Capitol Prison courtyard.

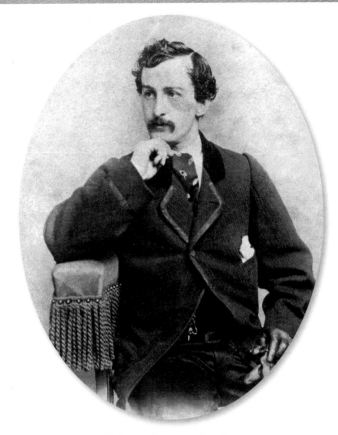

John Wilkes Booth—the president's assassin. (NARA)

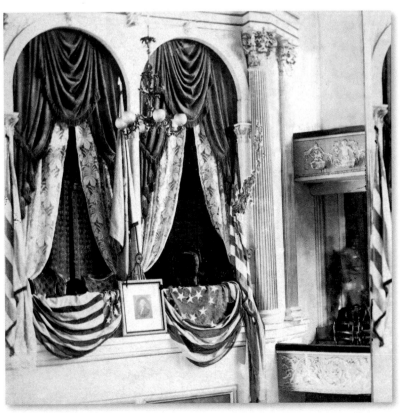

This is the private box in Ford's Theater, Washington, D.C., where President Lincoln was assassinated by John Wilkes Booth on the night of April 14, 1865. (NARA)

WRECK OF THE U.S.S. *MAINE*

L ike the images taken at Pearl Harbor on December 7, 1941, or of the World Trade Center on September 11, 2001, the twisted wreckage of the USS *Maine*, sitting on the bottom of Havana Harbor in Cuba, galvanized the American public for war against Spain. The *Maine*, a U.S. Navy battleship built in 1895, arrived in Cuba on January 24, 1898, by order of U.S. President William McKinley. The purpose of the port call was symbolic and offered an immediate military presence in case the need arose to protect American life and property on the island torn by revolution. On the night of February 15, 1898, at 9:40 p.m., the 6,683-ton *Maine* was lifted nearly two feet out of the water by two explosions that ripped apart her bow and midsection. The damaged ship quickly sank to the bottom of the harbor. 230 sailors, 28 marines, and two officers died from effects of the

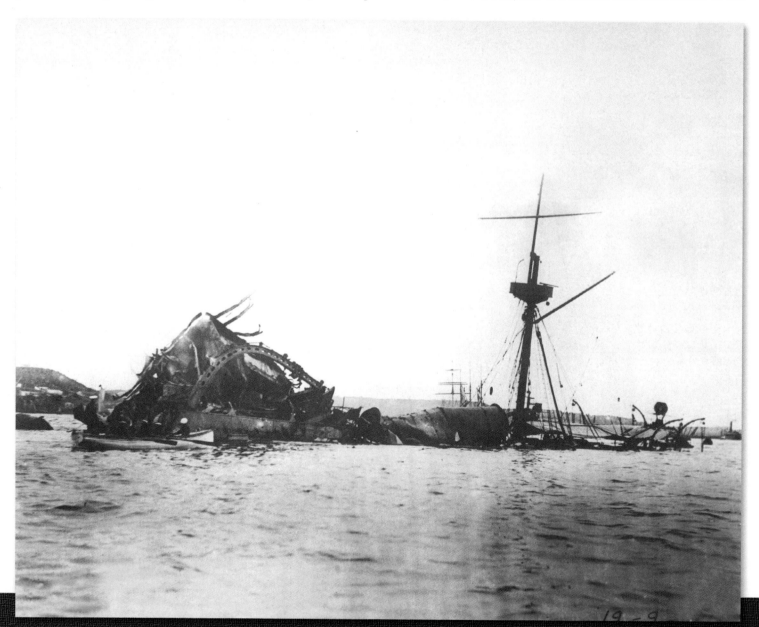

The wreck of the USS *Maine*, 1898. (Bureau of Ships)

explosion, many while asleep in their bunks. Eight more would die from their wounds days later. By the evening of February 16, New York City newspapers were already speculating about the cause of the explosion, inferring sabotage.

President McKinley ordered a Naval Court of Inquiry to investigate. Navy divers collected evidence, and a report was presented to Congress on March 28, concluding the *Maine* had been sunk by a submerged mine of unknown origin. This finding was enough for the public to assign culpability to Spain and demand intervention in the revolt that was grinding on in Cuba. Newspa-pers published the images of the sunken *Maine*, and soon catch-phrases such as "Remember the Maine! To hell with Spain!" resonated with an outraged American public. On April 20, 1898, President McKinley signed into law the joint resolution for war against Spain.

In 1912, the wreckage of the *Maine* was salvaged, raised, and towed out to sea to be sunk with military honors, clearing the harbor of the navigational hazard. The ship's mast and "crow's nest" now rest in its final anchorage as part of the USS *Maine* memorial in Arlington National Cemetery.

The graves of the USS *Maine* victims with the salvaged mast of the *Maine* in the background, Arlington National Cemetery, USS *Maine* Memorial, Arlington, Virginia. (LOC)

The USS *Raleigh* and, on the left, the USS *Maine*. (LOC)

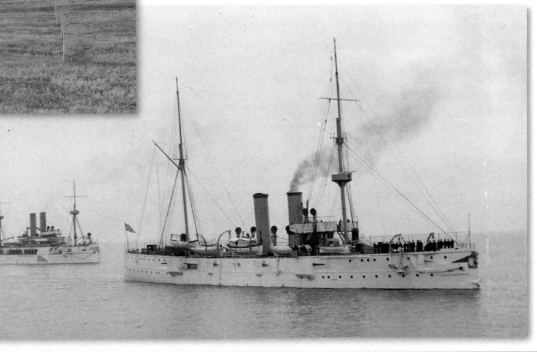

ENTRENCHED AGAINST THE FILIPINOS

The War against Spain brought American forces ashore among the vast complex of the Philippine Islands, which constituted Spain's colonial holdings in the Pacific. The quick national adventure of the campaign of 1898 in Cuba quickly

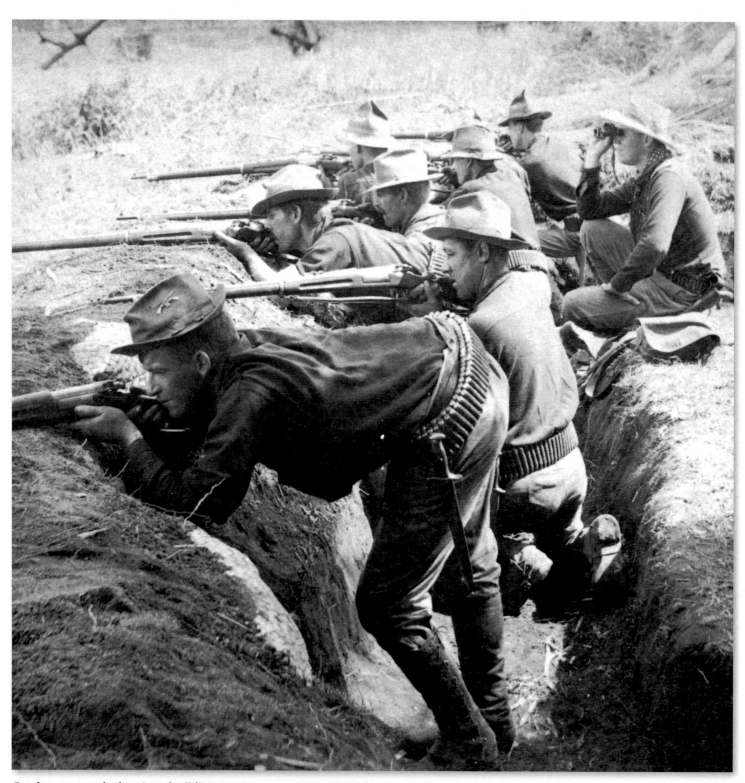

Our boys entrenched against the Filipinos, circa 1899–1900. B.W. Kilburn. Stereo. (War Dept.)

faded into the hot and steamy jungle atmosphere of fighting Philippine nationalists, who resented American intervention in their struggle to rid the island of Spanish influence. Fighting the insurgents in the Philippines would sporadically continue until a final five-day battle at the volcanic crater of Bud Dajo in 1911.

Here a platoon of "Hikers," or American infantrymen, possibly from the Fourth United States Infantry, are seen at the height of the insurgency wearing their signature upturned campaign hats and taking aim from a shallow trench with their Krag-Jorgensen bolt action rifles. The photograph was distributed by Benjamin West Kilburn; he and his brother Edward were the leading promoters of stereo-view photography in the United States during the later portion of the 19th century. Employing photographers around the world equipped with the latest in photographic equipment, Kilburn's published images of the Philippine Insurrection brought an intimate view of the daily life of the American soldier and the actions in which he was engaged straight from the jungles right into the gas-lit parlors of the United States, to be viewed in three dimensions with the aid of a stereo viewer.

A Moro helmet and Barong. The helmet was brought from the Philippines by Lieutenant Milo C. Corey, who was a member of the Philippine Scouts. Corey would remain in the army and as a lieutenant colonel would receive the Silver Star for gallantry in action on the west bank of the Meuse while serving with the 23rd Infantry Regiment, Second Infantry Division. (U.S. Army Center of Military History)

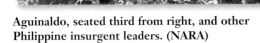

Aguinaldo, seated third from right, and other Philippine insurgent leaders. (NARA)

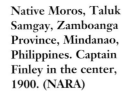

Native Moros, Taluk Samgay, Zamboanga Province, Mindanao, Philippines. Captain Finley in the center, 1900. (NARA)

AVENUE OF STATUES

The Boxer Rebellion pitted thousands of young members of the Righteous Harmony Society (Boxers) against foreign interests in China and resulted in an international intervention by German, Russian, British, Japanese, French, Italian, Austro-Hungarian, and American forces to save their besieged diplomatic missions in Peking and protect foreign investments. The trouble began when the Boxers openly revolted and attacked two British missionaries in May 1900. To compound the issue, the Dowager Empress Tzu His issued a statement saying the secret societies of China were not the same as criminal gangs—providing an all but official recognition of the Boxers.

On May 31, marine detachments from various Western ships made their way to reinforce their diplomatic compounds in the capitol of Peking (now Beijing). Soon the Boxers moved into the cities, attacking anything that had perceived Western influence—shops, railroads, telegraph lines—and murdering foreigners, including the diplomatic ministers of Japan and Germany. By June 20, the diplomatic compound in Peking was besieged and the Boxers were being openly aided by Chinese Imperial troops. On June 21, China declared war against the Western alliance. On August 14, a Western relief column made up of troops from the eight countries broke the 55-day siege. After the siege was lifted, the coalition forces suppressed resistance in the countryside until October. An official peace protocol was signed on Septem-

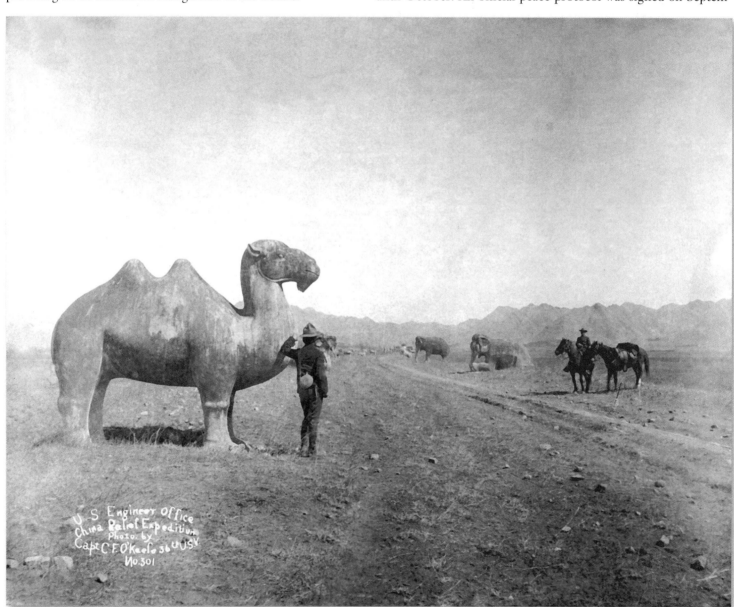

Avenue of Statues on the road to the Ming Tombs, near Peking, China, 1900. Members of the Sixth U.S. Cavalry in foreground. Photographer: Captain C.F. O'Keefe. (Corps of Engineers)

ber 7, 1901, which opened China to everything the Boxers had opposed.

This photograph (taken by Captain C.F. O'Keefe of the 36th Infantry Regiment, United States Volunteers, serving as an attached staff officer to General Adna R. Chaffee, who com- manded the American China Relief Expedition) shows members of the Sixth United States Cavalry inspecting one of the 24 carved animals on the Avenue of Statues that leads to the Ming Tombs northwest of Peking, China.

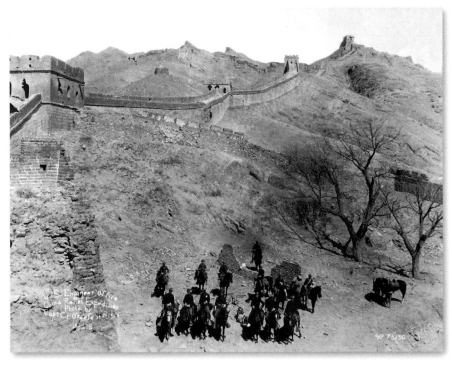

Troop L, Sixth Cavalry, at the Great Wall of China, near the Ming Tombs, 1900. (NARA)

Group of Signal Corps men in China. (NARA)

GENERAL FRANCISCO VILLA

After two years of bloody revolution and unrest in which factions split to overthrow their former comrades, General Francisco Villa (baptized Doroteo Arango) crossed the Rio Grande back into Mexico from his self-imposed exile in El Paso, Texas, on an April night in 1912. Villa quickly rebuilt his old revolutionary command of irregulars and set about to avenge the murder of his friend President Francisco I. Madero, who was assassinated at the hands of Villa's former commanding officer General Victoriano Huerta. Within a year, Villa had thousands of armed followers and engaged upon a campaign that would temporarily seat him as governor of the Mexican state of Chihuahua.

This image was taken and distributed by El Paso, Texas, photographer and real postcard manufacturer Walter H. Horne (1883–1921), who specialized in documenting the violence and characters along the El Paso–Cuidad Juárez border area. The image was shot either with Horne's standby Kodak Model 3A camera or the brand-new Kodak Graflex camera outfit he purchased that year. Horne's hand annotation can be seen in the lower left hand corner of the image along with the image number of 829. Unfortunately, Horne's key to all the images he made along the border has yet to be found. The photograph is dated 1913; pictured standing with Villa from left to right are two unidentified men, the violent General Rodolfo Fierro, General Villa (gray suit in center), General Toribio Ortega, and Colonel Juan N. Medina (Villa's chief of staff).

After the United States allowed Mexican troops to pass through the American side of the border on the railroad and cross back into Mexican territory to attack Villa's command, Villa lashed out at the United States, killing a carload of American mine workers at Santa Ysabel, Mexico, on January 9, 1916, and raiding Columbus, New Mexico, on the night of March 9. The raid prompted President Woodrow Wilson to authorize an expedition into Mexico to catch General Villa and his band, but he was never captured. Villa was assassinated on July 20, 1923, at the age of 45 while driving near his home in Parral, Chihuahua.

**General Francisco Villa, Mexican bandit, fourth from left.
Photograph circa 1913, W.H. Horne Co. (War Dept.)**

Inspecting packs, Company M, 16th Infantry regiment, El Valle, Mexico, September 16, 1916. (NARA)

Around the campfire, men of Company A, 16th Infantry, San Geronimo, Mexico, May 27, 1916. (NARA)

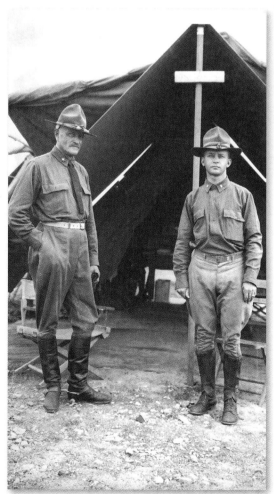

Brigadier General John J. Pershing commanded the expedition to Mexico. At headquarters of the American Expeditionary Forces in Colonia Dublan, Mexico, General Pershing and his aide Lieutenant James L. Collins pose for the photographer, 1916. (NARA)

SECOND DRAFT

The Selective Service Act was passed on May 18, 1917, and resulted in three distinct drafts of men between 21 and 31 years of age, and later expanded to 18 to 45. The first draft took place on June 5, 1917, and was followed a year later by a second call up on June 27, 1918. To document the second draft, photographers and movie cameras were allowed to record the proceedings in Room 226 of the Senate office building. The shutter snapped as Secretary of War Newton D. Baker, wearing a blindfold, retrieved a capsule containing a small piece of paper with the draft number 246 from the fish bowl. Behind Secretary Baker's right shoulder stands Brigadier General Enoch Crowder, Provost Marshal General in charge of the draft. Each number represented a group, spread across the country, that held that assigned number on their draft card, rather than a single individual. The draft boards were organized into 52 state (or territory) offices and further arranged into 155 district boards, 1,319 medical advisory boards, and 4,648 local boards. The blackboard behind the table was used to record the draft numbers as they were called out. The second draft took two hours to pull and record, and at its conclusion the blackboard was photographed with all the numbers posted as the official record. The information was then wired out to all the draft boards in the nation.

Unlike the draft during the American Civil War, the Selective Service Act was universal regardless of race or color. A drafted person could object to military service for religious or other reasons of conscience, which had to be proved before the board. The law

Second draft. The first number drawn was 246, picked from the urn by Secretary of War Newton D. Baker. Photo shows Secretary Baker picking the first capsule out of the bowl. June 1918. IFS. (War Dept.)

also took into account family dependency and critical occupations. To facilitate the draft law, each male in the United States within the designated age range had to register for the draft on a certain date. Each man was placed into five distinct classifications. When the draft was officially closed on July 15, 1919, more than 2.5 million of the 4.8 million men in the service were draftees. The draft law, challenged in court in the Arver v. the United States case, was upheld by the Supreme Court as constitutional on January 7, 1918.

Physical examination of an aviation recruit at the Episcopal Hospital, Washington, D.C., 1918. (NARA)

Mother escorting her son to a train bound for an army camp, Newark, New Jersey, 1918. (NARA)

James Montgomery Flagg stands with his iconic poster, 1917. (NARA)

NIGHT ATTACK, GONDRECOURT

A white phosphorus shell provides the flash-bulb light to silhouette a crouching American "Doughboy" as he participates in night maneuvers at the American Expeditionary Force (A.E.F.) First Corps Training Camp, Gondrecourt-le-Chateau, Department Meuse, France. White phosphorus was first used in warfare in World War I and was employed as an incendiary filler and smoke agent in grenades, mortar rounds, and artillery shells. In combustion, white phosphorus will continue to burn if exposed to oxygen and will inflict very painful wounds that are hard to treat. After nearly a century, the chemical is still part of the arsenals of many armies around the world.

This image of an explosion at night, although taken during live-fire training, provides an up close view of what night combat in the trenches and the wrecked terrain of "no man's land" looked like to the soldier on the ground. Warfare had dramatically changed from the 19th century, and a good deal of specialized training would be required to survive in modern combat. In order to facilitate training and acclimation, the French government designated a large area around the village of Gondrecourt as a training center for the newly arrived United States Army and Marines, and assigned battle-hardened French combat units to teach them. The First Expeditionary Division arrived in France on June 26, 1917, and moved to Gondrecourt and established the first of four infantry schools in France in the first weeks of July.

The Gondrecourt training ground evolved into a very specialized infantry training area and school where the United States Army created training concepts that would remain part of the basic training experience to this day. Here the A.E.F. learned the latest in French trench warfare techniques and specialized weapons. Troops were taught how to fire and maintain machine guns, employ mortars, and throw grenades, as well as how to utilize and respond to gas and chemical weapons. Night maneuvers added a new dimension of realism to the training program and better prepared the troops for the round-the-clock tempo of warfare at the front in World War I. On average, the American soldier sent to France received six months of stateside training and two months of training in the French countryside before going up to the front.

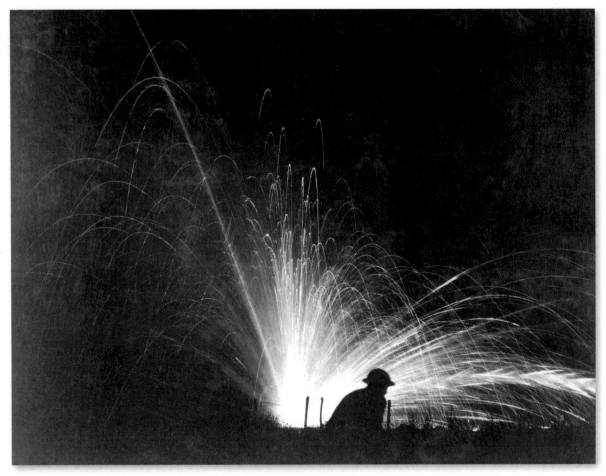

Night attack with phosphorus bombs in maneuvers, First Corps School. Gondrecourt, France, August 15, 1918. Photographer: Sergeant First Class J.J. Marshall. (Army)

GERMAN SUBMARINE ENGINE ROOM

A German naval officer oversees operations in the propulsion room of an Imperial German submarine. The first 18 German submarines (designated with a *U* for *Unterseeboot*) were numbered U-1 to U-18 and equipped with "paraffin" or kerosene-burning Korting engines that were known for producing lots of smoke and sound while underway. Later submarines added to the Imperial fleet utilized the newly perfected diesel engine, which increased efficiency and range. Due to the particular layout of the engine room, it is speculated that this view may have been taken in one of four submarines of the first series numbered U-5 through U-8.

Germany entered World War I with only 28 submarines, but by 1918 had built 369, which sunk a total of 13,000,000 tons of Allied shipping during the war. Running on the surface until a target was sighted, the submarine would then submerge to attack unseen from below. Submarines of this period utilized a fuel-driven engine that would also run battery-powered electric motors to be employed when running below the surface. The main offensive weapon of the submarine was an unguided, gyro-stabilized, propeller-driven torpedo that was launched from an air-pressurized tube in the bow of the submarine. The torpedo was driven along by an engine powered by compressed air and packed more than 200 pounds of TNT. A submarine captain had to line up his boat to create an accurate shot, and many German submarine captains became national heroes. During World War I, Germany placed great faith in the submarine's ability to turn the fortunes of war in their favor, even basing land strategy on the hoped-for effects of the submarine campaign of 1917.

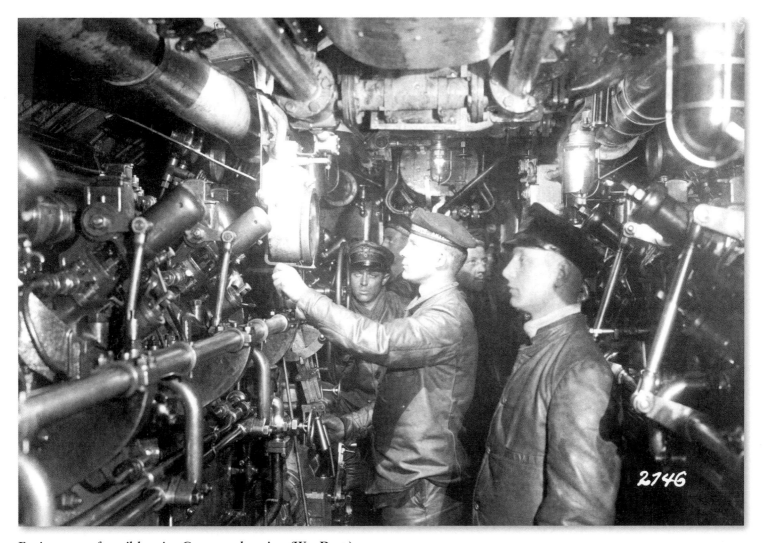

Engine room of an oil-burning German submarine. (War Dept.)

SERGEANT ALVIN YORK

Drafted into service from Pall Mall, Tennessee, Alvin York first refused to serve, declaring himself a conscientious objector for religious reasons. York was told that once he saw his comrades in danger he would understand that to fight to save lives was well within the teachings of the Bible. During training York displayed skill as one of the best shots in his regiment. York had learned to handle firearms from years of putting meat on the table to help his family survive. In France, while his regiment attempted to take a position defended by the German 120th Infantry Regiment, they became pinned down and took heavy casualties. Acting Corporal York put his skills as a woodsman and sharpshooter into action and saved his comrades and the mission of the regiment.

The official Medal of Honor citation for Alvin C. York reads as follows: "for extraordinary heroism on 8 October 1918, while serving with Company G, 2d Battalion, 328th Infantry, 82d Division, in action at Chatel-Chehery, France. After his platoon had suffered heavy casualties and three other noncommissioned officers had become casualties, Corporal York assumed command. Fearlessly leading seven men, he charged with great daring a machine-gun nest which was pouring deadly and incessant fire upon his platoon. In this heroic feat the machinegun nest was taken, together with four officers and 128 men and several guns."

In his own diary York wrote of the event: "those machine guns were spitting fire and cutting down the undergrowth all around me something awful. And the Germans were yelling orders. You never heard such a racket in all of your life. I didn't have time to dodge behind a tree or dive into the brush. . . . As soon as the

Sergeant Alvin C. York, 328th Infantry, captured 132 German prisoners; the image shows the hill on which the raid took place on October 8, 1918. Argonne Forest, near Cornay, France, February 7, 1919. Photographer: Private First Class F.C. Phillips. (Army)

machine guns opened fire on me, I began to exchange shots with them. There were over thirty of them in continuous action, and all I could do was touch the Germans off just as fast as I could. I was sharp shooting. . . . All the time I kept yelling at them to come down. I didn't want to kill any more than I had to. But it was they or I. And I was giving them the best I had."

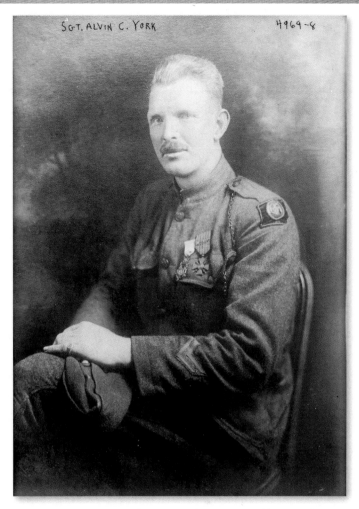

A portrait of Sergeant Alvin C. York taken after the award of his Medal of Honor; he proudly wears his 82nd Infantry Division shoulder insignia. (LOC)

This World War I 82nd Division patch is similar to the one York wears in his portrait. (U.S. Army Center of Military History)

ADOLF HITLER WITH GERMAN SOLDIERS

A group of comrades, World War I soldiers, pose together for a postcard image in a scene that was universally repeated in all the armies of the day. But as your eye focuses on the nondescript soldier under the white X, you realize you're gazing into the eyes of a monster: Adolf Hitler. Hitler, a corporal in the 16th Bavarian Reserve Infantry Regiment (List Regiment) of the Sixth Bavarian Reserve Division, is shown with other non-commissioned officers and their mascot dog named Fuchsl. A loner who had lived as a homeless artist for several years in Vienna, Austria, Hitler displayed signs of having a high-strung disposition, lecturing on politics and flying into a rage if corrected.

Hitler served as a regimental runner delivering messages. He was present with his regiment in four major campaigns spanning the whole of the war from 1914 to 1918, including the battles of First Ypres, Neuve Chapelle/Aubers Ridge, Fromelles on the Somme, and Montdidier on the Marne. He was struck by a piece of shrapnel in the left thigh on or about October 7, 1916, while in action around Fromelles, and then was gassed near Comines during the long retreat on October 13, 1918. During his rise to power, he and the other members of the National Socialist German Workers Party (NSDAP, or Nazi Party) propagandized his frontline service.

Scholars debate the truth about Hitler's service: some point out that he received the Iron Cross in both first and second class, while others point out that some of his comrades who wrote about him often cited that he was in the rear in relative safety. The second-class award was won by Hitler for his actions around the Belgian town of Wytschaete (Ypres) on December 1, 1914, supposedly for saving the regimental commander. Ironically, the first-class award was recommended by Hugo Gutmann, the Jewish adjutant of the regiment, for consistently volunteering to run messages that exposed him to great danger.

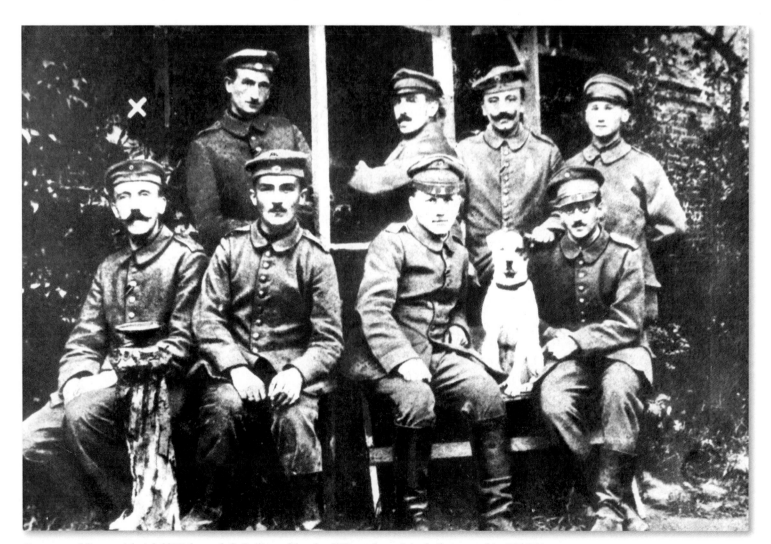

German soldiers, with Adolf Hitler at left (indicated by the "X" on the original photograph). (NARA)

Two years after the end of the war, Hitler announced the NSDAP party platform in Munich and began to claw his way to power. He eventually became one of the most infamous fascist dictators and war criminals of the 20th century.

Adolf Hitler would become one of the most infamous men in history as dictator of the Third Reich. (LOC)

LIEUTENANT EDDIE RICKENBACKER

When the United States entered World War I, Rickenbacker, already an international racing celebrity, proposed a squadron of race car drivers and mechanics who were used to risking their lives in fast machines and maintaining them. The idea was rejected. Using his connections, he was able to get to France as General John J. Pershing's driver. He had hoped once in France he would be permitted to transfer to the air service. After several attempts, he was finally permitted, and through hard work received a commission and began flight training.

In April 1918, he was placed in the newly formed American 94th Aero Squadron. He flew obsolete French Nieuport 28 aircraft, flying his first practice patrol on April 6. Twenty days later he scored his first victory, downing a German Pfalz D.III aircraft over Baussant, France. On May 30 he was credited with his fifth victory and was designated an "ace." In August, the 94th transitioned into the more advanced French SPAD S. XIII aircraft, which Rickenbacker put to good use, often downing two enemy planes a day while on patrol.

By war's end, Rickenbacker had logged 300 hours in flight and was credited with 26 victories, 13 of them over the feared German Fokker D.VII. Rickenbacker was awarded the Distinguished Service Cross seven times for action against the enemy and in 1930 was awarded the Medal of Honor for action alone against seven German airplanes over Billy, France. Rickenbacker then went on to form Eastern Airlines, introducing commercial air travel to the United States.

First Lieutenant E.V. (Eddie) Rickenbacker of the 94th Aero Squadron. The American ace is standing up in his SPAD plane near Rembercourt, France, October 18, 1918. Photographer: Sergeant Gideon J. Eikleberry. (Army)

Here, Rickenbacker is seen looking over the barrels of his SPAD's twin Vickers machine guns. This photograph is noted to have been taken on October 18, 1918, right after his 20th victory. The photographer was Sergeant Gideon Eikleberry, Photographic Section, Signal Corps, who at the time he photographed Rickenbacker held the Distinguished Service Cross for photographing the U.S. 104th Infantry of the 26th Division while they were attacking near Bouresches, France, on July 20, 1918. Most of the photographic work of the Signal Corps during the Great War was predominantly conducted using large-format Graflex cameras.

The insignia of the 94th Aero (Pursuit) Squadron; the famous "Hat in the Ring," symbolizing America throwing into World War I. (U.S. Army Center of Military History)

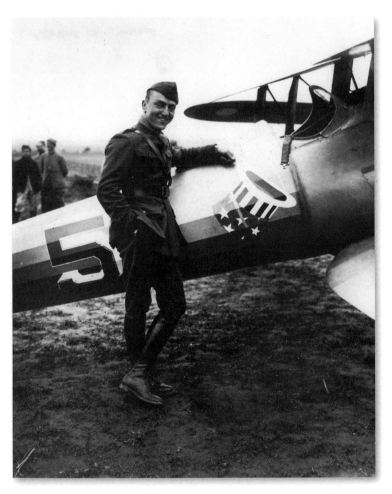

Captain Eddie Rickenbacker stands near his airplane. Note the insignia of the 94th Aero Squadron on the fuselage. (LOC)

FIRST SHOT FIRED ON THE LORRAINE FRONT

The Sixth U.S. Field Artillery Regiment was the first American artillery unit to arrive in France on June 26, 1917. The regiment was sent to a French Artillery school at Valdahon and was trained and equipped with the French Model 1897 75 mm gun. On September 21, 1917, the regiment was attached to the French 18th Division and went into the line with them north of Luneville, Toul Sector. On October 23, Major John R. Starkey sent a communication to the U.S. First Division Headquarters that at 6:05 a.m., Battery C. of the Sixth United States Field Artillery fired the first American shot of the war. In a gentle rain, Captain Indus McLendon's battery went about setting up their "75" for the important action. According to the Captain's account, Sergeant Edward Worthen loaded the gun, Corporal Robert E. Braley sighted the piece, and Sergeant Alexander L. Arch pulled the lanyard to send the shell toward the German lines.

Sergeant J.A. Marshall's photograph of a Battery C gun crew ejecting a spent case and loading a fresh round captures the rate of fire that could be achieved with the French 75. The date and location of September 12, 1918, near Beaumont indicates that this was taken on the opening day of the Saint Mihiel Offensive, almost a year after the crew fired the first shot. It was this type of quick-firing artillery, as well as machine guns that caused men to dig in for their lives and created the trench stalemate on the Western Front. The M1897 was the first smokeless powder artillery piece in the world that was developed with an integral recoil mechanism; it utilized a hydro-pneumatic piston and spring that allowed the gun to return to its original position ready to be reloaded and fired without requiring the gun crew to roll the piece back into line and re-sight the gun. A good crew could expect a common rate of fire of 15 rounds per minute.

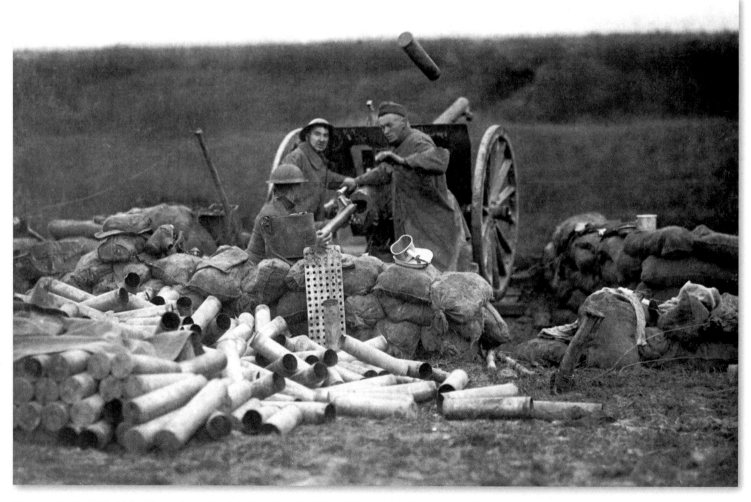

Battery C, Sixth Field Artillery, fired the first shot for the United States on the Lorraine front. The image shows a shell case flying through the air and a new shell sliding into the breech in the same fraction of a second. Beaumount, France, September 12, 1918. Photographer: Sergeant J.A. Marshall. (Army)

OVER THE TOP

Hearts pounding, shells cracking overhead, a shrill cry from an officer's whistle, and then hands and boots clambering as Canadian infantry scramble out of the trenches. Few images produced during World War I capture the moment of "going over the top" or "hopping the bags into no man's land" as well as this action image of Canadian infantry taken by Lieutenant Ivor Castle, the official photographer of the Canadian War Records Office. A newspaper photographer for the *London Daily Mirror* before the war, Castle had won local fame by taking the first aerial images of the British countryside and had a reputation for coolness in difficult circumstances. Between August 1916 and June 1917, Castle made over 800 images of primarily Canadian troops at the front for the Canadian War Records Office. Canadian entrepreneur and newspaper tycoon Max Aitken (Lord Beaverbrook) created the office for the purpose of documenting the activities and martial exploits of Canadian troops in Europe. After the organization was established, Aitken used his wealth and political influence to ensure the organization would be officially integrated into the War Office.

As the Canadian War Records Office transitioned from capturing newspaper-style images to true documentation, Castle and Aitken were not above enhancing photographs to convey the spirit of what they were trying to communicate about the troops in combat. This photograph, published on October 28, 1916, in the *London Daily Mirror*, is taken from a series of images by Castle reportedly showing Canadian infantry fixing bayonets and "going over the top," but upon closer scrutiny, it has been enhanced and doctored. The original image negative does not contain the painted-in airburst explosions, and the rifle being carried by the soldier on the extreme right had a breech cover over the mechanism. In this version of the image, which was published as a real action shot taken of troops attacking during operations in the Somme sector, the rifle has been changed to omit the breech cover. Although great debate surrounds the image concerning exactly where it was taken, under what circumstances, and of what unit, it still captures the moment and has remained an icon of the Canadian soldier in the trenches.

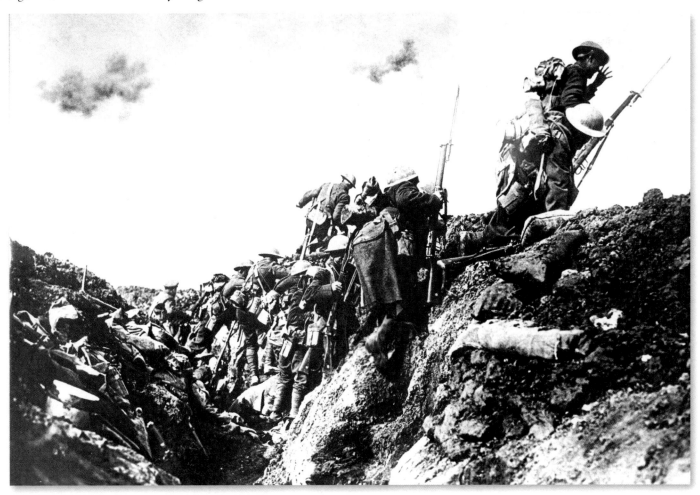

Canadian troops going "over the top" during training near St. Pol, France, October 1916. Photographer: Lieutenant Ivor Castle, Canadian official. (Army)

"GAS! GAS!"

Gas! Gas! Quick, boys!—An ecstasy of fumbling,
Fitting the clumsy helmets just in time;
But someone still was yelling out and stumbling,
And flound'ring like a man in fire or lime . . .
Dim, through the misty panes and thick green light,
As under a green sea, I saw him drowning.
In all my dreams, before my helpless sight,
He plunges at me, guttering, choking, drowning.

*—Wilfred Owen, from his wartime
poem "Dulce et Decorum Est"*

This image, staged safely behind the lines in France by famed pre-war architect and artist Major Evarts Tracey, Chief Instructor in Camouflaging with the U.S. 40th Engineer Regiment, illustrates Owen's words about the horrors of gas warfare. The photograph of an infantryman who has failed to maintain his gas mask in a gas attack was intended for instructional purposes to impress upon troops the dangers of gas warfare and the need to maintain and properly wear their gas masks. One of Major Tracey's wartime accomplishments was to create a large amount of instructional materials for the troops while working at the Engineer School at Langres, France, the presumed location of this image.

Chemical or gas warfare began with the use of "tear gas" type irritants by the French and Germans in 1914 with little tactical effect. On April 22, 1915, chlorine gas was employed by the Germans at Ypres, Belgium, under the direction of Professor Fritz Haber, who is cited as the father of modern chemical warfare. The race was on to develop deadly chemicals that could be quickly delivered on the battlefield to create both physical and psychological casualties. Chlorine, phosgene, diphosgene, mustard, chloropicrin, and cyanides were all developed during the war, along with weapons systems to discharge them in both large and small quantities on the battlefield. Each type of gas required advancements in protective masks and equipment. Chemical munitions accounted for an estimated 1,296,853 casualties during the war.

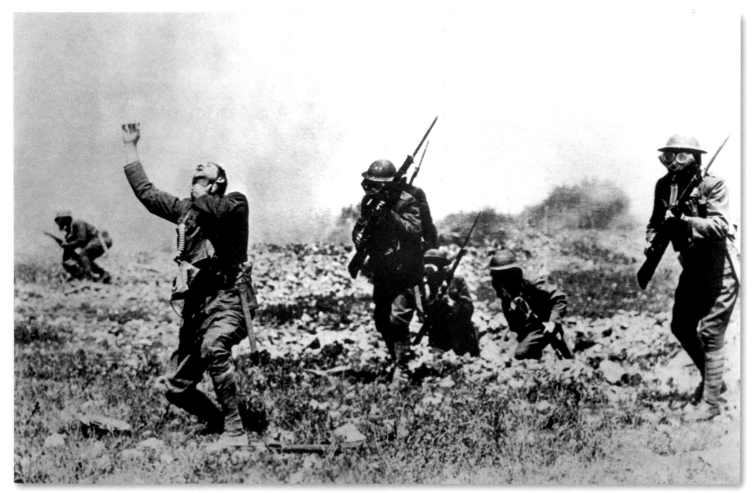

Posed picture in France near frontline trenches by Major Evarts Tracey, U.S. Engineer Corps, to illustrate the effects of phosgene gas. 1918 (Army)

Musician Randolph H. Hoefs of the 345th Field Artillery Regiment strikes a martial pose at Berncastle, Germany, April 14, 1919. He proudly shows off his constant companion during the war—his gas mask. (Military History Institute)

The German use of gas evoked fear in every heart. This image shows a German steel helmet worn with gas mask. (Military and Historical Image Bank)

"Big Nims" with gas mask, Third Battalion, 366th Infantry, Ainville, France, August 8, 1918. This photograph was annotated, "Happy—Something struck this American Negro soldier as funny and he paused to laugh even during the gas mask drill." (Military History Institute)

DEAD GUNNER

An intimate portrait of death, with a youthful German soldier and his Maxim-type 08-15 machine gun as the subjects. This image was taken by Second Lieutenant Meyer S. Lentz, Signal Officer, Signal Corps, assigned to division headquarters of the 90th Division during its drive toward the French town of Stenay on the Meuse River outside the village of Villers-devant-Dun near the Bois (wood) de Sassey and Hills 243 and 321.

According to the 90th Division narrative, on November 2 the advance was opposed by a mixture of regimental elements of the German 88th, 27th, 28th, and 107th divisions outside of Villers-devant-Dun, which were defending a position the Germans called the Freya Stellung. This line consisted of hastily dug rifle pits manned by machine gun crews that, according to eyewitness accounts, fought to the death at their guns. The division history pinpoints elements of the 27th Wurttemberg and 28th Baden divisions as the main defensive force in front of the Aincreville to Villers-devant-Dun road leading to the village. With this intelligence, the dead machine gunner in the photograph may have belonged to either the 53rd Wurttemberg or 37th Baden machine gun sharpshooter battalions.

The 180th Infantry Brigade of the 90th Division, which engaged the machine gun nests of the Freya Stellung around the

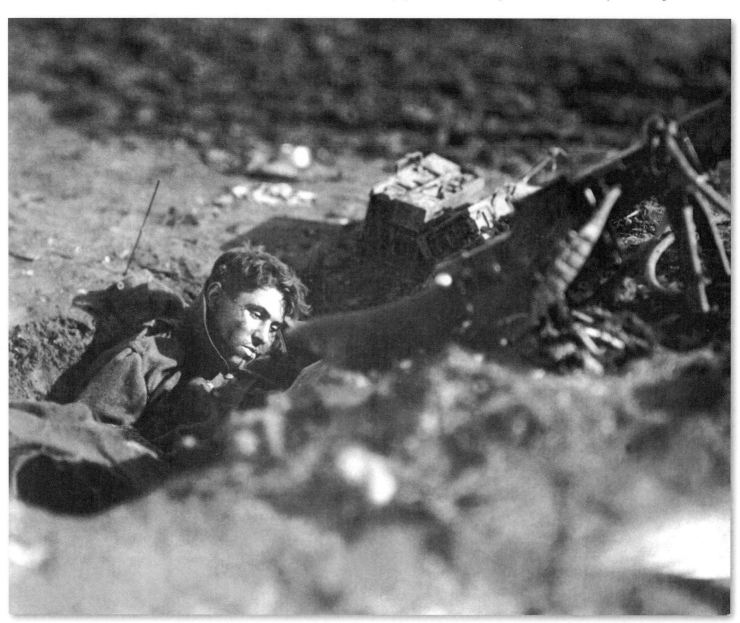

German machine gun nest and dead gunner. Villers-devant-Dun, Sassey, France, November 4, 1918. Photographer: Lieutenant M.S. Lentz. (AEF Signal Corps)

village, consisted of the 359th and 360th infantry regiments. The divisional narrative singles out men of Company D and H of the 359th as having engaged the machine gunners outside the village in front of the road. The following is one of the citations resulting from the engagement: "The Distinguished Service Cross is presented to Glenn A. Bell, Corporal, Co. D, 359th Infantry Regiment, U.S. Army, for extraordinary heroism in action near Villers-devant-Dun, France, November 2, 1918. Corporal Bell was wounded in the arm by machine-gun fire, but in spite of his injury continued to lead his squad and assisted in taking several machine-gun nests."

Death was everywhere in the trenches, and soldiers rapidly became desensitized to the macabre. Here a group of American 79th Division soldiers pose with the remains of their dead enemies. (Courtesy Eric L. Dorr, Gettysburg Museum of History)

CEASE-FIRE

The 105th Field Artillery Regiment was one of three artillery regiments assigned to the 27th Infantry Division, which was made up entirely from New York National Guard troops. Once in France they were armed with French 75 mm howitzers, one of which these jubilant gunners are gathering around. On October 23, 1918, the 52nd Field Artillery Brigade of the 27th Infantry Division was attached to the 79th Infantry Division for the drive into the Meuse-Argonne operation. When this photograph was taken, the regiment was in position at Etraye in front of the town of Damvillers, 15 miles north of Verdun.

Rumors of a cease-fire or armistice had begun to circulate in the Allied line as early as late October 1918. When the order was announced that there was to be a cessation of hostilities on November 11 at 11 a.m., troops were also ordered to keep up the pressure and continue firing until the exact hour. This was done to gain as much ground from the retreating German army as possible because the agreement was a cease-fire, not a surrender, and hostilities could resume at any moment. Many men on both sides were killed in the last hours and even minutes on that day; then the guns fell silent and the cheering began. It was a moment that defined a generation, for everyone in Europe could tell later in life what they were doing at that all-important hour. In many artillery units, each gun crew grasped the lanyard to take part in firing the last shot of the war from its gun. Years later, many veterans remarked how foolish it was to fire and possibly take lives until the last moment. Army reports state that, like the infantry, the artillery troops, the guns, and the supply lines that feed them were simply worn out during the constant action of the Meuse-Argonne fighting. The armistice came just in time.

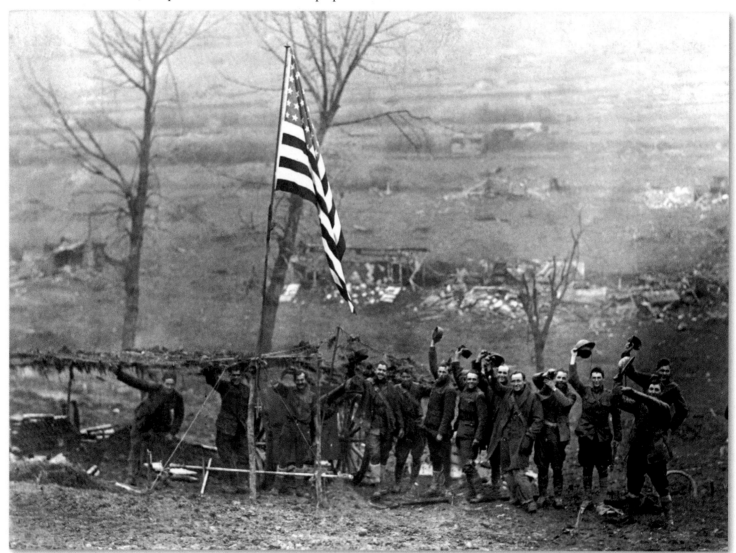

One of the guns of Battery D, 105th Field Artillery, showing an American flag that was hoisted after the last shot had been fired when the armistice took effect. Etraye, France, November 11, 1918. Photographer: Sergeant First Class Morris Fineberg. (Army)

Hq. 5th Division,
11 November 1918.
8 Hours.

FIELD ORDER,
 No. 76.

1. Field Order #75, these headquarters, is revoked.

2. Hostilities will cease along the whole front at 11 hours, 11 November 1918, Paris time.

3. No allied troops will pass the line reached by them at that hour and date until further orders.

4. All communication with the enemy, both before and after termination of hostilities, is absolutely forbidden. In case of violation of this order, the severest disciplinary measures will be taken. Any officer offending will be sent to these headquarters under guard.

5. Every emphasis will be laid on the fact that the arrangement is an armistice only and not a peace.

6. There must not be the slightest relaxation of vigilance. Troops must be prepared at any moment for further operations.

7. During the armistice should any one from the enemy's position approach our line with a white flag, he will be received by an officer, blind-folded, and conducted to the nearest battalion P. C., where he will be detained and the fact of his arrival communicated as promptly as possible to these headquarters for instructions. Pending receipt of these instructions, no conversation will be had with the person, or party, who has thus presented himself, except by the officer who has received him, and his conversation will be limited to finding out the purpose for which he was sent.

8. Special steps will be taken by all commanders to insure the strictest discipline, and that all troops are in readiness and fully prepared for any eventualities. Brigade commanders will personally inspect all organizations with the foregoing in view.

 H. E. ELY,
 Major General,
 Commanding.

Distribution:
No.
1–C.G.
2–C.of S.
3–5, G–1, G–2, G–3
6–Div. Surgeon
7–Div. M.G.Off.
8–Div. Gas Off.
9–3rd Corps.
10–1st Army
11–32nd Div.
12–15, C.G. 9th Brig.
16–19, C.G. 10th Brig.
20–35, C.G. 3rd F. A. Brig.

No.
36–9th Balloon Co.
37–38, 7th Engrs.
39–C.O. 13th M.G.Bn.
40–War Diary
41–C. G. 90th Div.
42–C.O. 128th Inf.
43–C.G. 3rd Div.
44–9th F. S. Bn.
45–Div. Signal Off.
46–88th Aero Squadron
47–284th Aero Squadron
48–Air Service.

The U.S. Fifth Infantry Division order to cease fire, implementing the Armistice. (U.S. Army Center of Military History)

A soldier from the 173rd Aero Squadron beats in the Armistice. The painting on the drum is a caricature of Kaiser Wilhelm II, the symbol of the Allies' "beaten" enemy. (Military History Institute)

COUNCIL OF FOUR

On November 11, 1918, when the guns fell silent at 11 a.m., it was only an armistice, not a surrender or a signed peace agreement; hostilities could resume at any moment. For several months the world held its breath to see if the armistice would hold. There was reason for concern. During the negotiations between Russia and Germany after the Russian Revolution in 1917, an armistice agreement twice failed and the hostilities continued.

Being a part of the Paris Peace Conference was a major personal and political goal for President Woodrow Wilson, who tried in vain before America's entry into the war to involve the hostile nations in peace negotiations. His pleas and official messages were ignored by both sides, motivating Wilson to change his position from armed neutrality to that of armed intervention once Germany resumed hostile submarine raids on Allied and American shipping. The size and effect of the American effort in providing men and money during the war—and large quantities of food and fuel in the immediate aftermath to a starving Europe—placed Wilson on equal footing politically with other European leaders.

The United States had become a world power, and Wilson wanted to share his ideals of international cooperation and management. Popularly known as Wilson's Fourteen Points, this vision was delivered to Congress on January 8, 1918, as a sweeping visionary platform. It dealt with everything from the needs of nations to avoid secret international alliances to free trade and independence for colonies and occupied territories. It was the only declared set of war aims announced by any of the fighting nations.

The result of the peace conference was disappointing to Wilson, who was quite ill during the negotiations, a fact which may have limited his ability to influence events. The terms of the Treaty of Versailles, which actually ended the war, rejected the spirit of Wilson's idealistic views and was a treaty of punishment both economically and militarily against Germany, setting the stage for World War II. Standing with Wilson from left to right in this image is David Lloyd George, prime minister of Great Britain; Vittorio Emanuele Orlando, prime minister of Italy; and Georges Benjamin Clemenceau, prime minister of France. Absent from this political powerhouse was a representative from the newly formed Bolshevik government of Russia.

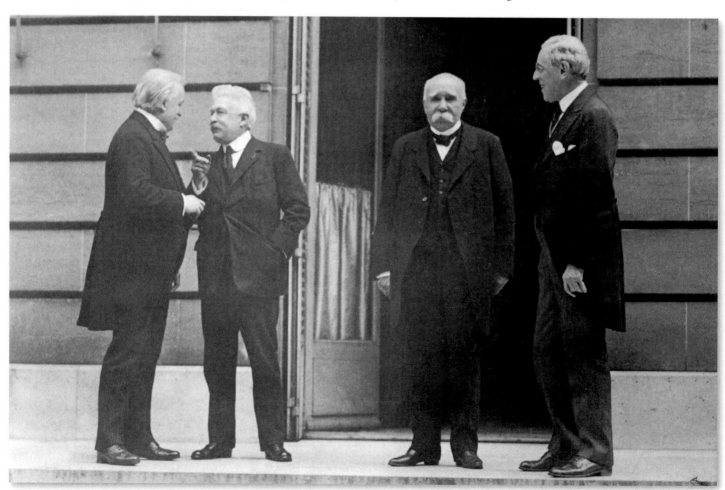

Council of Four of the Peace Conference: Lloyd George, Vittorio Orlando, Georges Clemenceau, and Woodrow Wilson. Hotel Crillon, Paris, France, May 27, 1919.

FALLING SOLDIER

The Spanish Civil War (1936–1939) was not only fought on the battlefields in Spain, it was waged globally by both warring parties through a "media blitzkrieg" to win over the world public's hearts and minds. Loyalists (supporters of Spain's left-wing elected government) easily won the media campaign. The armies of their rebel right-wing Nationalist opponents, however, won the war. Although the fighting lasted three bloody years, Nationalists, led by General Francisco Franco and supported militarily by Nazi Germany and fascist Italy, clearly were superior to Loyalist forces composed of constantly squabbling, inadequately trained, and indifferently armed militia. The Loyalists held out for three years principally because they received weapons (planes, tanks, small arms), war supplies, and experienced military advisers from dictator Josef Stalin's communist Soviet Union. Indeed, as the war progressed, Stalin's advisers and Spain's home-grown communists effectively seized control of the Loyalist war effort; communist secret police ruthlessly suppressed any opposition by purging or executing their socialist and anarchist opponents within the Loyalist ranks. When Loyalist defeat became inevitable by late 1938, Stalin brought his advisers back to the USSR—along with Spain's gold reserves.

The Loyalists' propaganda campaign succeeded in gaining widespread global moral support for their cause, although beyond a few thousand foreign volunteers (the International Brigades) it failed to generate much non-USSR military aid. Successful Loyalist propaganda efforts notably included Pablo Picasso's "Guernica" painting, symbolizing the horrors of the German Condor Legion's aerial bombing of the town; and the 1937 propaganda film *The Spanish Earth* by Dutch communist Joris Ivens, with narration written and spoken by Ernest Hemingway. Yet the most well-known example of stirring Loyalist propaganda is famed Hungarian-born war photographer Robert Capa's brilliant image, apparently capturing a Loyalist militiaman at the moment he is killed by Nationalist fire. Capa titled his photograph "Loyalist Militiaman at the Moment of Death, Cerro Muriano, Spain, September 5, 1936," but this iconic image of the Spanish Civil War has become known simply as Capa's "Falling Soldier" photograph. It is also almost certainly a fraud. Beginning in 1975, researchers exposed glaring inconsistencies that refuted Capa's claims of the photograph's location and that the militiaman was killed as Capa took his picture. It seems clear that Capa staged the war's most famous photo.

Although Robert Capa titled this famous photograph "Loyalist Militiaman at the Moment of Death, Cerro Muriano, Spain, September 5, 1936," research reveals that he almost certainly staged it. Nevertheless, it became the most iconic image of the Spanish Civil War.

NAZI BOYCOTT OF JEWISH BUSINESSES

German anti-Semitism gained traction in the interwar years with the legitimate rise to power of Adolf Hitler as the leader of the Nazi, (National Socialist German Workers Party) and his subsequent appointment as chancellor of Germany on January 30, 1933. Following the Reichstag fire on February 27, 1933, Hitler assumed power by decree of President Paul von Hindenburg under the belief that a communist plot existed to overthrow the German government. At this point the Nazis were free to begin eliminating their political opponents and enemies, both real and perceived. Chief among them were the Jews.

From its inception, Hitler's regime moved quickly to introduce anti-Jewish policies. The 500,000 Jews in Germany, who accounted for only 0.76 percent of the overall population, were singled out by the Nazi propaganda machine as an internal enemy responsible for Germany's defeat in the First World War and for its subsequent economic difficulties, including the Great Depression. Beginning in 1933 with the call for a national boycott of Jewish-owned businesses, the German government enacted a series of anti-Jewish laws restricting the rights of German Jews to earn a living, to enjoy full citizenship, and to educate themselves, including the Law for the Restoration of the Professional Civil Service, which forbade Jews to work in the civil service. The subsequent 1935 Nuremberg Laws stripped German Jews of their citizenship and forbade Jews to marry non-Jewish Germans.

Political events both inside and outside Germany came to a crisis point in 1938 with an argument with Poland over Polish Jews living in Germany. When a German diplomat in Paris, Ernst vom Rath, was assassinated by a Polish Jew, Herschel Grynszpan, the Nazi leadership expressed outrage, and its armed branch, the S.A. (*Sturmabteilung*, the brown-shirted storm troopers), began a series of coordinated attacks against Jews across Germany and parts of Austria on the night of November 9 and 10, 1938.

Known afterwards as *Kristallnacht*, or the Night of Broken Glass, the attacks left the streets covered with broken glass from the windows of Jewish-owned stores, buildings, and synagogues. At least 91 Jews were killed in the attacks, and a further 30,000 were arrested and incarcerated in concentration camps. Jewish homes, hospitals, and schools were ransacked as the attackers demolished buildings with sledgehammers. More than 1,000 synagogues were burned and more than 7,000 Jewish businesses destroyed or damaged. This marked a turning point for Germany with regard to the Jews and is seen as the beginning of the Holocaust.

Firemen work on the burning *Reichstag* building in February 1933, after fire broke out simultaneously at 20 places in the structure. The fire enabled Hitler to seize power under the pretext of protecting the country from the menace to its security. Berlin. (NARA)

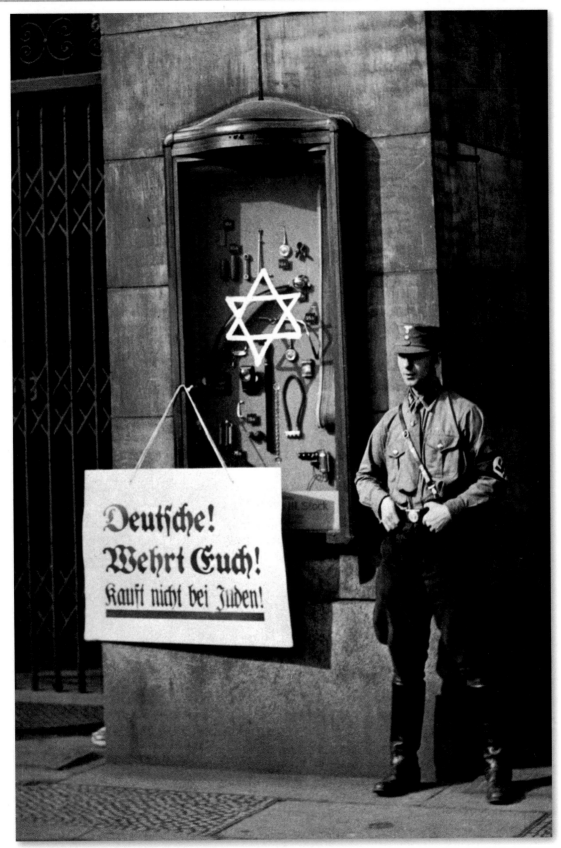

On April 1, 1933, the boycott announced by the Nazi party began. The placard reads, "Germans, defend yourselves, do not buy from Jews," at the Jewish Tietz store, Berlin. (NARA)

OVATION FOR HITLER

Evocative of the theatrical cult of personality that followed Adolf Hitler and Nazi Party rallies, this photograph was taken after Hitler announced the peaceful acquisition of Austria as part of Greater Germany. Anschluss Österreichs was the occupation and annexation of Austria into Nazi Germany in 1938. After several years of pressure from supporters inside Austria and Germany, which included Nazis and non-Nazis alike, the Austrian chancellor, Kurt Schuschnigg, tried to hold a referendum for a vote on the issue. Although Schuschnigg expected Austria to vote in favor of maintaining autonomy, a well-planned coup d'état of Austria's state institutions by the Austrian Nazi Party in Vienna took place on March 11, 1938, prior to the referendum, which they canceled. The following day, they transferred power to Germany, and German troops entered Austria to enforce the Anschluss. The Nazis held a plebiscite within the following month, asking the people to ratify the fait accompli. They claimed to have received 99.7 percent of the vote in favor of annexation. Thus began the creation of Hitler's Greater Germany Reich, which was to include all ethnic Germans and lands and territories which the German Empire had lost after World War I. After the Anschluss, Hitler moved to annex Czechoslovakia, provoking an international crisis that led to the Munich Agreement in September 1938, giving the Third Reich control of the industrial Sudetenland and its predominantly ethnic German population. In March 1939, Hitler annexed the Sudetenland of Czechoslovakia and made the rest of the nation a protectorate. That same year, Memelland, on the northern edge of East Prussia, was returned from Lithuania.

From its beginnings, the Nazi regime was obsessed with image. Always Hitler stood at the center, as the benevolent father, victorious leader, or the steadfast protector of the Aryan race. Pageantry replaced substance and deflected thought from the less pleasant realities of the rise of the regime.

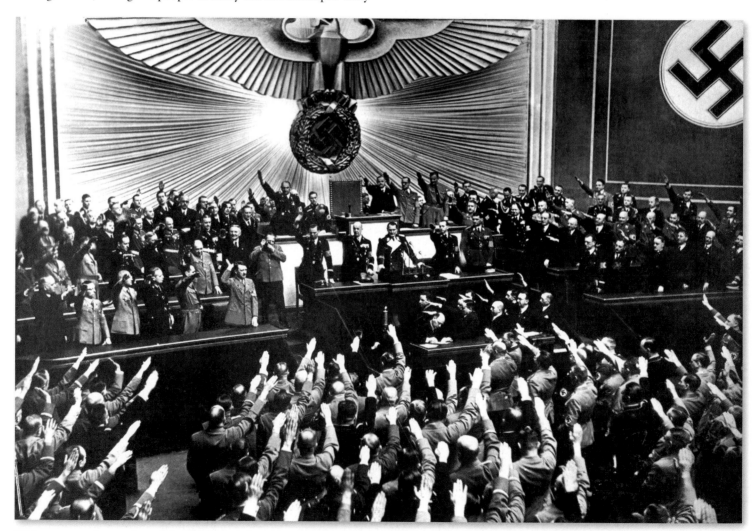

Hitler accepts the ovation of the Reichstag after announcing the "peaceful" acquisition of Austria. It set the stage to annex the Czechoslovakian Sudetenland, largely inhabited by a German-speaking population. Berlin, March 1938. (NARA)

Austria becomes German. The entry of German police into Imst, March 1938. (NARA)

FIELD MARSHAL ERWIN ROMMEL

When the unknown German army photographer captured this image of Field Marshal Erwin Johannes Eugen Rommel "between Tobruk and Sidi" on November 24, 1941, his campaign in North Africa had already earned him the nickname "the Desert Fox" and made him a national hero. Debatably one of the best armored commanders of the war, Rommel was never afraid to take bold risks to secure victories.

In November 1941, Rommel faced a renewed Allied offensive designed to use its superior numbers to encircle and destroy his Afrika Korps. Outnumbered nearly two to one, Rommel's forces defeated the initial assaults and immediately launched a vigorous counterattack. During the ensuing battles, among the largest armored engagements of the North African campaign, British tanks were surrounded, with about two-thirds destroyed and the survivors fleeing south.

On the day this photo was taken, Rommel counterattacked into British rear areas in Egypt, exploiting British disorganization and confusion and cutting their supply line. He knew that his enemy,

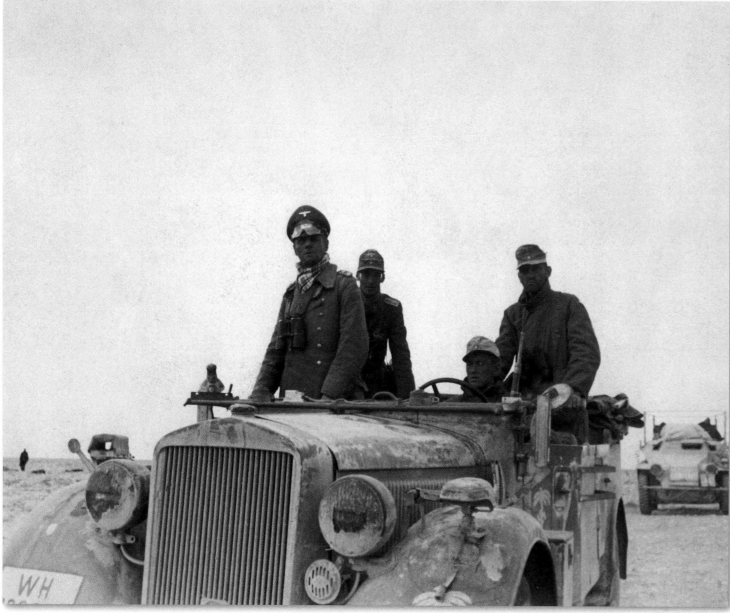

Field Marshal Erwin Rommel with the 15th Panzer Division between Tobruk and Sidi Omar, Libya. November 24, 1941. (NARA)

traumatized by defeat, would abandon its defenses along the border at the appearance of a threat to its rear areas. Although some of the Allied forces initially withdrew to Egypt, the British high command was able to halt the withdrawal, foiling Rommel's plan. The German attack, which began with only 100 operational tanks, stalled as it outran its supplies and met with stiffening resistance.

The future would hold a series of military and political setbacks for Rommel, ultimately leading to assignment as commander of the West Wall, Hitler's English Channel defense, and a military tribunal to investigate his part in the attempt on Hitler's life in July 1944, culminating in Rommel's suicide on October 14, 1944.

His adversary, British General Harold Alexander, best summed up Rommel's talents and flaws: "He was a tactician of the greatest ability, with a firm grasp of every detail of the employment of armor in action, and very quick to seize the fleeting opportunity and the critical turning point of a mobile battle. I felt certain doubts, however, about his strategic ability, in particular as to whether he fully understood the importance of a sound administrative plan. Happiest while controlling a mobile force directly under his own eyes, he was liable to over-exploit immediate success without sufficient thought for the future."

Rommel's visor cap. (Military and Historical Image Bank)

An Afrika Korps enlisted man's pith helmet. (Military and Historical Image Bank)

GERMANS MARCH INTO PARIS

With the German invasion of Poland in 1939, France declared war on Germany. From September 1939 until the Battle of France began in May 1940, the French had been in a state of war with Germany, but during this period of the "Phony War," there were no major military operations.

Beginning on May 10, 1940, German armored units pushed through the Ardennes to cut off and surround the Allied units that had advanced into Belgium. During the fighting, the British Expeditionary Force and many French soldiers were evacuated from Dunkirk in Operation Dynamo. Then, on June 5, German forces outflanked the armored Maginot Line and pushed deep into France. France's capital of Paris was occupied on June 14, 1940. As German troops entered the city, which they had last occupied in 1870, many Parisians feared the level of destruction that would accompany the taking of the city and subsequent occupation.

On June 17, French Prime Minister Philippe Pétain publicly announced France would ask for an armistice; on June 22, an armistice was signed between France and Germany that would take effect on June 25. Following this, France was divided into a German occupation zone in the north and west and a nominally independent state in the south. The new French state, known as Vichy France, was headed by Pétain. Surprisingly, the occupation

A Frenchman weeps as German soldiers march into the French capital, Paris, on June 14, 1940, after the Allied armies had been driven back across France. OWI.

of Paris initially was a far different experience from that of other occupied countries. Hitler was content to let the city remain, and after a few weeks the daily life in the city was almost identical to that of the prewar years. It became almost a tourist vacation spot for the German armed forces. Clubs, cafes, and theaters continued uninterrupted, and there was little in the way of resistance to the Germans or reprisals from them. Hitler, far from trying to eradicate French national culture, chose to nourish it. During the years of occupation, the German authorities encouraged literature, theater, and the arts—as long as Jews, Freemasons, and communists were excluded. The country was also subjected to an inundation of high German culture. Following the invasion in June 1944 and the subsequent liberation of Paris in August 1944, arrests of collaborators and settling of old scores took place before Paris could return to its prewar self.

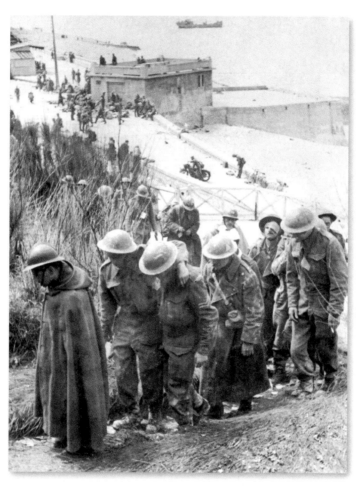

British prisoners at Dunkirk, France, June 1940. It seemed that all of Europe was Hitler's for the taking. (NARA)

THE BLITZ: ST. PAUL'S CATHEDRAL

One of the most enduring images of the Second World War, and for the City of London, is this iconic photograph from the "Blitz" period. The Blitz on London, which began on September 7, 1940, is considered the fourth phase of the Battle of Britain, which lasted from July 10, 1940, until May 1941.

On September 4, 1940, Adolf Hitler changed the strategy of the battle by directing bombing raids away from Royal Air Force bases to city and industrial centers. London was especially hard hit. On the night of December 29, 1940, beginning at 6 p.m., 136 German bombers began a fire bomb raid that lasted until 9:30 that night. During the raid German bombers dropped more than 10,000 phosphorus incendiary bombs and ignited the second great fire of London. More than 9,000 fire fighters battled the blaze, which was whipped into an inferno by gale force winds.

Early in the raid, *Daily Mail* newspaper photographer Herbert Mason took his camera to the roof of the newspaper's office building at Northcliffe House, Carmelite Street, approximately a half mile east of St. Paul's Cathedral. Mason wrote of the moment he snapped the inspiring image: "I focused at intervals as the great dome loomed up through the smoke," he later said. "The glare of many fires and sweeping clouds of smoke kept hiding the shape. Then a wind sprang up. Suddenly, the shining cross, dome and towers stood out like a symbol in the inferno. The scene was unbelievable. In that moment or two, I released my shutter."

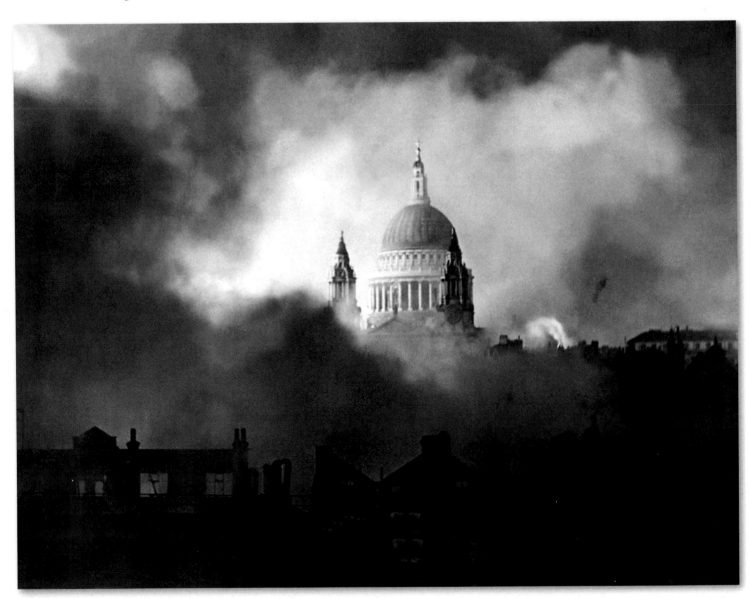

Standing up gloriously out of the flames and smoke of surrounding buildings, St. Paul's Cathedral is pictured during the great fire raid of Sunday, December 29, 1940. *New York Times* **Paris Bureau Collection. (USIA)**

St. Paul's Cathedral, completed in 1708 and towering 365 feet above the city on Ludgate Hill, was built in the aftermath of the first great fire of London in 1666. The cathedral survived the raid in 1940 even though it had taken a direct hit by an incendiary bomb. Many who saw the cathedral's dome still standing through the havoc that claimed 160 lives stated that it gave them hope.

Dorothy Barton, an eyewitness to the devastation, remembered that when she saw the cathedral the next day, "I felt a lump in my throat because, like so many people, I felt that while St Paul's survived, so would we." Mason's image was suppressed for two days by British censors until it was judged that it would be inspiring; it was released in the *Daily Mail* on Tuesday, December 31, 1940.

Aircraft spotter on the roof of a building in London with St. Paul's Cathedral in the background. (NARA)

Big Ben and the Houses of Parliament, London. (NARA)

GERMAN TROOPS IN RUSSIA

Operation Barbarossa was the code name for Germany's invasion of the Soviet Union during the Second World War. Beginning on June 22, 1941, more than 3.9 million troops of the Axis powers invaded the USSR along a 2,900-kilometer (1,800-mile) front, the largest invasion in the history of warfare. In addition to troops, Barbarossa involved 600,000 motor vehicles and 750,000 horses. The ambitious operation was driven by Adolf Hitler's persistent desire to conquer the Russian territories. Operation Barbarossa was named after Frederick Barbarossa, the medieval German ruler who, as myth had it, would rescue Germany in her time of need. Planning started on December 18, 1940; the secret preparations and the military operation itself lasted from June to December 1941.

The operation occurred in four phases. In the first phase, three separate army groups comprising roughly 3 million Wehrmacht troops went into action on June 22, 1941. By the end of the first week, all three German army groups had achieved major campaign objectives. However, in the vast pocket around Minsk and Białystok, the Soviets were still fighting; reducing the pocket was causing high German casualties and many Red Army troops were escaping. The usual estimated casualties of the Red Army amount to 600,000 killed, missing, captured, or wounded.

In the second phase, the Germans continued to push eastward on to Smolensk, capturing 300,000 Red Army soldiers in a pincer movement. In early August, the third phase began with the Battle of Kiev and the Siege of Leningrad. By the beginning of October 1941, Kiev had been encircled and taken with 452,720 men and 3,867 artillery pieces captured, and Leningrad was besieged. Hitler's fixation on capturing Moscow was the final phase of the operation. From October through December, the Wehrmacht inched closer to Moscow as the weather worsened. The Red Army grew stronger, and German supply lines became more attenuated. A few small elements got to within five miles of Moscow and could see the spires of the Kremlin, but they advanced no farther. In early December, the Red Army launched a massive counterattack and pushed the German forces back more than 200 miles. The invasion of the USSR eventually cost the Germans more than 250,000 dead and 500,000 wounded, and marked the beginning of the end of Germany's ambitions in Russia.

German soldiers assault an enemy position in Russia in 1941. (NARA)

HITLER IN PARIS

When Hitler received word from the French government that they wished to negotiate an armistice, he selected the Compiègne Forest as the site for the negotiations. Compiègne had been the site of the 1918 Armistice, which had ended the First World War with a humiliating defeat for Germany. Hitler viewed the choice of location as a supreme moment of revenge for Germany over France.

The armistice was signed on June 22, 1940, in the very same railway carriage in which the 1918 Armistice was signed. Hitler ordered it removed from a museum building and placed on the precise spot where it was located in 1918. Hitler sat in the same chair in which French Marshal Ferdinand Foch had sat when he faced the defeated German representatives in 1918. Following the armistice, Hitler toured the occupied capital and lost no opportunity to have images taken of him with iconic French landmarks to document his triumph over the French. None was more iconic than the Eiffel Tower. In this image he is with two of his closest nonmilitary associates. Albert Speer, on the left, was Hitler's chief architect and later minister of armaments and war production for the Third Reich. Arno Brecker, on the right, was a sculptor best known for his many public works commissioned under the Nazi regime, notably the statues of "The Party" and "The Army," which flanked the entrance of the Reich Chancellery building in Berlin. He was a part-time resident of Paris before the war. Given their professions and training, it is not surprising to see them touring Paris, a city of monuments and Pierre Charles l'Enfant's architectural design, with Hitler. Speer had designed the German Pavilion in Paris for the 1937 World's Fair. Following the fall of the Third Reich, Speer, as a member of the Nazi leadership and final government under Admiral Karl Doenitz, was arrested and tried at Nuremberg. He was sentenced to 20 years in prison, which he served in Spandau Prison. Brecker continued his career after the war and divided his time between his home in Düsseldorf and Paris.

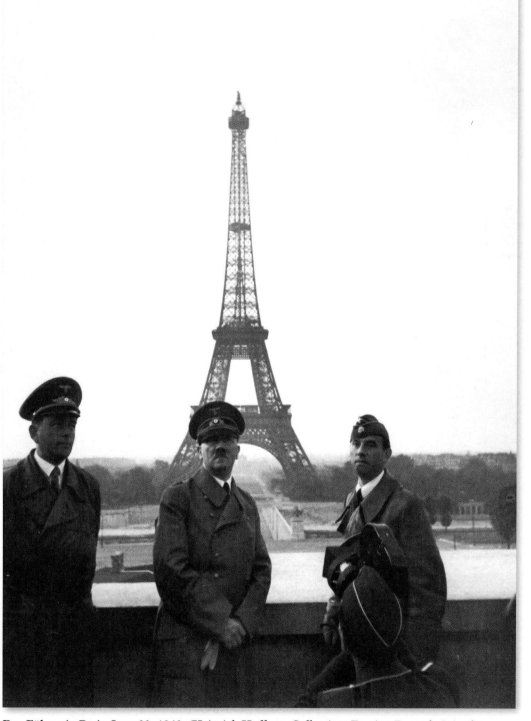

Der Führer in Paris. June 23, 1940. (Heinrich Hoffman Collection: Foreign Records Seized)

ABOARD THE U.S.S. *SOLACE*

Among the most feared tactics in the Pacific campaign were kamikaze attacks. Beginning in 1944, Japanese forces recruited special units of pilots who were trained to crash explosives-laden planes onto Allied ships. This tactic increased the lethality of the plane, as in addition to a normal bomb payload, the plane carried additional explosives and gasoline. The usually massive explosions resulted in fires that often spread throughout the ship and burned far longer than those caused by high explosives from bombs or naval shells alone. The name *kamikaze* is usually translated as "divine wind." The word originated as the name of major typhoons in 1274 and 1281, which dispersed Mongolian invasion fleets attacking Japan. Before the formal establishment of kamikaze units, deliberate crashes had been used as a last resort when a pilot's plane was severely damaged and he did not want to risk being captured, or he wanted to do as much damage to the enemy as possible since he was crashing anyway. The Battle of

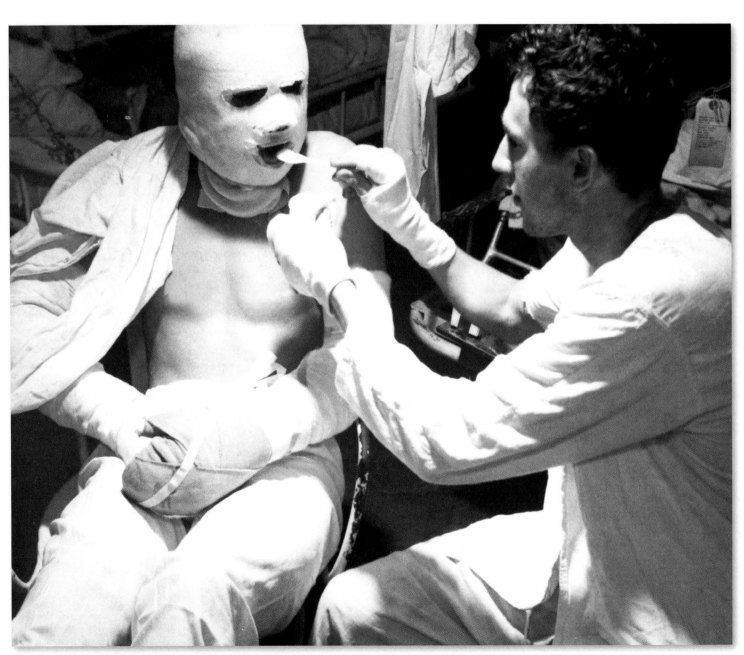

Pressure-bandaged after he suffered burns when his ship was hit by a kamikaze attack, a patient is fed aboard the USS *Solace*, 1945.

Midway had irreparably damaged the Japanese carrier force, and their air superiority had declined due to outdated planes and inexperienced pilots.

The first massive kamikaze attack occurred in October 1944 at the Battle of Leyte Gulf, where 55 planes attacked and damaged seven carriers—sinking one, the *St. Lo*—and damaged or sank 40 other ships (five sunk, 23 heavily damaged, and 12 moderately damaged). The height of the kamikaze effort was from April to June 1945 during the Battle of Okinawa, when more than 1,400 planes sank or put out of action at least 30 U.S. warships. Allied defense of the carriers consisted of airplanes constantly flying above the fleet and outer defense rings of destroyers or smaller vessels, on picket duty for early detection and destruction of the incoming planes. The destroyer USS *Laffey* earned the nickname "The Ship That Would Not Die" after surviving 16 kamikaze attacks, including five hits during the Battle of Okinawa. By the end of the war, 2,800 kamikaze attacks were responsible for sinking 34 navy ships and damaging 368 others, which killed 4,900 sailors and wounded more than 4,800.

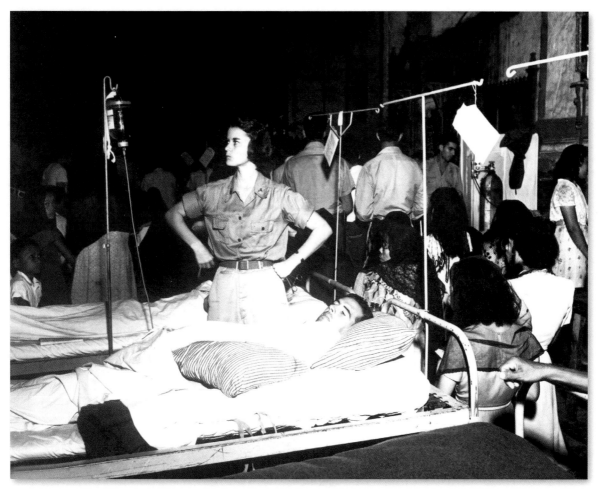

First Lieutenant Phyllis Hocking checks the glucose injection apparatus for a GI patient in the 36th Evacuation Hospital, Palo, Leyte, P.I., quartered in a church. December 24, 1944. (NARA)

SUBMARINE WARFARE

At the close of the First World War, the U.S. Navy decided that submarines could provide more than screens for ports and renewed their plans for a Fleet submarine with greater range and the ability to go on extended war patrols. Through many design changes, the navy finally began to commission T-class submarines in 1940, followed closely by the Gato and Gar class boats. With a cruising range of 12,000 miles, these were the first true Fleet boats. On December 7, 1941, there were 21 submarines attached to the U.S. Pacific Fleet based in Pearl Harbor, although only 11 boats could actually be considered available for combat operations. After the attack had ended, the American submarine fleet received orders issued by Admiral Harold Stark, the chief of naval operations, at 4 p.m. on December 7, 1941, for all available boats to immediately put to sea and for those already underway to conduct "unrestricted submarine warfare" against anything Japanese. Thus began the submarine war in the Pacific.

While the Navy conducted operations in the Atlantic against the Axis powers, its greatest impact was in the Pacific. While much has been made of the Nazi "wolf packs," by 1943 they were on the defensive and rendered mostly ineffective by the convoy tactics the Allies adopted. Far more effective were the U.S. submarines in the Pacific. Their contributions were far more important. Japan at the outset of the war was already lacking in manufacturing ability, raw materials, and food. The highly effective campaign against the Japanese fleet caused irreparable damage to the logistical and combat capabilities of the Japanese. With U.S. submarines sinking enemy vessels at a rate of 50 per month in 1944 and with specific orders to attack oil tankers, serious supply shortages were affecting the Japanese ability to continue the war effort. At the conclusion of hostilities in 1945, of the 10 million tons of military and merchant shipping lost by the Japanese during World War II, U.S. submarines accounted for a total of 54 percent. Despite early setbacks with few boats and a problem in the early years of 1941 to 1943 of faulty torpedoes, the U.S. submarine fleet was an integral part of the U.S. victory.

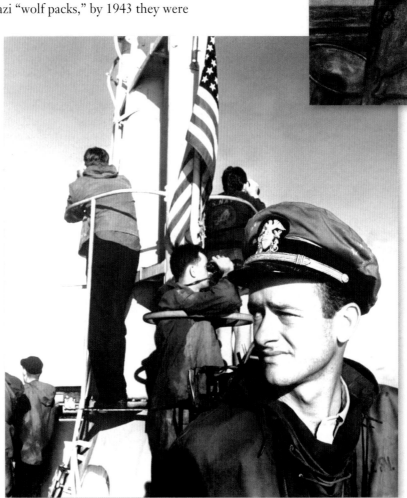

Although U-boat warfare became synonymous with Germany, American submarine captains crippled Japan through highly effective attacks against Japanese merchant shipping. This German postcard, used to raise war funds, pictures one of Germany's most famous U-boat captains, Kapitanleutnant Gunther Prien, who sank more than 30 Allied ships. The card commemorates his most famous engagement—the sinking of the British battleship HMS *Royal Oak* at Scapa Flow on October 14, 1939. (Private collection)

USS *Sea Dog* prowls the Pacific in search of enemy ships, May 1945. (NARA)

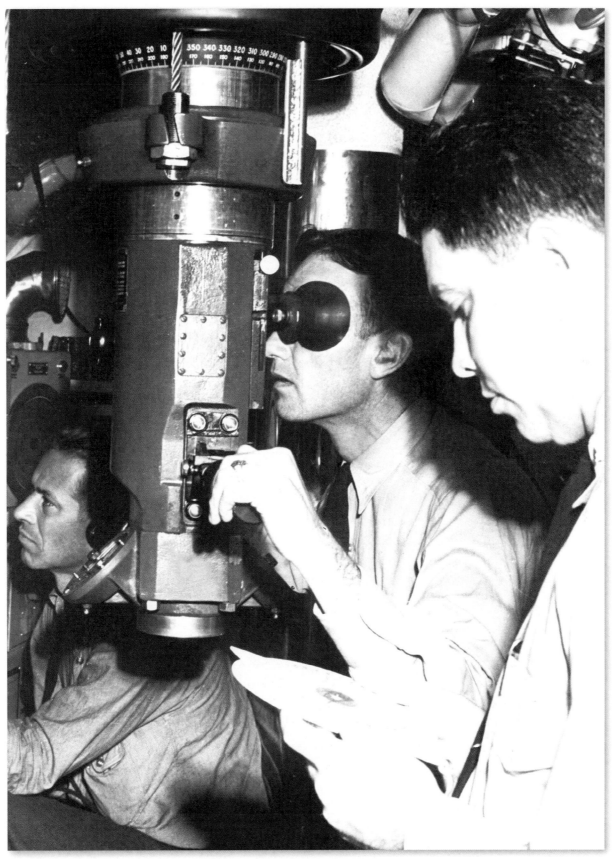

Inside the conning tower of a U.S. submarine. August 1943, Commander Edward J. Steichen.

BATTLE OF SANTA CRUZ

In March 1922, the USS *Langley* was commissioned as the first aircraft carrier in the U.S. Navy. Advocates for naval air power led the navy to commission more carriers in the years leading up to World War II. Japanese naval planners recognized the importance of the carrier to modern warfare. The attack at Pearl Harbor was aimed primarily to destroy the U.S. carriers based in the Pacific. The Imperial Japanese Navy was the first to assemble a large number of carriers into a single task force. This task force was used with devastating effect during the Pearl Harbor attack. The Japanese navy continued to use the carrier battle group until four of its carriers were sunk at the Battle of Midway.

The U.S. Navy deployed its large carriers in separate formations, with each carrier assigned its own cruiser and destroyer escorts. These single-carrier formations would often be paired or grouped together for certain assignments, most notably at the Battle of the Coral Sea and at Midway. In the Battle of the Santa Cruz Islands, Rear Admiral Thomas Kinkaid swept his forces around the Santa Cruz Islands on October 25 searching for the Japanese naval forces. His warships were deployed as two separate carrier groups, each centered on either the *Hornet* or *Enterprise* and separated by about 10 nautical miles. Both forces spotted one another at approximately the same time on the morning of the 26th. Attack aircraft from three Japanese carriers struck the *Hornet* first, severely damaging her. She would be damaged beyond repair and abandoned by the end of the day. *Enterprise* was also hit but managed to leave the battle under her own power.

This image shows the volume of antiaircraft fire aimed at the attacking Japanese planes. Based on the light damage visible, this carrier is most likely the *Enterprise*, who after the battle was the sole U.S. carrier left in the Pacific. By 1943, however, large num-

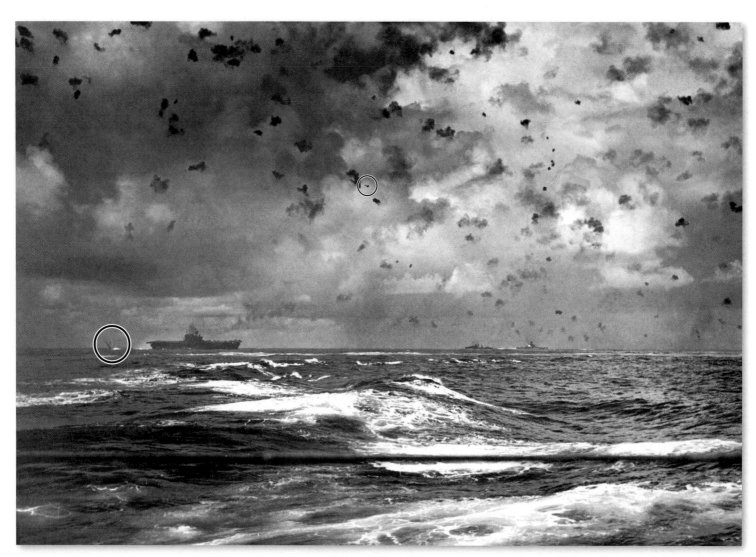

A Japanese bomb splashes astern of a U.S. carrier during the Battle of Santa Cruz as the enemy plane pulls out of its dive above the carrier. In the center is another enemy plane that has made an unsuccessful dive. Battle of Santa Cruz Islands, October 26, 1942. U.S. Navy.

bers of fleet and light escort carriers became available to the U.S. Navy, which created formations of three or four carriers. Over the course of the conflict, the carrier would grow in importance and ultimately would shape naval warfare to the present day.

The USS *Yorktown*, a WWII Essex class carrier, earned 11 battle stars and a Presidential Unit Citation during the Pacific campaign. (LOC)

A U.S. Navy SBD-5 Dauntless dive-bomber from Bombing Squadron Sixteen (VB-16) flies an antisubmarine patrol over the battleship USS *Washington* (BB-56). Aircraft carrier USS *Lexington* (CV-16) is in the background. Carrier aircraft proved vital to prosecuting World War II across the vast expanse of the Pacific Ocean. (NARA)

THE BIG THREE AT YALTA

The conference was held February 4 to 11, 1945, at Livadia Palace in the Crimean seaside resort of Yalta on the Black Sea. It was only the second time the leaders of World War II's three major Allied powers met face-to-face (the first was the Teheran Conference, November 28 to December 1, 1943). Although U.S. President Franklin D. Roosevelt and British Prime Minister Winston Churchill met frequently during the war, Soviet dictator Josef Stalin typically absented himself from the high-level meetings with claims that the "pressing matters" of managing the brutal war against Hitler's Nazi armies on the Eastern Front required his presence in Moscow's Kremlin. Most likely, the paranoid Soviet dictator was simply uncomfortable traveling very far away from the iron-clad security provided by his ruthless NKVD secret police.

At this stage of World War II, Nazi Germany's defeat was assured—American and British armies in the west were preparing to cross the Rhine and pour into Germany, while Stalin's massive Red Army in the East was staging to steamroller its way to Berlin only 40 miles away. The main Yalta Conference agenda, therefore, concerned Germany's postwar disposition after its uncondi-

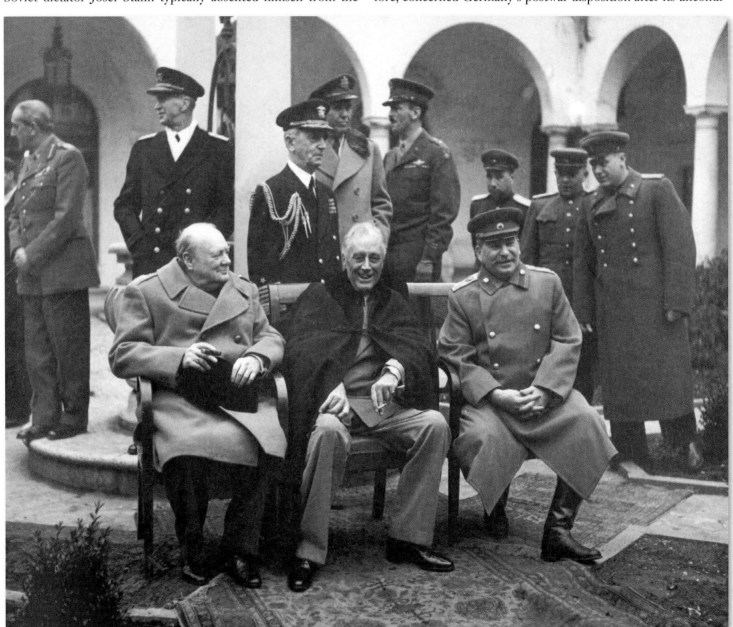

Conference of the Big Three at Yalta making final plans for the defeat of Germany: Winston S. Churchill, Franklin D. Roosevelt, and Josef Stalin, in February 1945. (Army)

tional surrender. Roosevelt also had two additional points on which he was extremely anxious to get Stalin's agreement: getting Stalin's promise to engage Red Army troops in the continuing war against Japan, and securing USSR membership in Roosevelt's most ardent project, the new United Nations organization. To achieve Stalin's support of both, Roosevelt was willing to acquiesce to nearly any concessions Stalin demanded. The subsequent half-century-long Soviet domination of Eastern Europe and half of Germany has often been claimed to have resulted from Roosevelt's "betrayal" of Eastern Europe's democracy at Yalta to please Stalin. Yet with Soviet armies in February 1945 already occupying that territory, there seems little Roosevelt could have accomplished to change the face of post–World War II Europe.

Standing behind the Big Three Allied leaders in this photograph are their key military advisers. Left to right: British Field Marshal Sir Alan Brooke; U.S. Chief of Naval Operations Admiral Ernest King; U.S. Fleet Admiral William Leahy; U.S. Army Chief of Staff General George C. Marshall; British Major General Laurence Kuter; Soviet General Aleksei Antonov; Soviet Vice Admiral Stepan Kucherov; and Soviet Admiral of the Fleet Nikolay Kuznetsov.

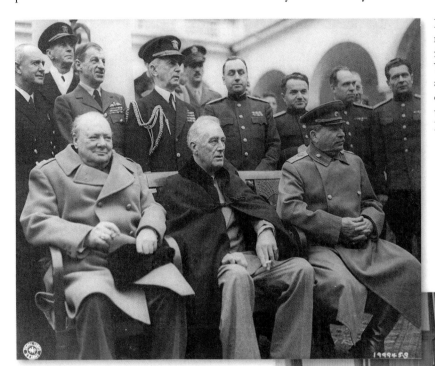

In this image taken moments after the facing photograph, the Yalta Conference was a huge public affairs opportunity, showing the solidarity of the Big Three. (LOC)

Crimean Conference, left to right: secretary of state Edward Stettinius, Major General L.S. Kuter, Admiral E.J. King, General George C. Marshall, ambassador Averill Harriman, Admiral William Leahy, and President F.D. Roosevelt at Livadia Palace, Crimea, Russia, February 4, 1945. (LOC)

TWO GENERALS

The December 7, 1941, Japanese surprise attack on Pearl Harbor that brought the United States into World War II caught General Douglas MacArthur in the midst of his unfinished task of building the Philippines army. Appointed as commander of the U.S. Army in the Far East in July 1941 as war loomed, MacArthur faced an overwhelming Japanese invasion with only 135,000 U.S. and Filipino troops (110,000 were barely trained Filipino soldiers, inadequately armed with castoff World War I rifles). Eight hours after the Pearl Harbor attack, an appallingly bad judgment by MacArthur's air commander, Major General Lewis H. Brereton, allowed a Japanese airstrike to destroy on the ground most of MacArthur's offensive air power—22 B-17 bombers. Japanese ground troops invaded December 22, and the fighting rapidly devolved into a bitter, five-month-long fight for Bataan Peninsula and Corregidor Island.

Against the odds, MacArthur's battered, starving American and Filipino troops managed to create a five-month "roadblock" to Japanese expansion that bought the U.S. and its allies vital time to organize counteroffensives, beginning in mid-1942, that rolled back Japan's Pacific conquests. But when MacArthur's belea-guered troops were finally forced to surrender (Bataan on April 9, 1942, and Corregidor on May 6), he was in Australia, having been ordered there in March by President Franklin D. Roosevelt. Upon arriving in Australia, MacArthur made his famous "I shall return" pledge to liberate the Philippines by leading his forces back. Two years and seven months later, MacArthur fulfilled that pledge with his invasion of Leyte, October 29, 1944.

When MacArthur escaped by U.S. Navy PT boat from the Philippines, he handed over command of his outnumbered U.S. and Filipino troops to then Major General Jonathan Wainwright. Facing an impossible situation, Wainwright was forced to surrender his army's remnants to his Japanese conqueror, General Masaharu Homma.

Although Wainwright was spared the murderous Bataan Death March—thousands of Americans and Filipinos died or were executed by Japanese guards during the 80-mile forced march to POW compounds—he shared their misery during three years of brutal Japanese captivity. Gaunt and haggard after his POW ordeal, Wainwright was reunited with MacArthur in Yokohama as the Pacific War ended. MacArthur brought Wainwright aboard the USS *Missouri* in Tokyo Bay to witness the Japanese surrender on September 2, 1945.

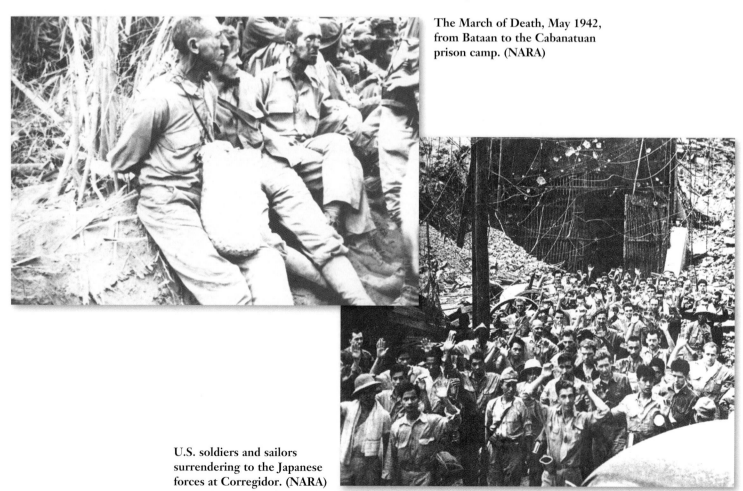

The March of Death, May 1942, from Bataan to the Cabanatuan prison camp. (NARA)

U.S. soldiers and sailors surrendering to the Japanese forces at Corregidor. (NARA)

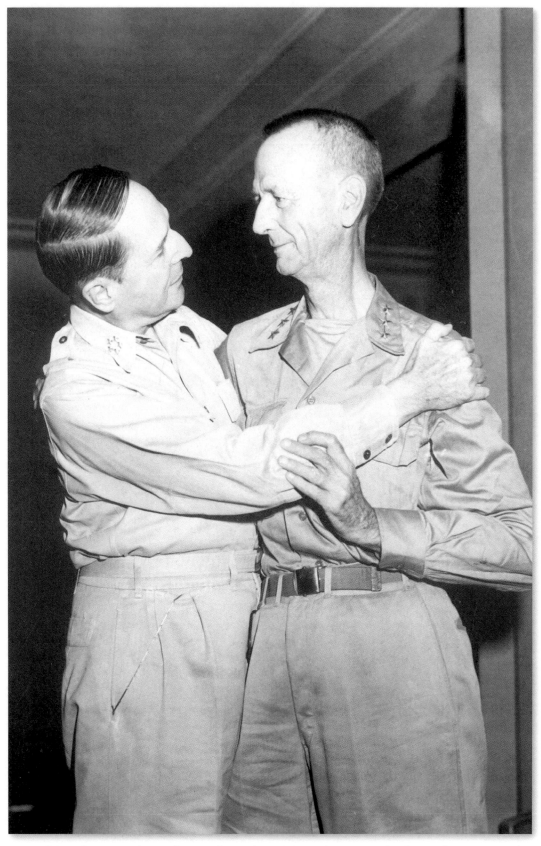

General Douglas MacArthur and General Jonathan Wainwright greet each other at the New Grand Hotel, Yokohama, Japan, in their first meeting since parting on Corregidor. August 31, 1945. (Army)

CZECH WOMAN SALUTES HITLER

The Sudetenland was the northern, southwest, and western regions of Czechoslovakia inhabited mostly by ethnic Germans, specifically the border areas of Bohemia, Moravia, and those parts of Silesia located within Czechoslovakia. Ethnic Germans had lived in these areas for at least five centuries. Following the end of the First World War, the peace treaty created Czechoslovakia from the ruins of the Austro-Hungarian Empire. The Great Depression hit these areas particularly hard and led them to be more open to populist movements such as fascism and ultimately to the rise of German Nationalism.

Following the Anschluss of Austria in 1938, the Sudeten Germans began to agitate for autonomy. Hitler made himself their advocate, creating the Sudeten Crisis. Negotiations with England, France, Italy, and Czechoslovakia ultimately led to the appeasement strategy of British Prime Minister Neville Chamberlain, as Hitler claimed this as his "last territorial demand." The Munich Agreement, signed by all parties on September 30, 1938, gave the Sudetenland to Germany; the first 10 days of October saw German forces move into the newly ceded territory. In March 1939, Germany invaded the remainder of Czechoslovakia, revealing the lie in Hitler's statement to Chamberlain. At this point the world saw the folly of the strategy of appeasement.

The reaction to Nazi rule was mixed, but many ethnic Germans favored the arrangement, with the Sudeten Germans being strongly pro-Nazi and the Czechs seeing themselves as a conquered and occupied people. In another view of this picture, which is cropped less, there are two other women to the crying woman's right. Both are saluting; the one closest to the Czech woman seems to have an ambiguous look on her face, while the third, in the far left of the picture, is happily smiling and rejoicing the entrance of the Führer. In these three women's faces we see the entire spectrum of the emotional situation in Czechoslovakia.

After the end of World War II, the Potsdam Conference in 1945 determined that Sudeten Germans would have to leave Czechoslovakia. As a consequence of the immense hostility against all Germans that had grown within Czechoslovakia due to Nazi behavior, the overwhelming majority of Germans were expelled while legislation provided for Germans who could prove their anti-Nazi affiliation to remain. The number of expelled Germans is estimated to be around 500,000 people.

In contrast to the photograph described, overjoyed Sudeten women cheer the arrival of German troops in 1938. (NARA)

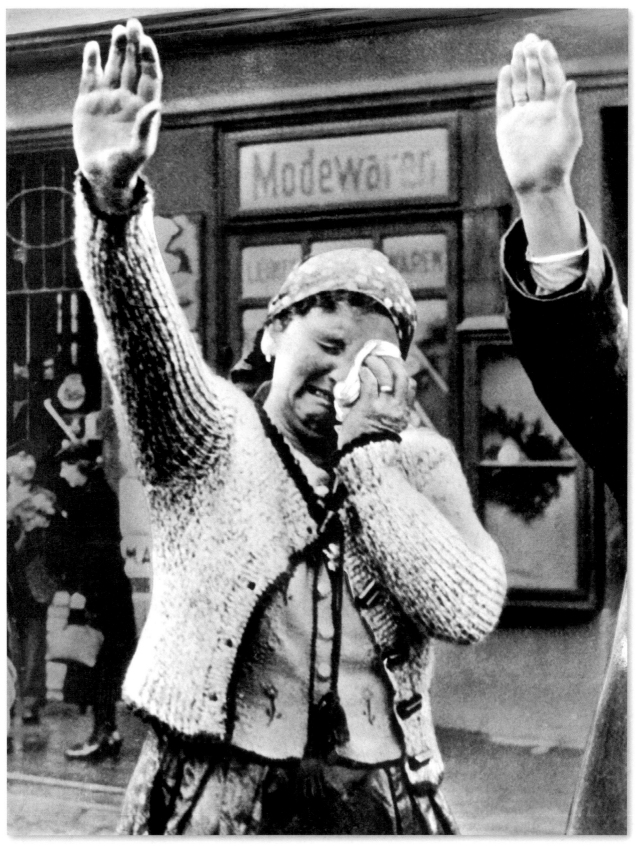

A distraught Czech woman gives the Nazi salute as Hitler enters
the city of Cheb (Eger to the ethnic Germans) in the fall of 1938.

SERGEANT FRANKLIN WILLIAMS

As early as the American Revolution, there were black soldiers serving in units of the Continental Army. Soon thereafter, the American Army became a white institution. It wasn't until the Civil War that African Americans served in large numbers in the military, and then only in segregated units under white officers. This trend continued up until the beginning of the Second World War. African American hopes had been raised during the First World War, as several black units performed well in combat and the National Association for the Advancement of Colored People (NAACP) had made inroads with the administration. However, after the armistice things returned to the status quo. In 1941 fewer than 4,000 African Americans were serving in the military, and only 12 African Americans had become officers. Even though black citizens were subject to the draft, racial prejudice caused many African Americans to be passed over by draft boards. Continued pressure from the NAACP led President Roosevelt to pledge that African Americans would be enlisted according to their percentage in the population. Although this percentage, 10.6%, was never actually attained in the services during WWII, numbers grew dramatically in all services.

Initially, prejudiced expectations about their abilities led the services to relegate African Americans to noncombat service roles, but by 1945 troop losses virtually forced the military to begin placing more African American troops into positions as infantrymen, pilots, tankers, medics, and officers in increasing numbers. Among all their contributions, several segregated units became famous in their own right. Among these were the all-black 761st Tank Battalion, which fought its way through France with Patton's Third Army; the "Tuskegee Airmen" of the 332nd Fighter Group; and the "Triple-Nickel" 555th Parachute Infantry Regiment. The 92nd and 93rd Divisions were all-black units that served in Italy and the Pacific. The Tuskegee Airmen were led by Captain Benjamin O. Davis Jr., whose father and namesake had become (in 1940) the first African American general in the U.S. military. Women of color were also represented. As the racial barriers were withdrawn over the course of the war, African American women became eligible to serve as army nurses and enlist in the WAAC, the WAVES, and the Coast Guard SPARS. By the end of the war in 1945, more than 1.2 million African Americans would be serving.

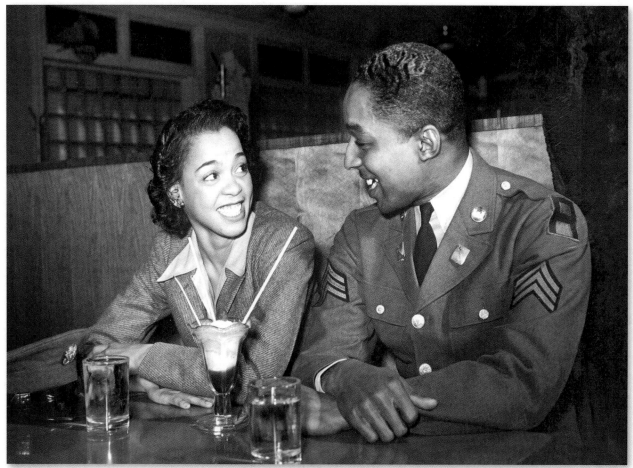

Sergeant Franklin Williams, home on leave, shares a soda with his girlfriend, Ellen Hardin, in May 1942.

THE RED BALL EXPRESS

When General George S. Patton Jr.'s bold armored advance across France in 1944 began after the Allied breakout from the D-Day beaches in Normandy, it was a significant contribution to the Allied victory in Europe in World War II. The breakout from Normandy and the French hedgerow country that summer started a race to Paris and other points north and east. Patton stretched his supply line to near collapse. Because an army without gas, bullets, and food would quickly be defeated, the Army Transportation Corps created a huge trucking operation called the "Red Ball Express" on August 21, 1944. Supply trucks started rolling August 25 and continued for 82 days.

The Red Ball Express was the army's name for the truck convoy system that stretched from St. Lo in Normandy to Paris and eventually to the front along France's northeastern borderland. The route was marked with red balls. The term *red ball*, a railroad phrase originated by the Santa Fe system around 1892 and used extensively by the 1920s, referred to shipping of priority and perishable items where the trains and express-use tracks were both marked with red balls. On an average day in 1944, 900 fully loaded vehicles were on the Red Ball route round-the-clock, with drivers officially ordered to observe 60-yard intervals and a top speed of 25 miles per hour (a rule often overlooked as the drivers strove to complete the journey as quickly as possible). At the Red Ball's peak, 140 truck companies were involved with a round trip taking 54 hours as the route stretched nearly 400 miles to First Army and 350 to Patton's Third Army. Nearly 75 percent of all Red Ball Express drivers were African American. Well before and even during the war, U.S. commanders in general believed African Americans had no mettle or guts for combat. Consequently, the Army relegated blacks primarily to "safe" service and supply outfits. When the program ended on November 16, 1944—with the opening of port facilities at Antwerp,

Belgium, the repair of some French rail lines, and deployment of portable gasoline pipelines—Red Ball Express truckers had delivered 412,193 tons of gas, oil, lubricants, ammunition, food, and other essentials. By then, 210,209 African Americans were serving in Europe, and 93,292 of them were in the Quartermaster Corps, the Army branch responsible for logistics support.

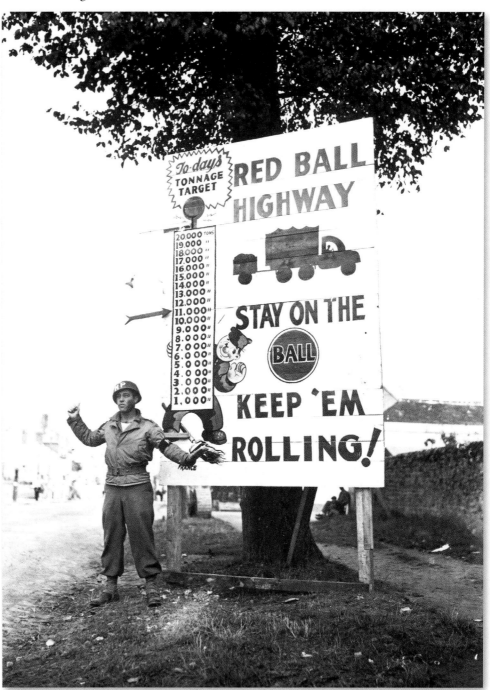

Corporal Charles H. Johnson of the 783rd Military Police Battalion waves on a "Red Ball Express" motor convoy rushing priority materiel to the forward areas, near Alençon, France. September 5, 1944. (NARA)

THE HIRANO FAMILY

One of America's darkest chapters of World War II was the internment of Japanese Americans in relocation camps during the war. The December 7, 1941, Pearl Harbor attack prompted widespread fear and loathing of the Japanese enemy among the American public; unfortunately, the anti-Japanese attitude also extended to Americans of Japanese ancestry. According to the 1940 U.S. Census, there were 126,947 persons of Japanese ancestry living in the continental United States, 112,353 of them residing in the three Pacific Coast states (California, Oregon, and Washington). California had 93,717, three-fourths of the U.S. national total. Additionally, there were 140,000 to 150,000 persons of Japanese ancestry living in Hawaii (37 percent of Hawaii's population). Of the Pacific Coast Japanese, 40,869 were aliens (not U.S. citizens, called *issei*); the remaining 71,484 were American-born (called *nisei*) and U.S. citizens by birth.

Responding to fear and panic on the West Coast, on February 19, 1942, President Franklin D. Roosevelt signed Executive Order 9066, authorizing the secretary of war to designate areas around sensitive military and defense industries as exclusion zones "from which any or all persons may be excluded." Although the order did not specify any nationality or ethnic group, it became the basis for the relocation and internment of Japanese (including nisei, U.S. citizens), German, and Italian aliens living in or near the exclusion zones. Armed with Executive Order 9066, General John L. DeWitt, commander of the Western Defense Command, issued Civilian Exclusion Order 34 on May 3, 1942; it ordered all people of Japanese ancestry (citizens and noncitizens) living in Military Area Number 1 (essentially the entire Pacific Coast to 100 miles inland) to report to assembly centers from which they would be moved to relocation centers. Eventually, about 110,000 people of Japanese ancestry living on the West Coast were interned. Approximately 60 percent were U.S. citizens. The relocations remained in effect until January 1945.

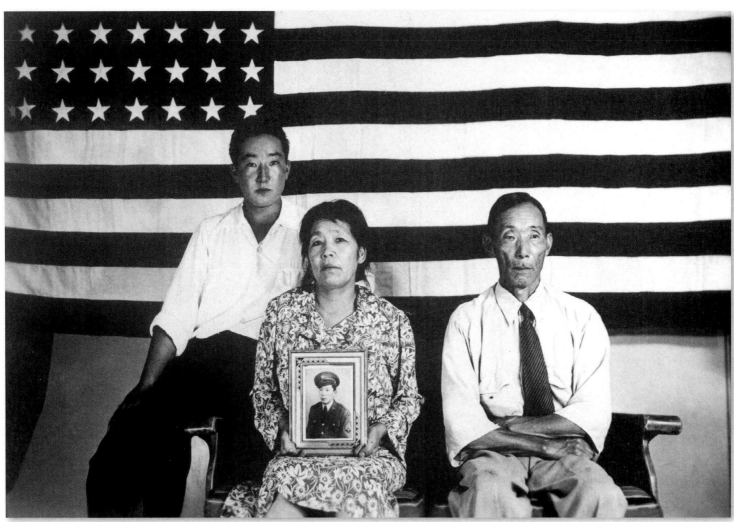

The Japanese American Hirano family: George, Hisa, and Yasbei. Hisa holds a photo of another family member serving in the U.S. Army. Colorado River Relocation Center, Poston, Arizona. (WRA)

Despite such egregious treatment, about 20,000 Americans of Japanese ancestry—including many who enlisted from relocation camps—served in the U.S. Armed Forces during the war, most in the 100th Infantry Battalion and 442nd Regimental Combat Team. Fighting in Europe, the 442nd became the most highly decorated regiment in U.S. history, with 18,143 medals, including 21 Medals of Honor.

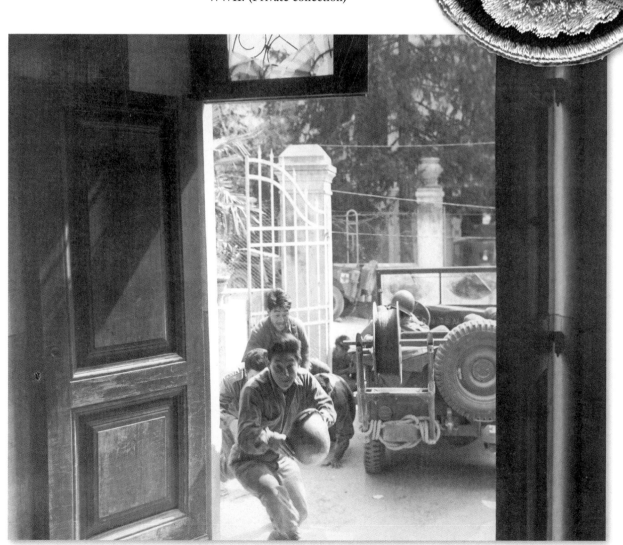

The shoulder sleeve insignia of the 442nd Infantry Regiment, a unit composed of mostly second-generation Japanese Americans or Nisei. The insignia features a yellow arm wielding a sword against the enemies of America. Although many of their families were in internment camps, the 442nd Infantry Regiment was the most decorated army unit of WWII. (Private collection)

Soldiers of the 442nd Infantry Regiment run for cover as a German artillery shell is about to land outside the building. Italy, April 4, 1945. (NARA)

WOMEN BUILDING A B-17

The massive mobilization of men to fight left the rapidly expanding war industries scrambling for workers. This gap was filled by women, who became the mainstay of the workforce. They were especially sought after in building aircraft, where they could fit in smaller spaces than most men, allowing for visual inspections and quicker construction times.

Perhaps the most iconic American bomber of World War II, the Flying Fortress was a four-engine heavy bomber aircraft developed in the 1930s for the United States Army Air Corps (USAAC). From its prewar inception, the USAAC touted the aircraft as a strategic weapon; it was a potent, high-flying, long-range bomber that was able to defend itself and return home despite extensive battle damage. It quickly took on mythic proportions, and widely circulated stories and photos of B-17s surviving battle damage increased its iconic status. With a service ceiling greater than any of its Allied contemporaries, the B-17 established itself as an effective weapons system, dropping more bombs than any other U.S. aircraft in World War II. Of the 1.5 million metric tons of bombs dropped on Germany and its occupied territories by U.S. aircraft, 640,000 tons were dropped from B-17s. The

Women workers installing the finishing touches in the fuselage of a Boeing B-17F "Flying Fortress" in October 1942.

Memphis Belle, a B-17F piloted by Captain Robert Morgan, gained lasting fame when she became the first U.S. bomber to complete 25 combat missions on May 13, 1943. A documentary film was made in 1944 starring the plane and crew, who went on a successful War Bond drive across the United States. The B-17s were flown by the United States and Britain in all theaters of the war.

The influx of women into the workforce marked a change in American society, as after the war many women retained their jobs (unlike after the First World War, when they were required to leave them). In addition to performing a vital role in supporting victory, they forever changed the face of American industry, as "Rosie the Riveter" became a fixture in many traditionally male vocations.

The Eighth Air Force was based in England and became the principal bombing command in Western Europe. (Private collection)

A woman machinist at work at Douglas Aircraft Company in Long Beach, California, 1942. The Douglas plant produced the B-17 "Flying Fortress," among other combat planes. (OWI)

B-17 BOMBER

Air warfare came into its own during World War II, and no country's military force could expect to win the ground battle without first controlling the skies above it. The U.S. air effort during the war was massive—of the 12 million total American forces (at their peak in 1945), 3.4 million served in the U.S. air arm. American airmen also paid a stiff price for victory: 88,000 air force personnel died, 52,000 of them in combat (representing 20 percent, or one in five, of America's 292,000 battle deaths). Another 20,000 U.S. airmen were wounded or captured.

Tactical air power—close support to ground troops—was a vital key to propelling Allied forces to victory. Yet the air arm's strategic bombing of enemy war industries and cities represented a truly massive effort to deprive German and Japanese forces of the materiel fueling their war machines. In Europe, U.S. bombers based in England (like the one in this photo by Margaret Bourke-White) and others flying from North African bases flew daylight bombing raids against targets in Germany and Axis-occupied countries. U.S. Army Air Forces commanding general Henry

"Hap" Arnold single-mindedly pursued strategic bombing as the path to eventual air force independence, and the American bombing effort sought to bring the German war effort to its knees by attacking key war industries. U.S. bomber targets included submarine bases, aircraft factories, ball bearing factories, oil production and storage plants, synthetic rubber factories, and military vehicle factories and stores.

Bombing accuracy, however, remained problematic throughout the war, and "pinpoint" accuracy proved beyond the capability of the era's air war technology. The difficulty in attempting precision aerial bombing was the abysmal lack of accuracy; even in daylight raids, pinpoint bombing from 20,000 feet or higher deposited only half the bombs within a quarter mile of the aiming point. Under the poor visibility conditions so often encountered in northern Europe, bombs aimed at a three-mile-radius target resulted in half the bombload merely plowing up surrounding farmland.

Despite the dubious accuracy of attacks on enemy industry, the Allied (U.S. and British) bombing campaign against Germany and the American strategic bombing of Japan helped batter the Axis powers into final submission.

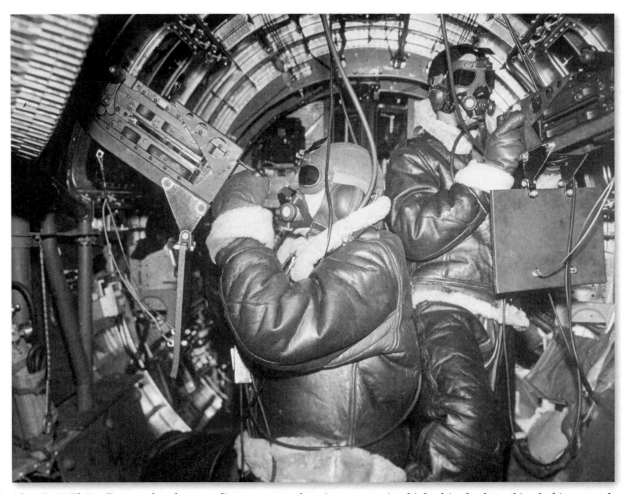

Inside a B-17 Flying Fortress bomber, a radio operator and engineer—wearing high-altitude sheepskin clothing, goggles, and oxygen masks—man .50-caliber waist guns during a bombing raid. Photographer: Margaret Bourke-White.

GENERAL BERNARD MONTGOMERY ("MONTY")

Field Marshal Bernard Law Montgomery, First Viscount Montgomery of Alamein, was nicknamed "Monty." Known for his methodical methods of warfare and acrimonious relationship with his American allies, he commanded the British desert forces. This command included the Battle of El Alamein, a major turning point in the war.

In this official British photograph, Monty watches his tanks advance during the fighting at the Second Battle of El Alamein, the first decisive Allied land victory of the war. Montgomery proved amazingly prescient, predicting both the length of the battle and the number of casualties. However, soon after his forces broke the German and Italian lines and were pursuing the enemy along the coast road, a violent storm burst over the region, bogging down British tanks and support trucks in the desert mud. Standing before his officers at headquarters, close to tears, Monty called off the pursuit; nevertheless, the Battle of El Alamein had been a great success, finally defeating Rommel's seemly invincible Afrika Korps.

In the months that followed, Montgomery continued a relentless campaign, forcing Rommel out of a series of defensive positions and keeping the initiative by applying superior strength when it suited him.

During his African campaign, Monty raised morale and virtually eliminated sickness and absenteeism in the Eighth Army. He also introduced other improvements that produced victories: he improved cooperation among military branches, including the air forces; he established superior logistical support; and he insisted on clarity in the issuing of orders.

For his role in North Africa, Montgomery was knighted and promoted to full general. He subsequently commanded Eighth Army in Sicily and Italy before being given responsibility for planning the D-Day invasion in Normandy. He was in command of all Allied ground forces during Operation Overlord, from the initial landings until after the Battle of Normandy. He then continued in command of the 21st Army Group for the rest of the campaign in northwest Europe.

On May 4, 1945, he accepted the German surrender at Luneburg Heath in northern Germany. After the war he became commander in chief of the British Army of the Rhine in Germany and then chief of the Imperial General Staff.

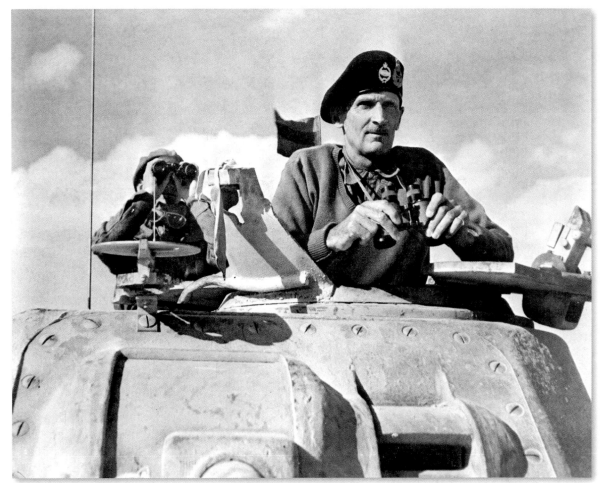

General Bernard L. Montgomery watches his tanks move up in North Africa, November 1942. British official photograph.

LIEUTENANT COLONEL LYLE BERNARD

Brolo, Sicily, on the road to Patton's prize: Messina. Lieutenant Colonel Lyle W. Bernard's 650-man task force, made up from men of the Second Battalion of the 30th Infantry, Third Division, Second Corps, U.S. Army, had just returned from a landing that was executed in the early hours of August 11, 1943, as another leapfrog operation down the coast road behind German lines. This was the second amphibious landing that Task Force Bernard accomplished in three days. The first of the "end runs" by Bernard's task force was at Sant' Agata Di Militello on August 8, which landed the force seven miles behind enemy lines, forcing a German withdrawal. The second, which targeted Monte Cipolla, outside of Brolo, was a daring 15 miles behind the Germans. These raids were conceived and ordered by General Patton as he pushed his subordinates to beat the British Eighth Army in a race to liberate the town of Messina in the northwest tip of the island.

During the landing at Brolo, Bernard's task force landed unopposed but then encountered the German 29th Panzer Grenadier Division and was nearly consumed, losing all five tanks and the guns of two batteries of artillery at a cost of 99 men killed and 78 wounded. Nearly out of ammunition, Bernard had just issued an order to disperse his command into small groups when they were rescued by elements of the Third Division, which were desperately trying to reach them.

Leaning over the back of one of his favored Dodge WC-56 command cars in this image to receive a briefing from Bernard, Patton talks with the 33-year-old lieutenant colonel fresh after the action that would see the task force awarded a Presidential Unit Citation and Bernard a Silver Star. Bernard told his men right before landing to "take this objective, and we'll be in Messina in a week." This Signal Corps photograph (number 246532) was probably taken on Highway 113 in Brolo, by men of the 163rd Signal Company (photographic).

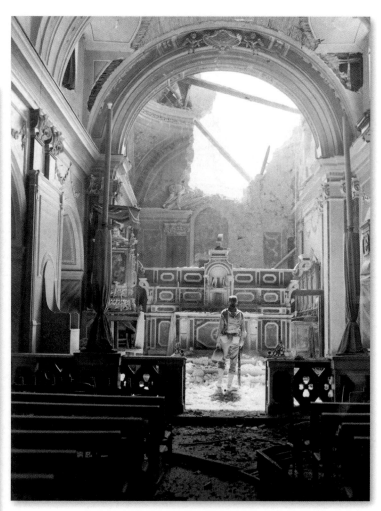

Moving up through Prato, Italy, men of the 370th Infantry Regiment have yet to climb the mountain that lies ahead. (NARA)

Private Paul Oglesby, 30th Infantry, standing in reverence before an altar in a damaged Catholic church. Note that the pews at the left are undamaged, while the bomb-shattered roof is strewn about the sanctuary. (NARA)

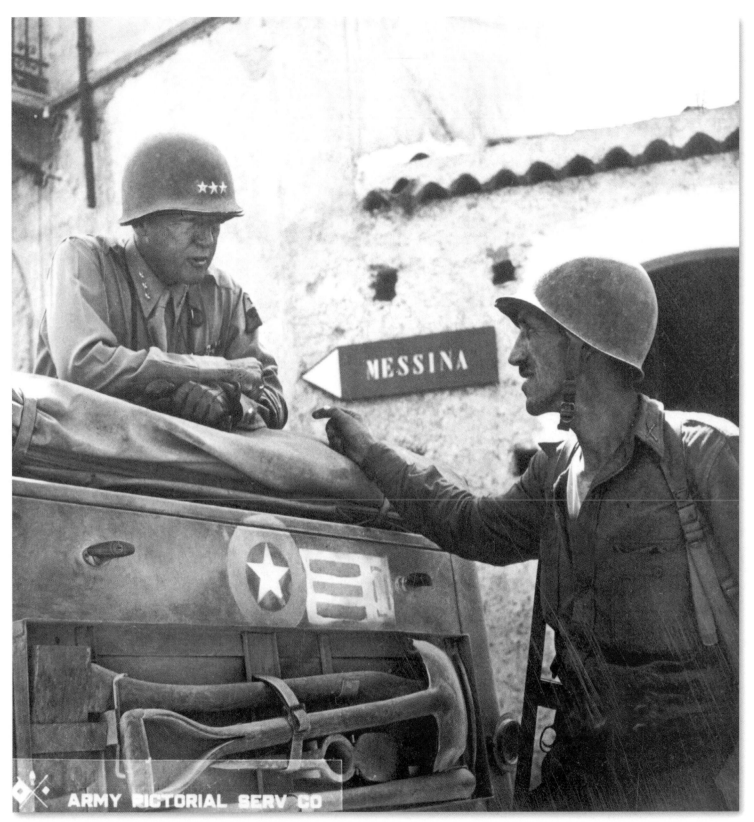

Lieutenant Colonel Lyle Bernard, commander of the 30th Infantry Regiment and a prominent figure in the second daring amphibious landing behind enemy lines on Sicily's north coast, discusses military strategy with Lieutenant General George S. Patton Jr., near Brolo, 1943. (Army)

LANDING AT NORMANDY

Giving the home-front American public the soldier's-eye view of the D-Day invasion—swiftly sent back to the States to be widely distributed—was U.S. Coast Guard Chief Photographer's Mate Robert F. Sargent's stunning war photo. It has been frequently reproduced in books and articles about the war—one recent edition of Homer's classic *The Iliad* even used it as its cover image to capture the timelessness of the subject of brave men assaulting a foreign shore. For its unique perspective showing American troops as they enter fierce combat, Sargent's iconic photo has been nicknamed "Into the Jaws of Death," borrowing a famous line from Alfred Tennyson's 1854 poem "The Charge of the Light Brigade." The event—D-Day—is momentous. The scene is strikingly dramatic. The danger the soldiers face is real and palpable. Viewing it evokes a compelling, chillingly realistic "you are there" feeling.

Sargent's photo dramatically reveals what landing on the Normandy beaches was truly like for American soldiers who first set foot in Nazi-occupied France: after the landing craft grounded in shallow water, the soldiers exited the boats into the chilling waters; carrying heavy packs and weapons, they slogged through waist-deep water as enemy bullets splashed the water surrounding them; ahead was a wide expanse of fire-swept beach with no pos-

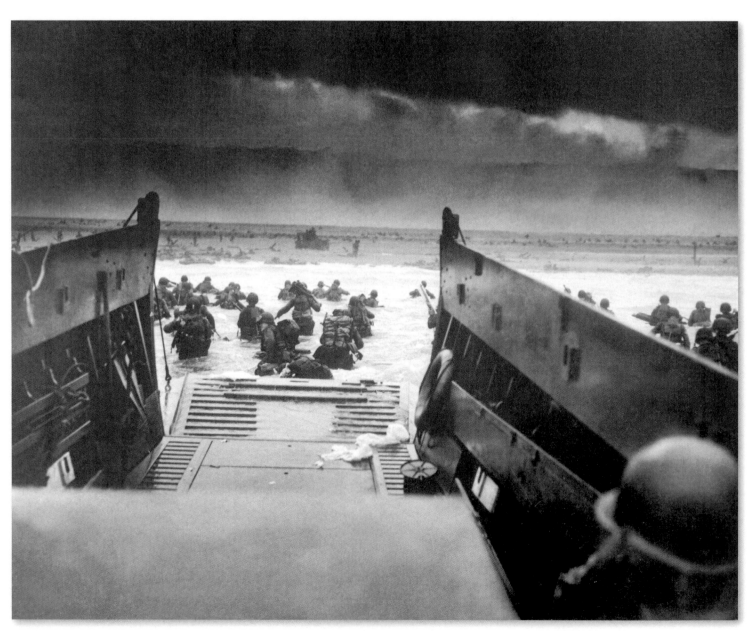

Landing at Normandy under heavy enemy fire are these American soldiers, shown as they leave the ramp of a Coast Guard landing boat. June 6, 1944. Photographer: Chief Photographer's Mate Robert F. Sargent. (Coast Guard)

sible cover from German bullets and shells; dangerously exposed, any shelter from the galling fire was hundreds of yards away. The lucky ones reached the base of the bluffs beyond the beach. The unlucky ones' bodies floated in the tide or littered the beachhead.

Often unfairly ignored in accounts of American forces in World War II combat, the U.S. Coast Guard played a vital role in winning the final Allied victory. About 240,000 U.S. Coast Guardsmen served in World War II in all theaters of the war,

principally manning the thousands of amphibious invasion landing craft and crewing antisubmarine patrol planes and warships. Nearly 2,000 Coast Guardsmen died during the war—574 were killed in action, many falling to German and Japanese bullets and shellfire while they manned landing craft putting U.S. assault troops ashore on heavily defended invasion beaches amid a blizzard of enemy fire. Their courage and sacrifice ought to be remembered.

Members of an American landing party lend helping hands to others whose landing craft was sunk by enemy action off the coast of France. These survivors reached Utah Beach using a life raft. June 6, 1944. (NARA)

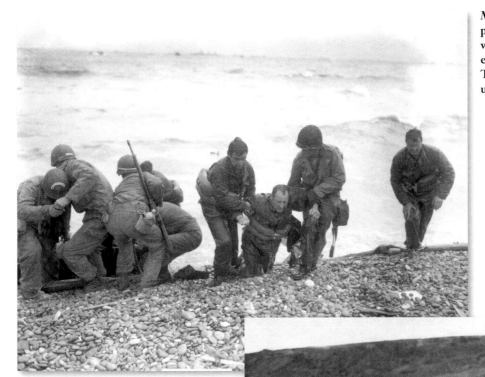

Crossed rifles in the sand are a comrade's tribute to this American soldier, who came ashore and died at the barricades of Western Europe. (NARA)

WOUNDED SOLDIERS AT OMAHA BEACH

As the June 6, 1944, D-Day assault on Omaha Beach continued under heavy fire, casualties mounted alarmingly—by the end of the day, 3,000 American troops of First and 29th Infantry Divisions would be killed, wounded, or declared missing in action. At one point during that terrible day, U.S. First Army commander General Omar N. Bradley, observing the assault from a warship off shore, seriously considered abandoning the Omaha assault and evacuating his surviving troops from the beach.

Yet the courageous efforts and costly sacrifice of American soldiers and their leaders at every level finally succeeded in overcoming German defenses and capturing a foothold atop the high bluffs overlooking Omaha Beach. Notable was the inspirational leadership of Brigadier General Norman D. "Dutch" Cota, assistant division commander of the 29th Infantry Division. At a critical point, Cota rallied troops huddling from the galling enemy fire in the lee of the bluffs by shouting, "Gentlemen, we are being killed on the beaches. Let us go inland and be killed!" The soldiers surrounding Cota, and more who rallied around other leaders along Omaha Beach, responded, finally fighting their way up the bluffs.

Wounded soldiers like the ones shown in this photo sought shelter from the heavy enemy fire in the welcome cover they found at the base of Omaha Beach's bluffs; the exposed beach area itself was a death zone where no one could survive for long. Army doctors, nurses, and medical corpsmen, often working under fire themselves, treated the wounded as best they could and prepared the casualties for evacuation to hospital ships waiting off shore. *Life* magazine described the effort in its June 19, 1944, issue: "The wounded have received magnificent care. The evacu-

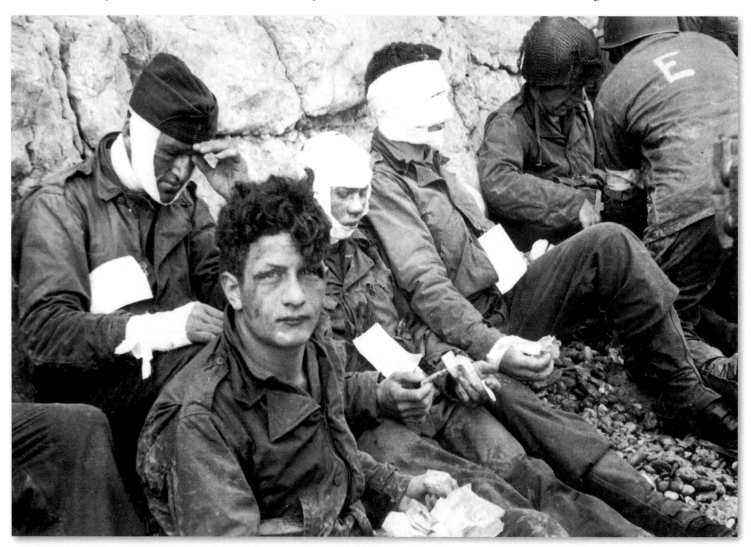

American assault troops of the 16th Infantry Regiment, injured while storming Omaha Beach, wait for evacuation for further medical treatment. Collville-sur-Mer, Normandy, France, June 6, 1944. (Army)

ation chain . . . appeared to be working smoothly. . . . Some of the wounded . . . walked off the ships with their uniforms torn and their bandages hastily applied, but swiftly and safely carried out of the battle zone. Others came on stretchers, their personal belongings piled beside them. Some carried their boots, with French sand still clinging to the soles, on their litters. Many spoke of fine work done by medical men on the beaches. Said one man: 'They're right in there, giving morphine and bandaging wounds while the bullets whiz past their ears.'"

The beachhead is secure, but the price was high. A monument to a dead American soldier somewhere on the shell-blasted shore of Normandy. (NARA)

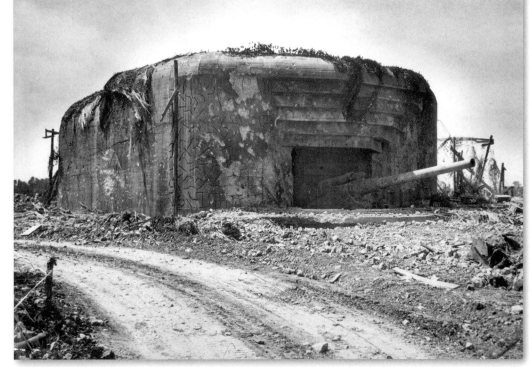

A Nazi gun battery silenced in France. This German gun emplacement has concrete walls 13 feet thick and four guns. The bunker was bombed and destroyed by Allied flyers. (NARA)

HOWITZER

The World War II U.S. Army was chiefly defined by two significant advantages that its Axis enemies were never able to match: amazing mobility and overwhelming firepower. When General Leslie J. McNair created the American army that would fight World War II, he incorporated two key innovations: he eliminated all horse-drawn transport, essentially "fully motorizing" the U.S. Army; and he made provisions to lavishly support all U.S. tactical maneuver units with huge numbers of artillery guns. With American factories spewing forth a constant stream of war materiel, U.S. forces had the vehicles and

artillery guns to achieve—even exceed—McNair's visionary requirements for an American army fighting a global war.

The U.S. Army's amazing mobility was most apparent in the campaigns in Europe against Germany. Despite inventing "blitzkrieg," the World War II German army remained a largely horse-drawn, foot-bound force throughout the war: millions of horses in German service pulled the army's supply wagons and transported its artillery guns, while most German infantrymen walked. The American army's incredible mobility came as a stunning shock to the Germans, who could only look on with envy. In only one telling example, German observers watched in amazement shortly after the July 1944 Normandy breakout as 15,000 Ameri-

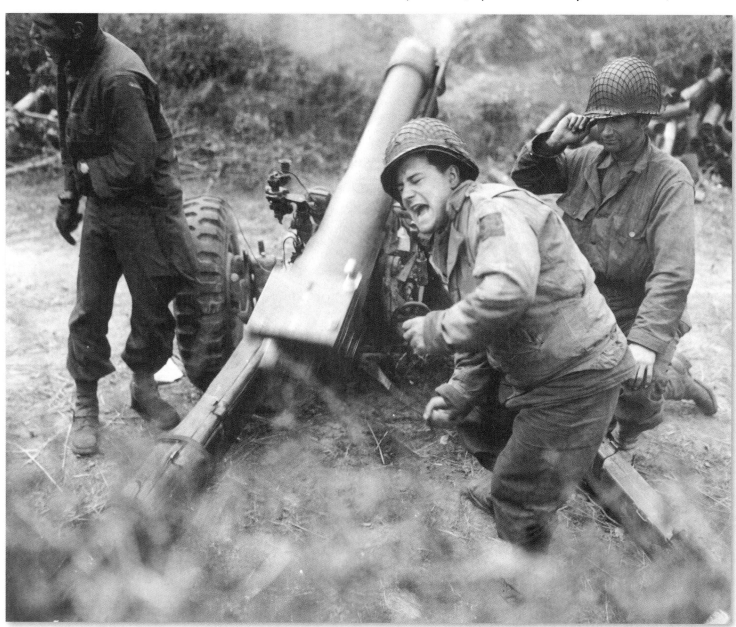

An American M3 105 mm howitzer shells German forces retreating near Carentan, France. July 11, 1944. (Army)

can vehicles passed through a road junction during one 24-hour period. No other army in the world was capable of accomplishing such feats of awe-inspiring mobility.

German as well as Japanese opponents were no less in awe of the U.S. Army's overwhelming amount of fire support, particularly American artillery. Provided in massive numbers and in various calibers (75 mm up to huge 240 mm guns), U.S. artillery dominated the war's battlefields and was freely employed by American maneuver commanders. U.S. corps commander General J. Lawton Collins recalled that in one 1944 instance he massed the fires of 23 artillery battalions—a total of 300 to 400 artillery guns of 105 mm and 155 mm—against a single enemy target. Rugged, reliable, highly accurate, and firing a seemingly inexhaustible supply of ammunition, American artillery clearly proved a "war winner."

The artillery gun in this photo is an M3 105 mm howitzer, a short-barreled, lighter version of the ubiquitous M2 howitzer used in airborne units and infantry regiment cannon companies.

Lined up in front of a wrecked German tank and displaying a captured Nazi flag, infantrymen stop for a picture while "mopping up" in Chambois, France, near the Falaise Gap, August 20, 1944. (NARA)

This dead German soldier was one of the last defenders of German-held Cherbourg. Captain Earl Topley, who led one of the first outfits into the city, blamed him for the deaths of three of his men. June 27, 1944. (NARA)

BATTLE OF THE BULGE

The offensive known as the Battle of the Bulge targeted the densely forested Ardennes mountain region of Belgium. Code-named by the German General Staff *Unternehmen Wacht am Rhein*, the objective for the operation was to take back initiative on the western front by driving through the seam between British and American forces, splitting them apart, capturing Antwerp, and then encircling and destroying four Allied armies.

Hitler hoped this lightning victory would force the western Allies to negotiate a peace treaty to end combat operations on this front. Once accomplished, German forces could then fully concentrate on the eastern theater of war.

To ensure success, the offensive was planned in the utmost secrecy, with minimal radio traffic and movements of troops and equipment under cover of darkness. Although Ultra intercepts suggested a possible attack and the Third U.S. Army's intelligence staff predicted a major German offensive, the Allied leaders were caught by surprise. This oversight occurred through a combination of Allied overconfidence, preoccupation with upcoming offensive plans, and poor aerial reconnaissance.

Near-complete surprise against a weakly defended section of the Allied line, which was occupied by newly assigned troops with no combat experience and worn-out divisions recuperating from battle, was achieved during heavily overcast weather that grounded the Allies' overwhelmingly superior air forces.

Fierce resistance, particularly around the key towns of St. Vith and Bastogne, and terrain favoring the defenders threw the German timetable behind schedule. Allied reinforcements, including General George S. Patton's Third Army, and improving weather conditions finally permitted air attacks on German forces and supply lines, dooming the offensive.

In the wake of the defeat, many experienced German units were left severely depleted of men and equipment as survivors retreated to the defenses of the Siegfried Line. For the Americans, with about 610,000 men committed and some 89,000 casualties, including 19,000 killed, the Battle of the Bulge was the largest and bloodiest battle of World War II.

The Allies pressed their advantage following the battle. By the beginning of February 1945, the lines were roughly stabilized to their December 1944 positions. Later in the month, the Allies launched an attack all along the Western front, pushing the shattered Wehrmacht back to the defenses along the German border.

Waffen SS winter white to spring pattern camouflage reversible parka with hood. (Military and Historical Image Bank)

A lanky GI, with hands clasped behind his head, leads a file of American prisoners along a road somewhere on the Western Front. Germans captured these soldiers during the surprise attack drive into Allied positions. (NARA)

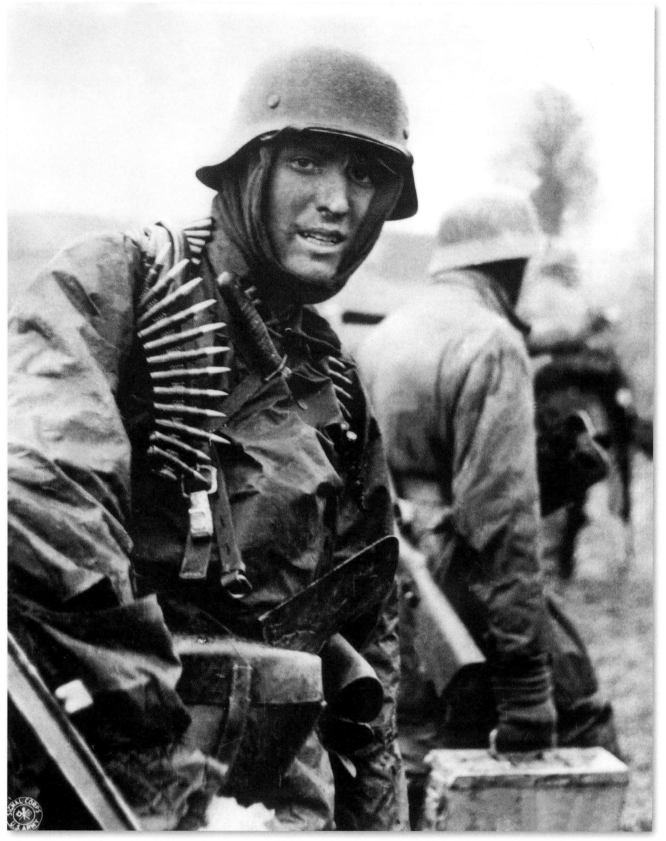

This German soldier, photographed at the opening of the Ardennes offensive, was part of the Wehrmacht assault that thunderstruck Allied forces in December 1944.

SNOW IN THE ARDENNES

The Ardennes Campaign is remembered by one aspect above all others—the weather. The historically cold winter of 1944–1945 wreaked havoc on the combatants and made mere survival difficult. January 1945 was the coldest on record, resulting in more than 15,000 Allied casualties from frostbite and other cold-weather injuries.

A military axiom states that the effects of weather on the battlefield are divided equally between the combatants—a truism apparently lost on German planners. The Germans based the start date of the Ardennes offensive on the prediction of poor flying weather. This type of weather crippled superior Allied airpower during the initial assaults on the American lines since it veiled the attacker with fog and mist, facilitating early German successes. The high-pressure system that came in on December 18 worked momentarily against the Germans when a thaw slowed attacking German tanks. By December 20 and 21, the higher ground began to freeze in patches, leaving stretches of the Ardennes roads slippery and muddy. On December 22, competing weather systems brought in a hodgepodge of snow, blizzards, fog, and rain. In the north the Sixth Panzer Army was bogged down in rain and mud, while in the south the Fifth Panzer Army was hampered in its swing around Bastogne by fog

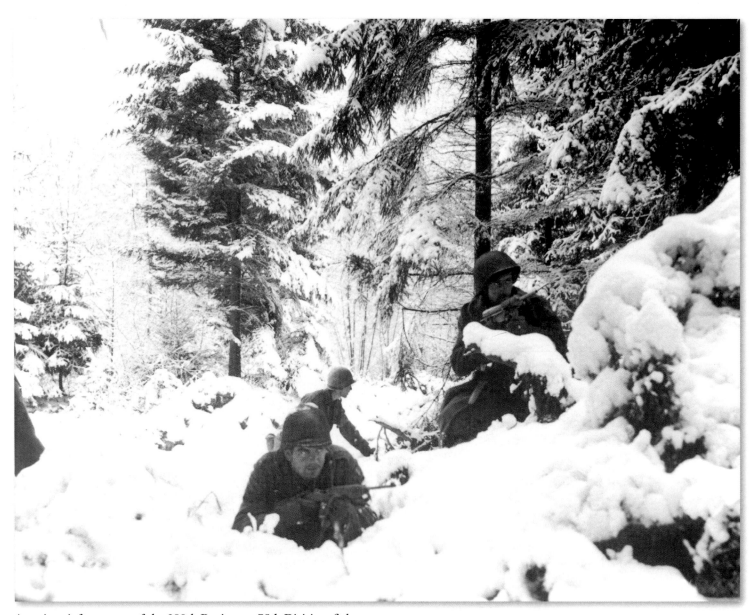

American infantrymen of the 290th Regiment, 75th Division, fight in fresh snowfall near the Ardennes, Belgium. January 4, 1945.

and snow, and all along the German supply routes snow fell continuously.

On December 23 there was another dramatic change brought on by cold, dry winds from the east. These winds stripped the German armies of their immunity to air attack but caused problems with drifting snow for both armies, further exasperating supply truck movement.

For the next five days the weather favored the Americans, in the air and on the ground. Superior numerically in tanks, the Americans benefited more than the Germans from the sure footing the big freeze provided for armor. Then, on December 28, clouds and overcast conditions followed, and a day later, arctic air brought heavy snows, blizzards, and greatly reduced visibility at ground level. Vehicle movement was slow, riflemen exhausted themselves wading through the drifts, and the wounded died if left in the snow. This was the state of the weather on January 3, the day the Allies began their final counterattack.

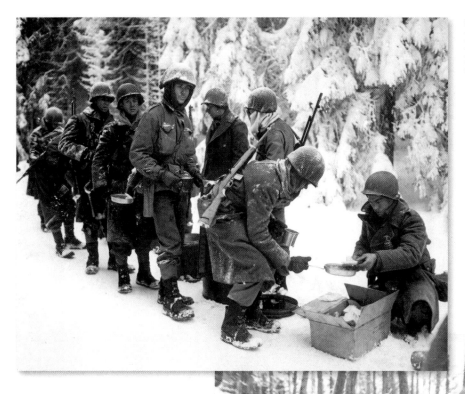

Chow is served to American Infantrymen of the 347th Infantry Regiment on their way to La Roche, Belgium, January 13, 1945. (NARA)

After holding a woodland position all night near Wiltz, Luxembourg, against German counterattack, three men of B Company, 101st Engineers, emerge for a rest, January 14, 1945. (NARA)

BODY OF PRIVATE HENRY TANNENBAUM

Tony Vaccaro fought as a private in the U.S. 83rd Infantry Division in France and Germany. His duties as a scout left him enough free time to shoot photos. By the end of the war in Europe, Vaccaro had become an official photographer for the division's newspaper. After he was discharged from the army, Vaccaro stayed in Germany, where he got a job first as a photographer for the U.S. authorities stationed at Frankfurt and then with *Weekend,* the Sunday supplement of the U.S. Army newspaper *Stars and Stripes.* Vaccaro photographed throughout Germany and Europe, documenting postwar life. After his return to the United States in 1949, he worked for *Life* and *Look* before joining the magazine *Flair.*

Vaccaro snapped this poignant photograph after an SS ambush near Ottré, Belgium—one of the horrifying tragedies of the war.

On January 11, 1945, as the 331st Infantry Regiment was driving toward the town of Langlire, Belgium, two assault squads of Company F made a dawn attack into a thickly forested area outside the town. They had gone 100 yards when they were pinned down by heavy machine gun cross fire. The slope they were moving up was raked with fire continuously for several minutes. When the fire lifted, many of the men were dead, most of the others wounded.

Vaccaro arrived at the scene shortly after the fighting died down and noticed an American soldier dead in the snow. He was struck by the peaceful beauty of the untouched snow juxtaposed with the brutality of war. Later, he penned his thoughts:

I cannot bear to look upon him in this lonely place
That turns men's hearts to hate as bitter as this cold
And do such deeds as were done here in their disgrace.

So bring spring's warm caress to melt away this snowy
 shroud,
And lift up on sunshine beams
To a kinder rest than this, somewhere beyond these
 clouds

Carry him away from this mortal place
To what nearby star where brothers wait
To wrap him in their sweet embrace.

Its soft light shines down and sparkles in the snow
To bring God's gentle peace at last to Bihain's field
Where the evergreen trees grow.

Tony Vaccaro's photograph of the body of Private Henry I. Tannenbaum lying in the snow is one of the most poignant photographs of WWII.

SOLDIER AT OMAHA BEACH

The Allied amphibious assault troops of the D-Day invasion simultaneously landed at five beaches along the Normandy coast, designated Utah, Omaha, Gold, Juno, and Sword. The fiercest struggle to get invasion troops ashore—and keep them there—occurred on Omaha Beach, assigned to U.S. First and 29th Infantry Divisions. Defended by about 8,000 German soldiers supported by artillery, antitank guns, and rocket launchers, Omaha Beach defenses featured artillery bunkers, pillboxes, and trenches running along the bluffs just beyond the beach. American soldiers assaulting "Bloody Omaha" confronted a blizzard of fire from enemy small arms, machine guns, and shells.

Life magazine photographer Robert Capa went ashore on Omaha Beach, accompanying the second wave of soldiers in the First Infantry Division's lead assault unit, the 16th Infantry Regiment. His photographs of the assault were published in the June 19, 1944, issue of *Life* under the headline "Beachheads of Normandy: The Fateful Battle For Europe is Joined by Sea and Air." In the accompanying article, *Life* editors explained: "*Life* photographer Robert Capa . . . went in with the first [*sic*] wave of troops. Although the first reports of landings indicated little opposition, his pictures show how violent the battle was and how strong the German defenses. His best pictures were made when he photographed the floundering American doughboys advancing through the deadly hail of enemy fire to goals on the beaches of Normandy."

Unfortunately, only 11 of the 106 historic photographs Capa took of the combat assault on D-Day's most critical invasion beach survived, due to a catastrophic developing accident when Capa's photos were processed in *Life*'s London laboratory. Most of the surviving "Magnificent 11" came out looking blurred and out of focus, causing *Life* to mistakenly explain in the article: "Immense excitement of moment made photographer Capa move his camera and blur picture." Capa, a seasoned war photographer who had likely experienced more combat than most of the soldiers he accompanied to Omaha Beach, was understandably incensed at *Life*'s claim that "excitement of the moment" made him move his camera.

After taking his photos, Capa found that getting safely off of Omaha Beach was as dangerous as assaulting it. *Life* wrote: "As Capa's LCT pulled away from the beach, it was hit three times by shells from German shore batteries."

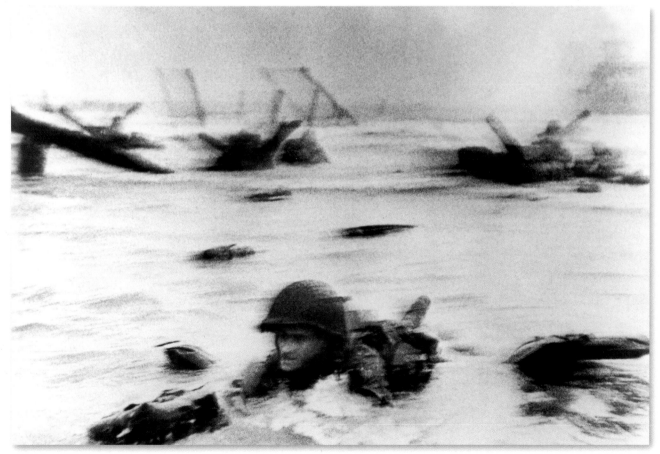

Crawling through the water, a U.S. soldier edges toward the beach. Germans pour machine gun and shell fire down on the beach. Photographer: Robert Capa. Published in *Life* magazine, June 19, 1944.

MEETING OF SOVIET AND AMERICAN ARMIES, TORGAU

Germany's location in central Europe left the country vulnerable to a two-front war. It was the nightmare of every officer on the German General Staff. That dreaded scenario played out with the Allied landings in France in 1944. However, allowing forces from the eastern and western fronts to link up would end any hope for a negotiated peace and be an unsurvivable setback for the German Wehrmacht.

When the day arrived, it was known as Elbe Day, April 25, 1945. Soviet and American troops met at the River Elbe, near Torgau, Germany. It was a milestone day, marking progress toward the end of war in Europe.

The first contact was made between patrols near Strehla, when First Lieutenant Albert Kotzebue, Company G, 273rd Infantry Regiment, U.S. 69th Division, crossed the River Elbe in a boat with three men of an intelligence and reconnaissance platoon. On the east bank, they met forward elements of the Soviet First Ukrainian Front under the command of Lieutenant Colonel Alexander Gardiev, 175th Rifle Regiment of the 58th Guards Division, 34th Corps.

The same day, another patrol under Second Lieutenant William Robertson, S-2, First Battalion, 273rd Infantry Regiment, accompanied by Frank Huff, James McDonnell, and Paul Staub, met Soviet Lieutenant Alexander Silvashko, 58th Soviet Guards Division, with some soldiers on the destroyed Elbe bridge of Torgau.

On April 26, the commanders of the U.S. 69th Infantry Division of the U.S. First Army and the 58th Guards Rifle Division of the Soviet Fifth Guards Army met at Torgau, southwest of Berlin.

Second Lieutenant William Robertson and Lieutenant Alexander Silvashko, Red Army, shown in front of an "East meets West" sign, symbolizing the historic meeting of Soviet and American armies near Torgau, Germany. April 25, 1945.

Arrangements were made for a series of formal photographs to be staged the following day, including the one pictured here, shot by U.S. Army Signal Corps photographer Private First Class William E. Poulson and entitled "Handshake at Torgau."

Statements were released simultaneously in London, Moscow, and Washington that evening, reaffirming the determination of the three Allied powers to complete the destruction of the Third Reich. For the Wehrmacht, the nightmare had become reality—Adolf Hitler committed suicide in his Berlin bunker four days later, ending the Nazi's "thousand year" Reich.

Marshal Zhukov decorates Field Marshal Montgomery with the Soviet Order of Victory. Other Allied chiefs who attended the ceremony at General Eisenhower's headquarters at Frankfurt are about to drink a toast. June 10, 1945. (NARA)

General Eisenhower, accompanied by Generals Bradley and Patton, inspects art treasures stolen by Germans and hidden in a salt mine in Germany, April 12, 1945. (NARA)

PRISONERS AT BUCHENWALD CONCENTRATION CAMP

Buchenwald concentration camp was established near Weimar, Germany, in July 1937. It was one of the first and the largest of the concentration camps on German soil. Camp prisoners came from all over Europe and Russia, including Jews, religious and political prisoners, Freemasons, criminals, homosexuals, and prisoners of war. Camp inmates worked primarily as forced labor in local armaments factories.

Although Buchenwald was technically not an extermination camp, it was the site of an extraordinary number of deaths. One of the primary causes of death was illness due to harsh camp conditions, with starvation prevalent. Malnourished and suffering from disease, many people literally were worked to death under the Nazi policy of extermination through labor. Additionally, many inmates died as a result of human experimentation or fell victim to arbitrary acts perpetrated by the SS guards. Other prisoners were simply murdered, primarily by shooting and hanging.

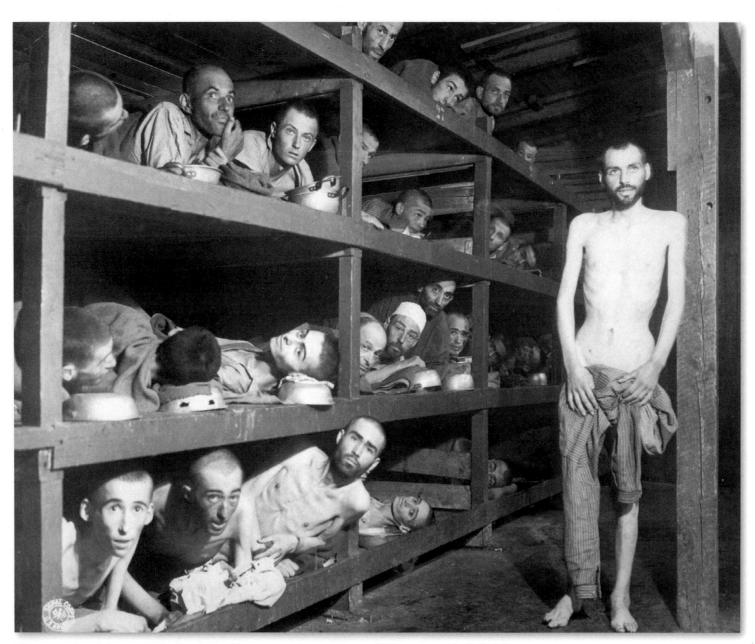

These are slave laborers in the Buchenwald concentration camp near Weimar; many had died from malnutrition by the time U.S. troops of the 80th Division entered the camp. Germany, April 16, 1945.

On April 4, 1945, the U.S. 89th Infantry Division overran a subcamp of Buchenwald. This was the first Nazi camp liberated by U.S. troops. In anticipation of the arrival of American troops at the main camp, Buchenwald was partially evacuated on April 8. A detachment of troops belonging to the U.S. Ninth Armored Infantry Battalion, U.S. Sixth Armored Division, arrived at Buchenwald on April 11 under the leadership of Captain Frederic Keffer. The soldiers were given a hero's welcome, with the emaciated survivors finding the strength to toss some liberators into the air in celebration. Later in the day, elements of the U.S. 83rd Infantry Division overran one of a number of smaller camps comprising the Buchenwald complex.

Third Army Headquarters sent elements of the U.S. 80th Infantry Division to take control of the camp on the morning of April 12. Several journalists arrived that same day, including Edward R. Murrow, whose famous radio report was broadcast on CBS:

I asked to see one of the barracks. It happened to be occupied by Czechoslovaks. When I entered, men crowded around, tried to lift me to their shoulders. They were too weak. Many of them could not get out of bed. I was told that this building had once stabled 80 horses. There were 1,200 men in it, five to a bunk. The stink was beyond all description.

They called the doctor. We inspected his records. There were only names in the little black book, nothing more. Nothing about who these men were, what they had done, or hoped. Behind the names of those who had died, there was a cross. I counted them. They totaled 242. 242 out of 1,200, in one month.

As we walked out into the courtyard, a man fell dead. Two others, they must have been over 60, were crawling toward the latrine. I saw it, but will not describe it.

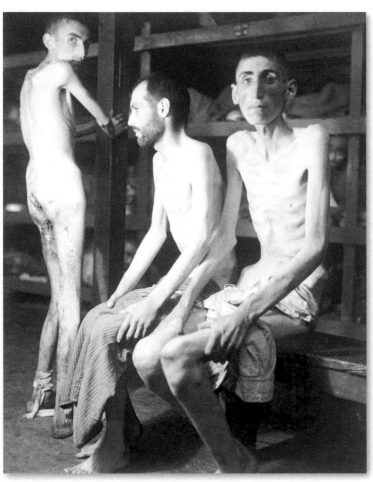

These Russian, Polish, and Dutch slave laborers interned at the Buchenwald concentration camp averaged 160 pounds each prior to entering camp 11 months before. Their average weight was 70 pounds at liberation. April 16, 1945. (NARA)

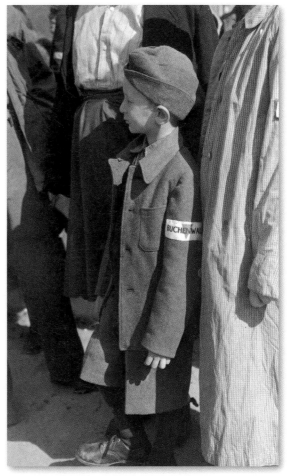

A six-year-old war orphan with a Buchenwald badge on his sleeve waits for his name to be called at roll call at Buchenwald camp, Germany, for departure for Switzerland. June 19, 1945. (NARA)

BODIES AT GUSEN CONCENTRATION CAMP

Mauthausen-Gusen concentration camp grew to become a large group of Nazi concentration camps built around the villages of Mauthausen and Gusen in upper Austria. Initially a single camp, it expanded over time and by 1940, Mauthausen-Gusen had become one of the largest labor camp complexes in German-controlled Europe. Apart from the four main subcamps at Mauthausen and nearby Gusen, more than 50 subcamps, located throughout Austria and southern Germany, used their inmates as slave labor. Several subordinate camps of the complex included quarries, munitions factories, mines, arms factories, and ME-262 fighter plane assembly plants.

Conditions at Mauthausen-Gusen were notably harsh and severe even by the standards of the "extermination through labor" camps. Prisoners there were subjected to malnutrition, overcrowded living conditions, and physical abuse from the guards. Moreover, extraordinarily severe hard labor was forced upon the inmates, most infamously at the rock quarry. There, prisoners were forced to carry huge blocks of stone—some outweighing the prisoners themselves—up a 186-step staircase that came to be known as the "Stairs of Death." If a prisoner broke down on this brutal journey, as was not uncommon, he might easily collapse upon the man behind him, causing a horrible chain reaction.

On May 3, the SS and other guards started to prepare for evacuation of the camp. The following day, the guards were replaced with unarmed *Volkssturm* soldiers and an improvised unit formed of elderly police officers and fire fighters evacuated from Vienna.

On May 5, 1945, the camp was approached by a squad of U.S. Army soldiers of the 41st Reconnaissance Squadron, U.S. 11th Armored Division. By May 6, all the remaining subcamps of the complex, with the exception of the two camps in the Loibl Pass, were also liberated by American forces.

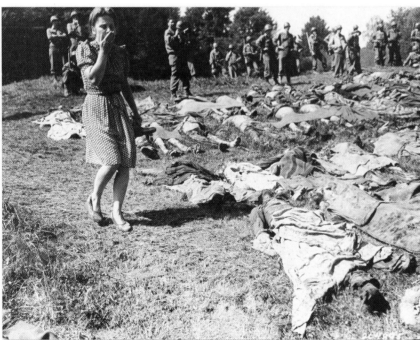

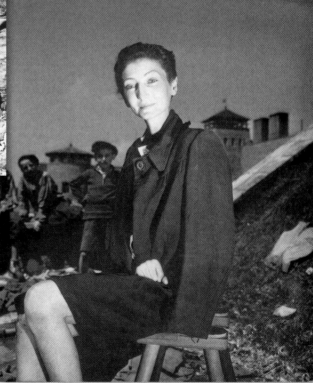

A German girl is overcome as she walks past the exhumed bodies of some of the 800 slave workers murdered by SS guards near Namering, Germany, and laid out so that townspeople might view the work of their Nazi leaders, May 17, 1945. (NARA)

Nador Livia in pre-Nazi days was a beautiful, talented, and famous actress on the Budapest stage. She was taken prisoner and was eventually transported to Gusen, where she is pictured, because of her Jewish heritage. May 12, 1945. (NARA)

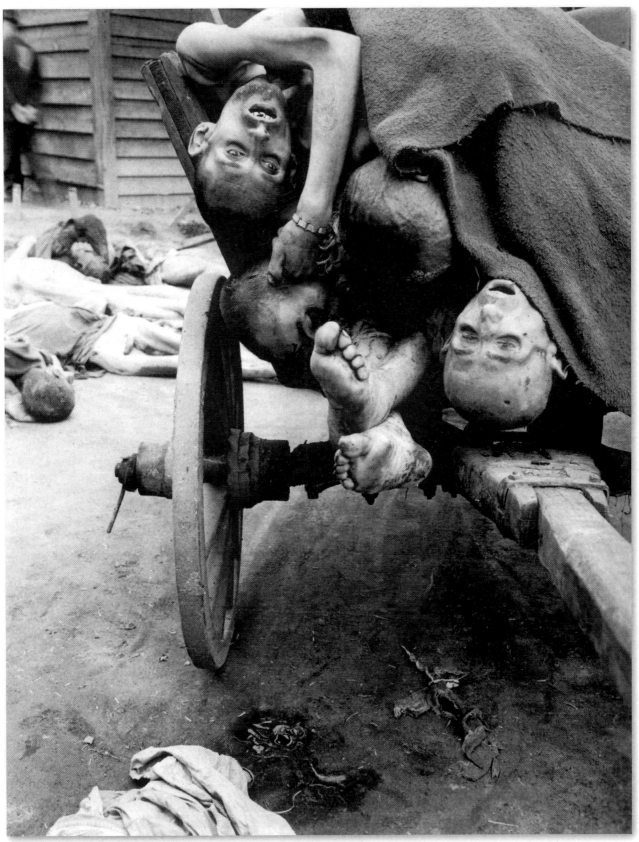

Bodies being removed by German civilians for burial at Gusen concentration camp, near Linz, Austria. Prisoners were forced to work in nearby stone quarries until they were too weak to do so, and then were killed. May 12, 1945.

JAPANESE VICTORY AT BATAAN

On the night of March 12, 1942, General Douglas Mac-Arthur, his family, and several staff officers left Corregidor for Mindanao aboard four PT boats. MacArthur was eventually flown to Australia where he broadcast to the Filipino people his famous "I shall return" promise. MacArthur's departure placed then Lieutenant General Jonathan Mayhew Wainwright IV in command.

After the failure of their first attack against Bataan, the Japanese General Headquarters sent strong artillery forces to the Philippines in order to smash the American fortifications. The Japanese High Command reinforced the Imperial Army, and toward the end of March, the Japanese forces prepared for the final assault.

On April 3, the entire Orion-Bagac line was subjected to incessant bombings that turned the Americans' Mount Samat stronghold into an inferno. Over the course of the next three days (Good Friday to Easter Sunday, 1942), the Japanese furiously attacked the American lines. Everywhere along the line, the American and Filipino defenders were driven back by Japanese tanks and infantry.

Based on his two prior attempts, Japanese Lieutenant General Masaharu Homma estimated that the final offensive would require a week to breach the Orion-Bagac line and a month to liquidate the two final defense lines he believed were on Bataan. When the opening attack required just three days, he pushed his forces harder. The Japanese launched a drive into the center, penetrating the defense and turning the flanks. The attack captured Mount Samat and outflanked all of the remaining American positions. Counterattacks by the U.S. Army and Philippine Scout regulars held in reserve were largely futile.

All along the battlefront, units crumbled and straggled to the rear. The commanders on Bataan quickly lost contact with their units. Over the next two days, the entire Allied defense progressively disintegrated and collapsed, clogging all roads with refugees and fleeing troops. By April 8, the senior U.S. commander on Bataan, Major General Edward P. King, saw the futility of further resistance and put forth proposals for capitulation.

The next morning King met with Major General Kameichiro Nagano. After several hours of negotiations, the remaining weary, starving, and emaciated American and Filipino defenders on the battle-swept Bataan peninsula surrendered, hastening the fall of Corregidor a month later.

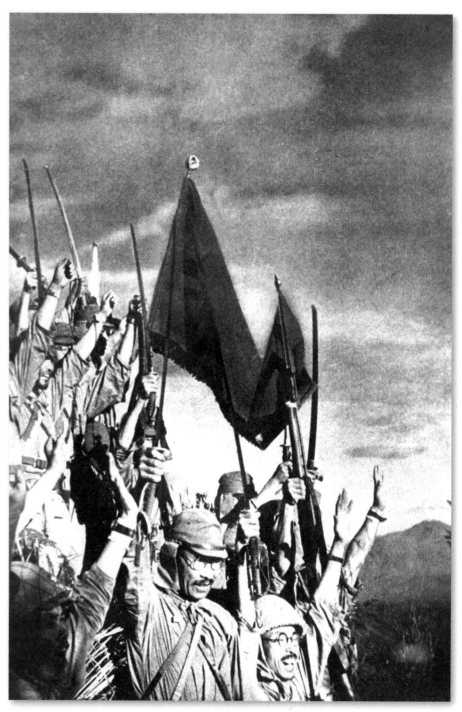

Japanese troops celebrate victory at Bataan, the Philippines. From a captured Japanese photograph.

U.S.S. *HORNET*

Between 7:30 and 8:24 a.m. on April 18, 1942, the Doolittle Raiders lifted off from the flight deck of the aircraft carrier USS *Hornet*. It was to be the first air raid by the United States to strike the Japanese home island of Honshu.

Originally suggested by President Franklin D. Roosevelt, the raid was planned and led by Lieutenant Colonel James "Jimmy" Doolittle of the U.S. Army Air Forces. Doolittle would later recount in his autobiography:

> The Japanese people had been told they were invulnerable. . . . An attack on the Japanese homeland would cause confusion in the minds of the Japanese people and sow doubt about the reliability of their leaders. There was a second, and equally important, psychological reason for this attack . . . Americans badly needed a morale boost.

Sixteen modified U.S. Army Air Forces B-25B Mitchell medium bombers were launched from the *Hornet* in the western Pacific Ocean, nearly 700 miles from their target. The plan called for them to bomb military targets in Tokyo, Kobe, Osaka, and Nagoya, and to continue westward to land in China as landing a medium bomber on the *Hornet* was impossible.

All the aircraft involved in the bombing were lost, and nine crewmen were either killed or captured; three men were executed by the Japanese army in China. One of the B-25s landed in the Soviet Union at Vladivostok, where it was confiscated and its crew interned for more than a year, only returning after an escape from their so-called allies. Thirteen entire crews, and all but one crewman of a 14th, returned either to the United States or to American forces.

The raid caused negligible material damage to Japan, but it succeeded in lifting American morale and casting doubt in Japan on the ability of the Japanese military leaders. It also caused Japan to withdraw its powerful aircraft carrier force from the Indian Ocean to defend its home islands, and the raid contributed to Admiral Isoroku Yamamoto's decision to attack Midway—an attack that turned into a decisive rout of the Imperial Japanese Navy by the U.S. Navy near Midway Island in the Central Pacific.

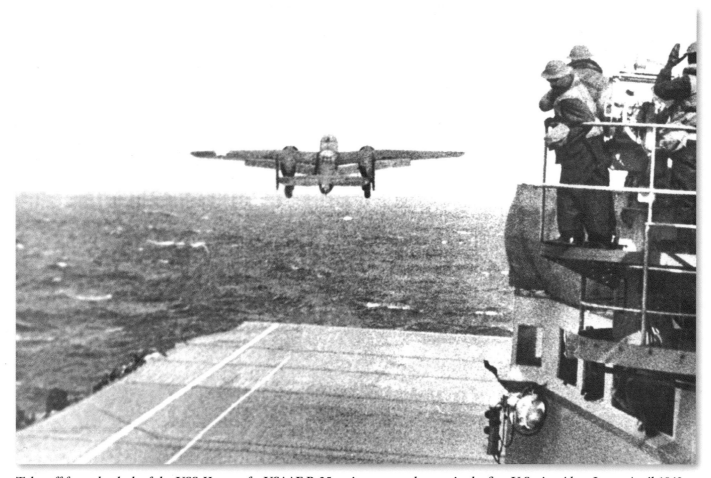

Take-off from the deck of the USS *Hornet* of a USAAF B-25 on its way to take part in the first U.S. air raid on Japan. April 1942.

SURRENDER OF AMERICAN TROOPS AT CORREGIDOR

On May 5, 1942, Japanese forces led by Major General Kureo Tanaguchi boarded landing craft and barges headed for the final assault on Corregidor. Shortly before midnight, intense shelling pounded the beaches between North Point and Cavalry Point. The initial landing of Japanese soldiers quickly bogged down amid fierce resistance from the American and Filipino defenders, whose artillery took a heavy toll on the landing fleet. However, the overwhelming number of Japanese infantry ultimately forced the defenders to pull back from the beach.

The second assault was not as successful. The invasion force did not prepare for the strong current in the channel between Bataan and Corregidor. The assault battalion landed east of North Point where the defensive positions were stronger. Most of the Japanese officers were killed early in the landing, and the survivors were hit with hand grenades, machine guns, and rifle fire. A few of the landing craft did make it to the correct location and captured Denver Battery early on May 6.

The Americans counterattacked at Denver Battery, which was the location of the heaviest fighting between the opposing forces, practically face to face. A few American reinforcements did make their way to the frontline, but without additional reinforcements, the battle quickly turned against the defenders. By 4:30 a.m., the Americans committed their last reserves, but Japanese snipers made movement very costly. Additional Japanese reinforcements arrived at 5:30 a.m., overwhelming local defenses.

The final blow came when three Japanese tanks landed and went into action. The men around Denver Battery withdrew to the ruins of a concrete trench a few yards away from the entrance to Malinta tunnel just as Japanese artillery delivered a heavy barrage. Fearful of the consequences should the Japanese capture the tunnel, and expecting further Japanese landings that night, Lieutenant General Jonathan M. Wainwright decided to sacrifice one more day of freedom in exchange for several thousand lives saved.

In a radio message to President Franklin Roosevelt, Wainwright said, "There is a limit of human endurance, and that point has long been passed." Wainwright surrendered the Corregidor garrison at about 1:30 p.m. on May 6, 1942.

Corregidor's defeat marked the fall of the Philippines, but Imperial Japan's timetable for the conquest of Australia and the rest of the Pacific was severely upset. Its advance was ultimately checked at the battle for New Guinea and at Guadalcanal, the turning point in the Pacific War.

The Philippine Department shoulder sleeve insignia was authorized July 8, 1922, and would have been worn by members of the headquarters staff. The insignia features a sea lion brandishing a sword. The sea lion is an element of the coat of arms of the house of Aragon, harking back to the Spanish heritage of the Philippines. (Private collection)

During the siege of Corregidor, the headquarters was based in the Malinta Tunnel. This photograph shows the finance section along with the Signal Corps staff. March–April 1942. (NARA)

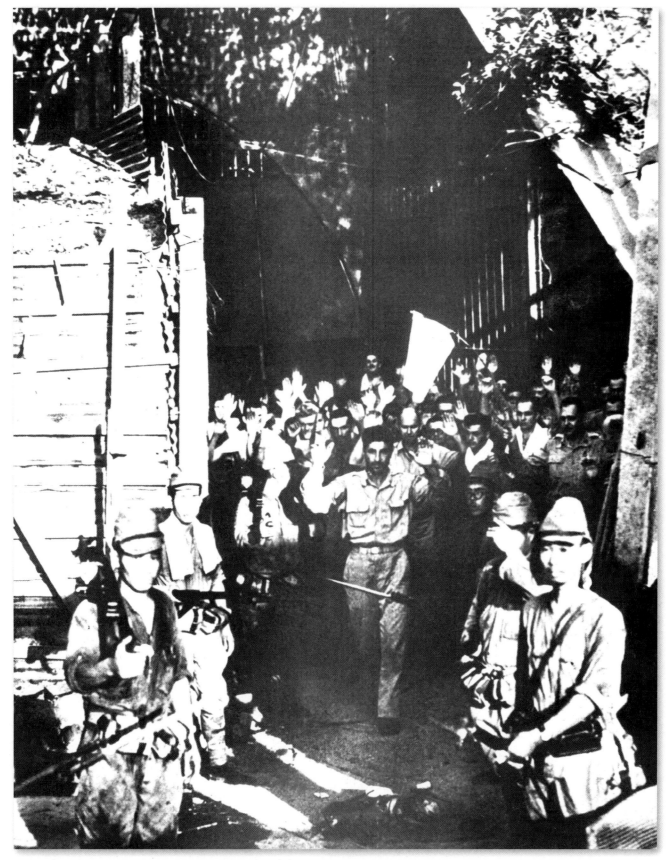

Surrender of American troops at Corregidor, the Philippines. May 1942.

B-17 OVER MARIENBURG

Marienburg in East Prussia was the home of one of the major Focke-Wulf aircraft assembly plants, where half of all FW-190s—the German single-seat, single-engine fighter aircraft—were produced.

The well-defended plant was destroyed in this daylight raid by U.S. Eighth Air Force bombers as one of the first demonstrations of the effectiveness of precision bombing. A survivor of the raid stated: "Coming back, the Germans were up in full force and we lost at least 80 ships—800 men, many of them pals."

The U.S. Army Air Forces (USAAF) used daylight precision bombing against industrial and military targets to complement the RAF Bomber Command's nighttime area bombing. Precision daylight bombing was made possible using two unique weapons systems: the B-17 bomber and the Norden Bombsite.

The Boeing B-17 Flying Fortress was a four-engine heavy bomber aircraft developed in the 1930s. From its prewar inception, the USAAF touted the aircraft as the strategic weapon of the future; it was a potent, high-flying, long-range bomber that was able to defend itself.

The B-17 proved itself an iconic air weapons system, dropping more bombs than any other U.S. aircraft in World War II. Of the 1.5 million metric tons of bombs dropped on Nazi Germany and its occupied territories by U.S. aircraft, 640,000 tons were dropped from B-17s.

The Norden bombsight, or "Blue Ox" as it was affectionately called, formed the perfect synergy with the B-17. This tachomet-

An Eighth Air Force B-17 Flying Fortress as it makes a bombing run over Marienburg, Germany. October 9, 1943.

ric bombsight aided the crew of bomber aircraft in dropping bombs accurately. Key to the operation of the Norden were two features: a mechanical computer that calculated the bomb's trajectory based on current flight conditions, and a linkage to the bomber's autopilot that let it react quickly and accurately to changes in the wind or other effects. Together, they allowed for unprecedented accuracy in day bombing from high altitudes; in testing, the Norden demonstrated a circular error probable (CEP) of 75 feet (23 meters), an astonishing performance for the era. However, under actual combat conditions during the USAAF strategic bombing campaign in Europe, such pinpoint accuracy proved difficult to achieve. Typically, clouds or fog obscured targets, making it difficult or impossible for bombardiers to see them and employ the bombsight accurately. Moreover, German defenses (fighter planes and anti-aircraft artillery) often interfered with level bombing runs, further reducing accuracy.

Photograph made from a B-17 Flying Fortress of the Eighth Army Air Force Bomber Command on December 31, 1943, when they attacked the vital ball-bearing plant and nearby aircraft engine depot near Paris, France. (NARA)

Adolf Hitler, accompanied by other German officials, grimly inspects a German city in 1944. (NARA)

MARINE AT BATTLE OF OKINAWA

The Battle of Okinawa (Operation Iceberg, April 1 to June 21, 1945) was the largest land-sea-air battle of the Pacific war. Ironically, *both* opposing commanders, U.S. General Simon B. Buckner (June 18) and Japanese General Mitsuru Ishijima (June 22), died during the battle. The appalling casualties suffered by the American invaders—12,513 killed, 39,000 wounded, and 33,000 non-battle losses—seemed a nightmarish preview of what they would be forced to endure if an amphibious assault on the Japanese home islands would prove necessary to force Japan's final surrender. In that event, U.S. President Harry S. Truman feared that American troops would face "an Okinawa from one end of Japan to the other."

The Marine racing through heavy enemy fire in this photograph, taken by combat photographer Private Bob Bailey, is Private First Class Paul E. Ison, a member of a demolitions detachment in Lima Company, Third Battalion, Fifth Marines. Ison recounted his dash across Okinawa's Death Valley to *Leatherneck* magazine in 1985: "It was May 10, 1945. Death was all around us. We came to a draw between two hills. Later it would be called 'Death Valley' because of all the casualties the Marines

Marine Private Paul Ison dashes through Japanese machine gun fire while crossing a draw called "Death Valley." Marines suffered more than 125 casualties here in eight hours. Okinawa, May 10, 1945. Photographer: Private Bob Bailey. (Marine Corps)

suffered there. Some of the men in our assault platoon were on the other side and one of them yelled over to us, 'Send one man at a time across the draw.' We could hear the enemy machine guns firing on the other side. I got ready to go first, leading the way. As I began making that run, I noticed a combat photographer [Private Bob Bailey] aiming a camera at me. I didn't slow down to wave or smile, believe me! I threw myself down on the ground and flopped into a foxhole. Two good buddies of mine told me that the photographer got a picture of me as I dashed past. 'Yeah, well that's just great, but I'll probably never live to see it,' I said."

Fortunately for Ison, he did survive the hell of Okinawa. And thanks to a new weapon of unbelievable destructiveness whose use against Japan on August 6 and 9, 1945, avoided a horrifically costly invasion of the enemy's home islands, Ison and hundreds of thousands of American marines, soldiers, sailors, and airmen survived the war.

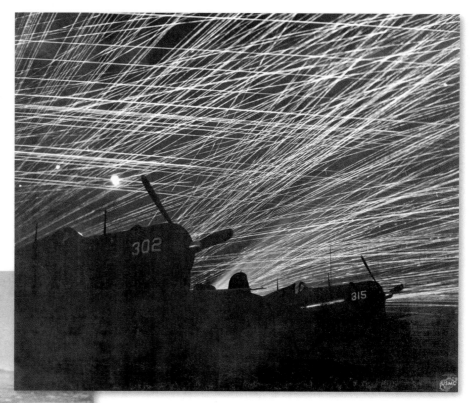

Japanese night raiders are greeted with a lacework of anti-aircraft fire by the Marine defenders of Yontan Airfield on Okinawa. In the foreground are Corsair fighter planes of the "Hell's Bells" squadron, 1945. (NARA)

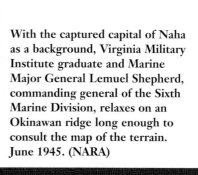

With the captured capital of Naha as a background, Virginia Military Institute graduate and Marine Major General Lemuel Shepherd, commanding general of the Sixth Marine Division, relaxes on an Okinawan ridge long enough to consult the map of the terrain. June 1945. (NARA)

BOMBING OF NAGASAKI

When Harry S. Truman was suddenly thrust into the U.S. presidency upon the April 12, 1945, death of Franklin D. Roosevelt, he was totally ignorant of a new, immensely powerful weapon being developed by the supersecret Manhattan Project. Yet within four months Truman faced the awesome responsibility of being the first head of state to authorize the use in warfare of the most terrible and destructive weapon ever devised: the atomic bomb.

By midsummer 1945 Japan clearly had lost the war. Its once powerful Imperial Fleet was sunk; its empire beyond the home islands was reduced to remaining footholds in China, Manchuria, and Korea; the country's vital supplies were choked off by the Allied naval blockade; and its cities were being reduced to ashes by the American fire-bombing campaign. Yet Japanese leaders stubbornly refused to surrender. Preferring national annihilation to surrender, Japanese military firebrands readied to meet the presumed, imminent American amphibious invasion by amassing troops, collecting thousands of "kamikaze" suicide weapons (planes, minisubmarines, and attack boats), and preparing Japan's civilian population to fight to the death. Meanwhile, U.S. military planners' casualty estimates for the invasion predicted hundreds of thousands of Americans killed and wounded. Inevitably, millions of Japanese soldiers and civilians would also die in the fighting.

After Manhattan Project scientists successfully tested an atomic weapon on July 16, 1945, near Alamagordo, New Mexico, Truman possessed a feasible alternative to a costly amphibious invasion. On August 6, 1945, Colonel Paul Tibbets's B-29 Superfortress bomber, *Enola Gay*, flying from Tinian Island in the Marianas, dropped a uranium-design atomic bomb—nicknamed *Little Boy*—on Hiroshima, Japan. The bomb created a 13-kiloton explosion that killed 90,000 to 170,000 Japanese from immediate blast effects and later radiation. The Hiroshima bombing shocked Japanese leaders, but they still refused to surrender. On August 9, a second atomic bomb—a plutonium-design weapon nicknamed *Fat Man*—was dropped on Nagasaki, Japan, from the B-29 *Bock's Car*. The 21-kiloton blast and its long-term radiation effects killed 60,000 to 80,000 in the Nagasaki target area. That same day, the Soviet Union entered the war against Japan with a massive invasion of Manchuria.

The shocks of the atomic bombings and the Soviet invasion finally convinced Emperor Hirohito to defy Japanese die-hards—he announced Japan's surrender August 15, 1945.

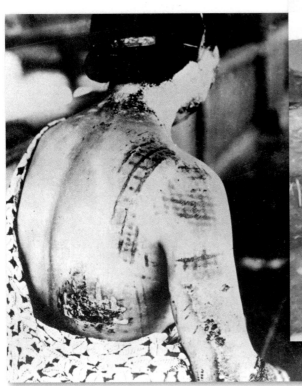

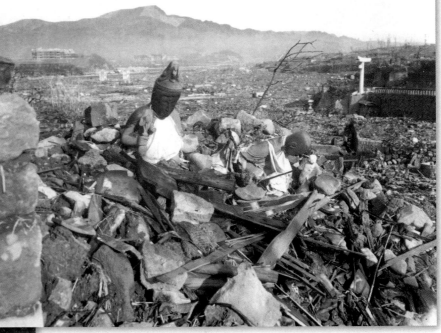

Battered religious figures stand watch on a hill above the remains of the city of Nagasaki, Japan. (NARA)

This patient's skin is burned in a pattern corresponding to the dark portions of the kimono worn at the time of the atomic explosion. (NARA)

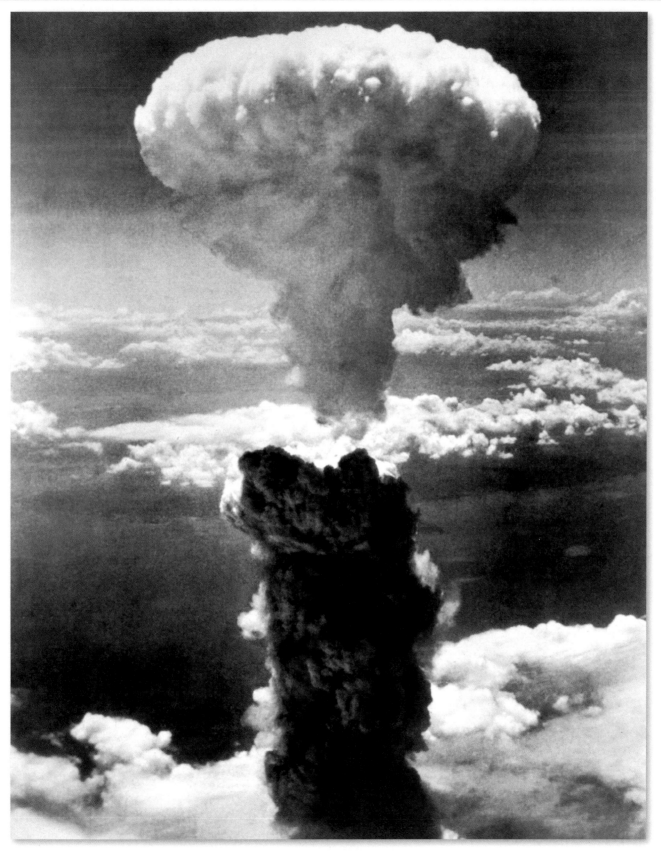

A dense cloud of smoke rises 60,000 feet over Nagasaki, Japan, the result of an atomic
bomb dropped August 9, 1945, from an American B-29 Superfortress. (OWI)

NUREMBERG TRIALS

Nazi dictator Adolf Hitler's "Thousand-Year Reich" lasted just 12 years—from his January 30, 1933, appointment as Germany's chancellor until his suicide in his Berlin bunker April 30, 1945. During those dozen years, however, Hitler and his henchmen annexed Austria and Czechoslovakia; invaded and occupied Poland, Denmark, Norway, Holland, Belgium, Luxembourg, France, Greece, and Yugoslavia; and launched attacks across North Africa and deep into the Soviet Union. Along the way, the Nazi thugs engineered the genocidal Holocaust and precipitated World War II, in which 50 million people died. Although Hitler's suicide as Soviet troops battered their way through Berlin's rubble spared him a seat in the prisoner's dock in the Allies' postwar Nuremberg trials, other high-ranking officials in his murderous regime survived to face justice for their crimes.

The post–World War II trials in Nuremberg, Germany (1945 to 1946), were the first and best-known of the Nazi war criminal trials that lasted until 1949. Judges in the International Military Tribunal from the major Allied powers (the United States, Britain, France, and the USSR), sitting in Nuremberg's Palace of Justice, presided over the trials of 25 top Nazis, including Reichsmarschall Hermann Goering, Deputy Führer Rudolf Hess, Grand Admirals Karl Dönitz and Erich Raeder, Field Marshal Wilhelm Keitel, Colonel General Alfred Jodl, and senior civilian functionaries Joachim von Ribbentrop, Alfred Rosenberg, Albert Speer, Julius Streicher, Franz von Papen, Hans Frank, Wilhelm Frick, and Arthur Seyss-Inquart. Die-hard Nazis vainly protested the trials as "victor's justice," but the judicial process they received at the hands of the Allies clearly provided Hitler's enablers more legal consideration than had their own callous actions, which had murdered millions. Twelve, including Hitler's private secretary Martin Bormann in absentia (he was not caught but likely died

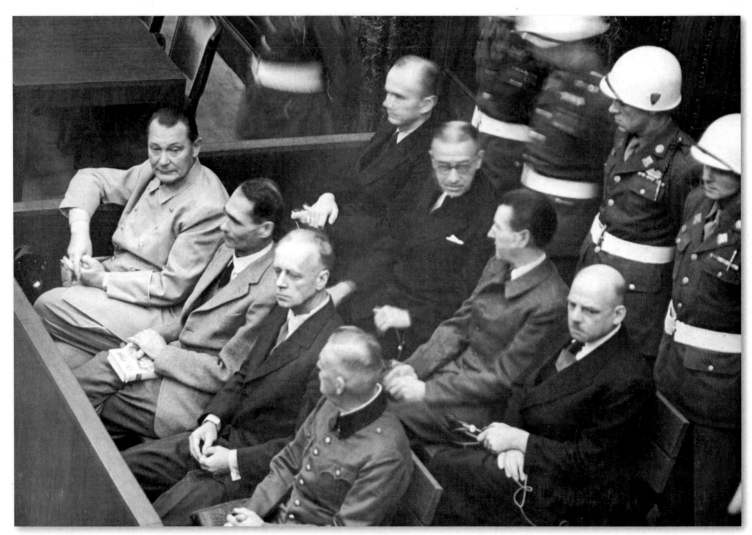

Nuremberg trials. Defendants in their dock: Goering, Hess, von Ribbentrop, and Keitel in front row, circa 1945–1946. (WWII War Crimes Records)

trying to escape from Berlin), were sentenced to death. Goering cynically smirked his way through the trial but was found guilty and sentenced to death; he avoided the hangman by committing suicide with a smuggled cyanide capsule on October 15, 1946, the day before the death sentences were carried out on the other condemned Nazi leaders. Although three of the accused were acquitted (von Papen, Hans Fritsche, and Hjalmar Schacht), others were sentenced to up to life in prison. Yet only Rudolf Hess served out a life term in Spandau Prison, dying at age 93 in 1987.

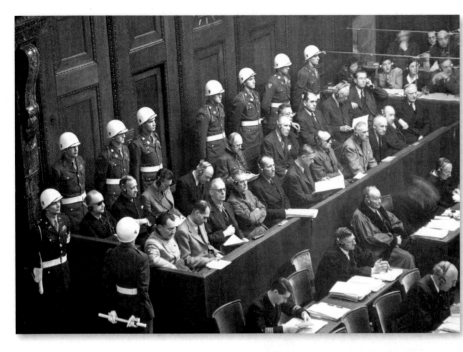

A scene from the Nuremberg trials looking down on the defendants' dock. (NARA)

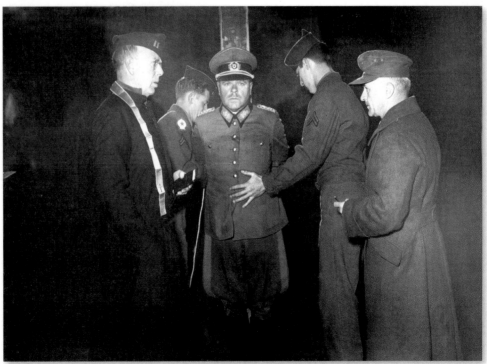

German general Anton Dostler is tied to a stake before his execution by firing squad in the Aversa stockade. The general was convicted and sentenced to death for war crimes by an American tribunal on December 1, 1945. (NARA)

P.O.W.S AT AOMORI

Only about two of every 100 Allied prisoners of Nazi Germany died in captivity. Yet one of every three Allied troops unlucky enough to be taken by the Japanese perished while living in appalling conditions in POW camps in the Philippines, Southeast Asia, Manchuria, and Japan. Allied prisoners of war suffered horribly in Japanese camps without proper medical care and amid terrible punishments. The Allied prisoners died from starvation, disease, overwork, and neglect, but too often they were callously murdered or tortured to death by sadistic Japanese guards. Tragically, some Allied prisoners even perished at the hands of their own countrymen when their POW camps were in the paths of U.S. bombers striking enemy targets or when American submarines sank the stinking "Hell Ships" carrying Allied prisoners to forced labor in Japan (the Japanese refused to mark the ships that carried POWs, making the vessels indistinguishable from the submarines' legitimate targets of enemy shipping).

The most notorious and brutal example of Allied POW forced labor in Japanese captivity was the building of the Burma-Thailand railroad, a 258-mile rail line hacked out of the remote, forbidding jungle to link Rangoon, Burma, to Bangkok, Thailand. About 46,000 Allied POWs (most were captured British and Commonwealth troops, many of whom were seized when Singapore fell in February 1942) and 180,000 civilian forced laborers from Asia worked in horrific conditions while living in filthy, disease-ridden jungle camps and constantly subjected to the capricious barbarity of Japanese guards. By the time the Burma-Thailand "Railway of Death" was completed in October 1943, 16,000 POWs had died of starvation, disease, and Japanese brutality, and more than 50,000 civilian laborers had perished.

Japanese brutality was by no means restricted merely to the enemy POWs they had captured. Despite calling their huge territorial conquests the benign-sounding "East Asia Co-Prosperity Sphere," Japanese occupiers ruthlessly exploited, scourged, and horribly mistreated the indigenous civilian populations of the countries they conquered. Tens of thousands of Filipinos perished under Japanese rule, and in China an estimated *12 million* Chinese civilians were murdered during the war. In one horrific incident in China—the six-week orgy of rape and murder beginning in December 1937 when the Japanese captured Nanking—*300,000* Chinese soldiers and civilians were slaughtered out of hand.

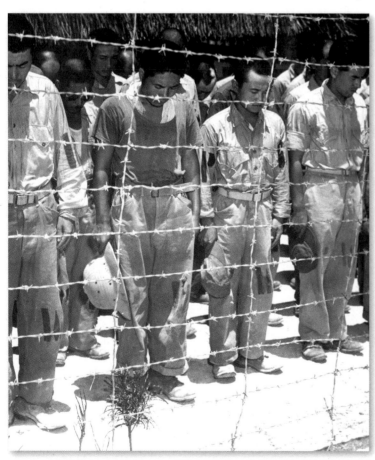

Japanese prisoners at Guam with their heads bowed after hearing Emperor Hirohito make the announcement of Japan's unconditional surrender, August 15, 1945. (NARA)

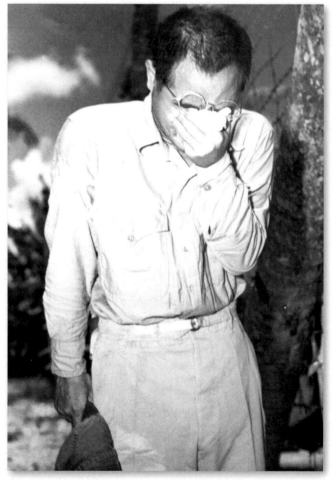

At Guam, a Japanese soldier reacts to the surrender. (NARA)

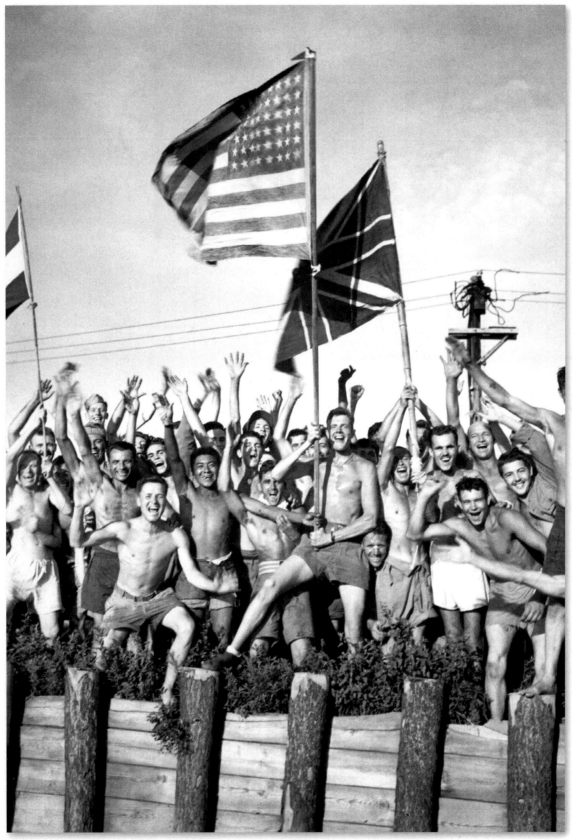

Gaunt Allied prisoners of war at Aomori camp near Yokohama wave U.S., British, and Dutch flags while they cheer U.S. Navy liberators. August 29, 1945. (Navy)

JAPANESE DESTROYER

During the 1930s, the U.S. Navy designed and commissioned various classes of submarines capable of supporting fleet operations. The Japanese attack on Pearl Harbor on December 7, 1941, ignited World War II in the Pacific. In the following months, Japanese forces defeated badly outnumbered and ill-prepared U.S., British, and Dutch naval forces, seizing the Philippines, Malaya, and the Netherlands East Indies. In spring 1942, U.S. Pacific Fleet forces and Australian ground troops stalled the Japanese offensive in New Guinea. Throughout the war in the Pacific theater, U.S. submarines were called the "Silent Service," their impact on the outcome of the war in the Pacific often understated. They commanded special transport and evacuation rescue operations of commandos, raiders, and military or civilian personnel. Submarines were also employed in both mine detection and photoreconnaissance missions.

At the outbreak of war, the Silent Service suffered from technological deficiencies and numerous torpedo failures. U.S. submarines lacked radar, but by August 1942, an air search system and the first surface search radar system were installed. The new Gato class boats began arriving on a regular basis. The *Nautilus*, one of only two Narwhal class submarines armed with six torpedo tubes, two six-inch deck guns, and anti-aircraft guns, was not initially equipped with radar when commissioned in 1930. In 1941, the *Nautilus* was modernized with radio equipment, new diesel engines, and external torpedo tubes.

During World War II, the *Nautilus* conducted 14 war patrols. In late May 1942, she left Pearl Harbor to take part in the defense of Midway by patrolling the seas northwest of Midway. In June 1942, she participated in the Battle of Midway. When this photograph was taken, the *Nautilus* was still in its first war patrol, and on June 25 torpedoed and sank the Japanese destroyer *Yamakaze*, likely the one pictured here.

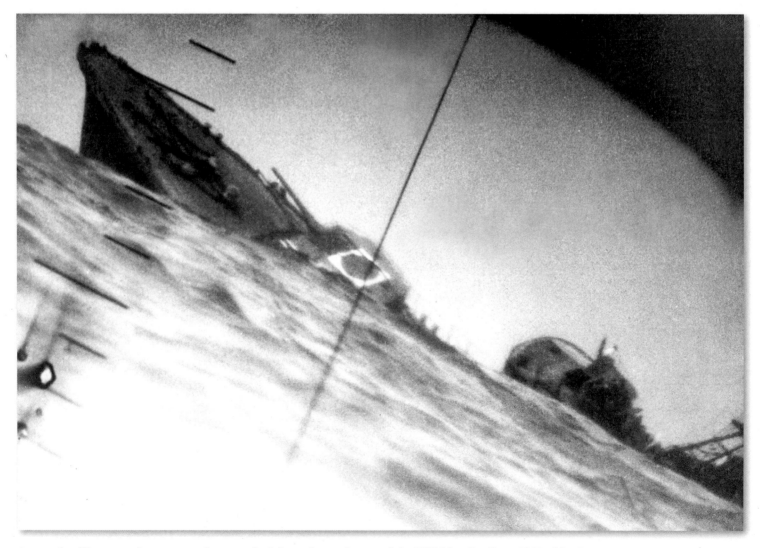

A torpedoed Japanese destroyer as photographed through a periscope of the USS *Nautilus*. June 1942. (Navy)

The *Nautilus* conducted 13 more patrols before the end of the war. During the course of the war, the submarine earned 14 service stars for its aggressive war patrols and participation in military campaigns in the Pacific theater.

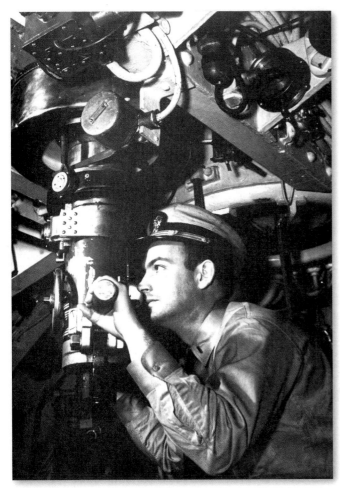

A U.S. navy officer at the periscope calls out fire direction, 1942. (NARA)

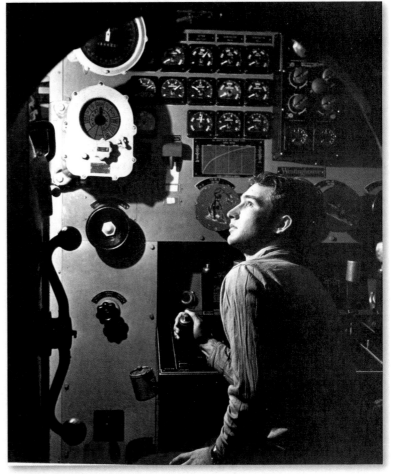

A sailor at work in the electric engine control room of the USS *Batfish* on war patrol. (NARA)

DEAD COAST GUARDSMAN

The U.S. Coast Guard, often the forgotten branch of the armed forces, operates as part of the navy during wartime. In keeping with its motto, *Semper Paratus,* Latin for "Always Prepared," the Coast Guard has seen combat in almost all major conflicts and wars fought by the United States since 1790. During World War II, more than 230,000 men and 10,000 women served in the Coast Guard; of those, almost 2,000 died, a third of them losing their lives in action.

During World War II, the Coast Guard went into action against the Nazi submarine fleet. Guardsmen nicknamed the much-feared U-boats "hearses" because they fought them to the death on the open seas. At the outset of the war, Coast Guardsmen were novices in antisubmarine warfare, but they honed their skills quickly, adapting to combat on the seas in an efficient and deadly manner. Battling fierce storms in the North Atlantic and up against the highly trained and well-equipped German submarine fleet, the famous Treasury class and other Coast Guard cutters earned the respect of allies and enemies. The U.S. Navy credited Coast Guard forces with sinking or assisting in the sinking of 13 Nazi U-boats. Coast Guardsmen also captured two Nazi surface vessels, making them the only U.S. service to do so during World War II.

As this photograph shows, however, not all Coast Guard cutters prevailed. In the Mediterranean on May 3, 1944, the German U-371 fired an acoustic torpedo that tore through the stern of the USS *Menges,* killing 31 crewmen. Despite serious damage, the *Menges* did not sink, and the next day two U.S. destroyer escorts and British and French surface craft attacked U-371. *Menges* was then towed into port in Algiers and later to the United States, where it received a new stern from another damaged destroyer, USS *Holder* (DE 401). The *Menges* rejoined the fleet and reported for duty in the first Coast Guard–manned hunter-killer group to see service on the North Atlantic.

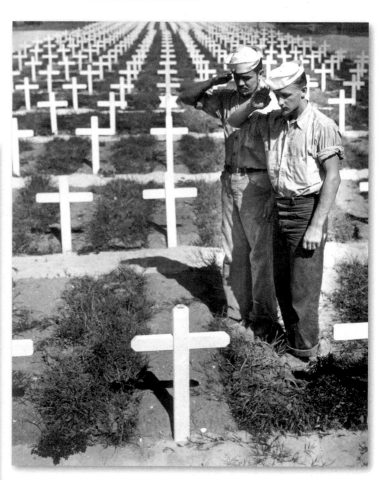

Standing by the grassy sod bordering row on row of crosses, two Coast Guardsmen pay homage to a fallen comrade. (NARA)

Silhouetted in the golden glory of a Pacific sunrise, crosses mark the graves of Americans who gave their lives, while a Coast Guardsman stands in silent reverence, 1944. (NARA)

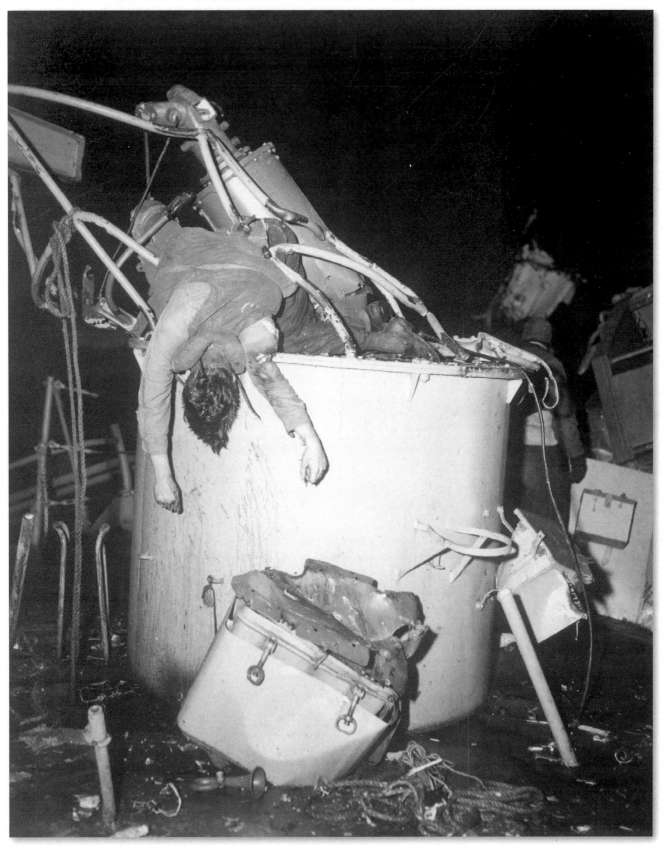

A dead Coast Guard seaman at his station aboard the USS *Menges* after being torpedoed by a Nazi submarine in the Mediterranean. (Coast Guard)

SURRENDER OF GERMAN ARMY AT BERLIN

By mid-April 1945, Russian armies in the east and the United States, England, and France in the west were moving toward Berlin. Confronting certain defeat, Hitler committed suicide on April 30. On May 2, the Soviets entered Berlin. The First Act of Military Surrender was signed at Supreme Headquarters, Allied Expeditionary Force, in Rheims, France, on May 7, 1945. General Dwight D. Eisenhower insisted that the Germans surrender simultaneously to the western Allies and the Soviets. General Alfred Jodl, chief of staff of the German army, signed the unconditional surrender of the German Third Reich on May 7, 1945.

The photograph here was taken at the Second Act of Military Surrender in Berlin on May 8, 1945. The only Soviet representative in Rheims had been General Ivan Susloparov, the military liaison mission commander. General Susloparov's authority to sign on behalf of the Soviet government was unclear, and he had no means of immediately contacting the Kremlin. Susloparov decided to risk signing for the Soviet side, but Stalin was displeased, believing the German surrender should have been accepted only by the envoy of the USSR supreme command. Sta-

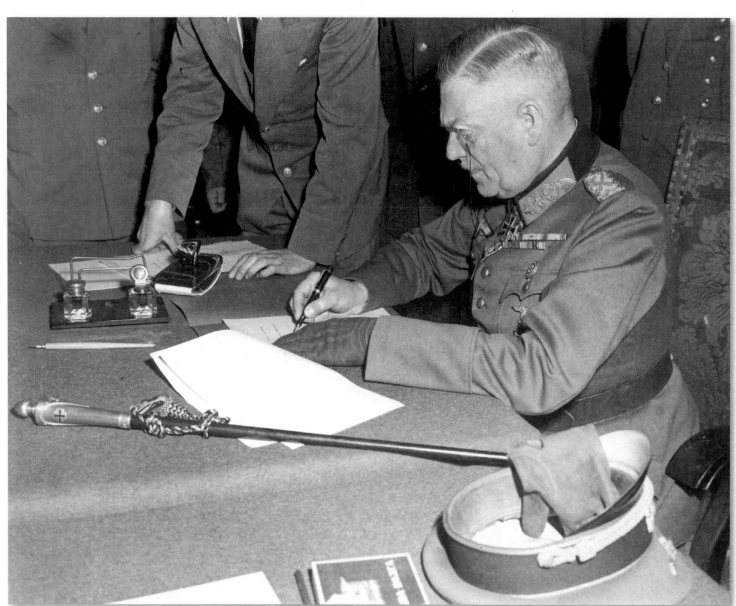

Field Marshal Wilhelm Keitel signs the ratified surrender terms for the German army at Soviet headquarters in Berlin, Germany. May 8, 1945. (U.S. Army)

lin then insisted that the Rheims protocol be considered preliminary, with the main ceremony to be held in Berlin, where Marshal Georgy Zhukov was at the time. After Zhukov opened the ceremony that included the western Allies, the German command representatives headed by Wilhelm Keitel were invited into the room, where they signed the final German Act of Unconditional Surrender. Thereafter, May 8 would be known as V-E Day, short for Victory in Europe Day. In Moscow, Victory Day is celebrated on May 9, since it was signed after midnight Moscow time. In Germany it is known as the Day of Capitulation.

The documents the Germans signed in Rheims and Berlin, both of which called for unconditional surrender, ended the war in Europe. The considerations behind this recommendation were to prevent the repetition of the "stab in the back legend" created in Germany following defeat in the First World War, since the act of surrender in November 1918 was signed by representatives of the German government and the militarist circles later claimed that the High Command was not responsible for that defeat.

News of V-E Day was received on May 8, 1945, in Delhi, where the HM-LST 538 immediately hoisted signal flags in celebration of victory. (NARA)

A jubilant American airman from the Eighth Air Force hugs an English woman as victory smiles light faces at Piccadilly Circus upon the announcement of victory in Europe. (NARA)

V-J DAY KISS

On August 15, 1945, crowds gathered in Times Square to celebrate the surrender of Japan. The throng of celebrators tossed items in the air, and photographers captured many spontaneous kisses, a favorite pose encouraged by photographers of servicemen during World War II. This cultural icon taken by *Life* magazine photographer Alfred Eisenstaedt was published in 1945 with the caption "In New York's Times Square a white-clad girl clutches her purse and skirt as an uninhibited sailor plants his lips squarely on hers."

Eisenstaedt, who was photographing many quickly moving people, did not have a chance to capture the names of the sailor and the nurse. Because the photograph does not show the faces of either subject, numerous people have come forth over the years claiming to be the famous sailor and nurse. In the late 1970s, Edith Shain, who had been working as a nurse in New York City at the time of the V-J celebration, wrote Eisenstaedt and claimed to be the woman in his picture. In the August 1980 issue of *Life*, the editors asked the "kissing sailor" to identify himself. Three months later, *Life* published the names of 11 men and two additional women who claimed to be the famous subjects. Shain's claim has been disputed by one author as impossible given her small stature (4 feet 10 inches), which could not correlate with the height of the men alleging to be the sailor. As for the identity of the man, forensic evidence done by a team of volunteers from the Naval War College in 2005 indicated that a George Mendonça of Newport, Rhode Island, was the "kisser." The forensic volunteers, using photographic analysis done by the Mitsubishi Electric Research Lab, matched tattoos and scars from Mendonça to those on the sailor in the photograph.

The definitive identity of the subjects notwithstanding, this photograph represented the universal jubilation that the war had come to an end. The photograph has become part of popular culture, referenced in movies and replicated in life-size sculptures displayed in several U.S. cities, including San Diego, California, and Sarasota, Florida.

On V-J Day in New York City, crowds gather to celebrate the victory against Japan and the end of a long war. (NARA)

The navy also snapped their own "kiss" photo; here is Lieutenant Victor Jorgensen's version. (NARA)

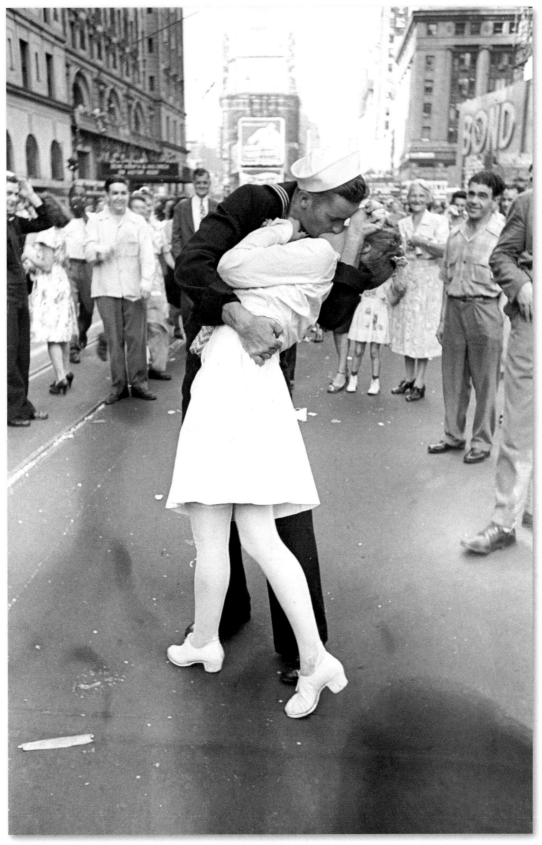

V-J Day in Times Square, New York City, August 15, 1945.
Also known under titles "V-J Day" and "The Kiss."

GENERAL GEORGE PATTON'S DOG

The World War II battlefield exploits of General George S. Patton Jr.—nicknamed "Old Blood & Guts"—became legendary, his superb accomplishments surpassing any achieved by his less-well-known fellow U.S. commanders. Patton also made headlines away from the fighting front, most notoriously with the infamous "slapping incidents" during which, on two separate occasions in military hospitals in Sicily, Patton slapped American soldiers who were apparently suffering from what was then termed "battle fatigue" (today, we call it post-traumatic stress disorder, or PTSD).

Although both General Dwight D. Eisenhower and General Omar N. Bradley initially hushed up the incidents, the story inevitably leaked to the press. Eisenhower then sidelined Patton, ordered him to publicly apologize to the two soldiers and to members of Patton's Seventh Army, and then kept the fiery general stewing in limbo as America's main war effort in Europe shifted to preparing the momentous D-Day invasion. Fortunately, Patton returned to favor and accomplished his greatest combat feats in leading the Third Army in the lightning-swift race across France in the summer of 1944, and then pulling off one of military history's greatest maneuvers: shifting the Third Army 90 degrees to launch a brilliant counterattack against the German Ardennes offensive and relieve besieged Bastogne.

A faithful friend mourns an American hero. Along with millions mourning the passing of General George S. Patton Jr. is his pet bull terrier, Willie. Bad Nauheim, Germany, January 1946. (OWI)

Yet for a consummate warrior like Patton, his December 21, 1945, death was uncharacteristically unwarriorlike—he succumbed to injuries he received in a minor automobile accident. On December 9, 1945, Patton was riding in his staff car with his chief of staff, Major General Hobart "Hap" Gay. The two were going on a brief hunting trip just prior to Patton's scheduled return to the United States. In fact, Patton had been riding in the safer front seat of the car but had given up his seat to one of his hunting dogs (which had been riding behind Patton in an open Jeep) so the wet, shivering animal could be near the car's heater. At about 11:45 a.m., a 2-1/2 ton cargo truck made a sharp turn in front of Patton's car, which, traveling about 30 mph, was unable to stop. The impact of the resulting crash caused Patton's head to strike the car's interior, inflicting a severe cervical spinal cord injury. Doctors' efforts proved unable to save him.

A portrait of George S. Patton, March 30, 1943. (LOC)

General Eisenhower meets with Generals Patton, Bradley, and Hodges on an airfield somewhere in Germany, March 1945. (LOC)

A LETTER HOME

Since the American Revolutionary War, soldiers have captured the pathos and horrors of warfare by writing letters home. Collectively, the letters form an epic record of wartime events; individually, they reveal the intense emotions of military men and women caught in the midst of a life-threatening conflict. The letter being written here by a young private during the Korean War has not made its way into the historical record. Yet at the time, the written word far more than the visual image allowed the American public to know what was happening in the far away Asian peninsula. The role of letters during the Korean War was utterly essential. From the letter announcing someone's draft, progressing to letters to and from Korea, and ending with a letter announcing his return—or worse, an official letter telling family of a loved one's death—wartime letters tracked the soldiers' entire Korean experience. Korea, in fact, represented a watershed in wartime letters in that they were free from the censor's critical eye that had been present during World War II. American soldiers wrote of combat, the bitter cold, and homesickness. As a whole, their letters form a rich tapestry of personal experiences and illustrate the raw emotion of wartime.

The taking of this photograph occurred after the entrance of Communist Chinese forces into the conflict. In late October 1950, while China was issuing warnings to the West against advancing past the 38th parallel, a large Chinese force entered North Korea. U.N. forces began encountering Chinese troops at that time. On November 24, General Douglas MacArthur announced what he believed would be the final offensive of the war, but the following day, a Chinese force estimated between 130,000 and 300,000 attacked the U.N. forces, quickly pushing them southward in a disorderly retreat. The U.N. abandoned Pyongyang on December 4. Communist forces invaded South Korea for the second time in the war on December 31, 1950, and captured Seoul on January 4, 1951. U.N. forces stopped the Chinese–North Korean advance about 30 miles south of Seoul and began a counteroffensive, eventually reoccupying Seoul in March 1951. The war stalemated, and perhaps the letter being written here tells of the weariness from a conflict that seemed to show no signs of abating.

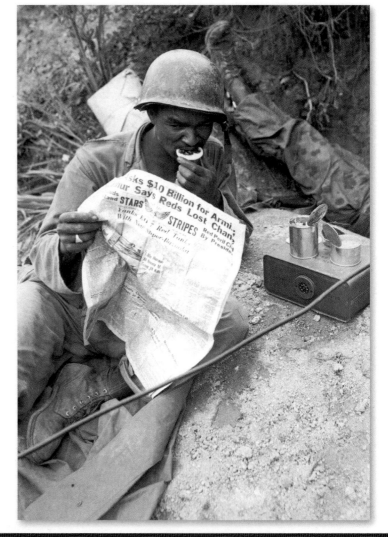

Private First Class Clarence Whitmore, voice operator, 24th Infantry Regiment, reads the latest news while enjoying a snack during a lull in battle near Sangju, Korea, August 9, 1950. (NARA)

Private First Class Dwight Exe of the Fifth Cavalry Regiment catches up on his letters to the folks at home during a break in action against the Chinese Communist forces along the fighting front in Korea. November 15, 1951. (Army)

LOSS OF A COMRADE

The Korean War (1950–1953) is often called the "forgotten war" by Americans because it received minimal public attention both during and after the war. More than 6.5 million American men and women served during the Korean War, resulting in more than 54,000 deaths, almost 34,000 of those from combat.

This highly emotional image was taken by celebrated combat photographer Albert Chung, who covered three wars (World War II, Korea, and Vietnam) and was twice nominated for the Pulitzer Prize. In Vietnam, he received the Purple Heart after a Viet Cong bullet hit his left eye. Because he never avoided the most dangerous combat areas, Chung was described by one American general as "the epitome of a combat photographer."

Cementing his reputation as one of the army's finest photographers, Chung's Korean War picture shows a distraught soldier, later identified as army Sergeant Bill Redifer, comforting a fellow soldier, later identified as Vincent Nozzolillo. The cause of the grief later became a source of debate, attributed either to Nozzolillo learning of his best friend's death or because his replacement as a radio operator had been killed. In any event, this acclaimed photograph was described by art critics as a "tableau of grief and comfort" and also was noted for being "a study in con-

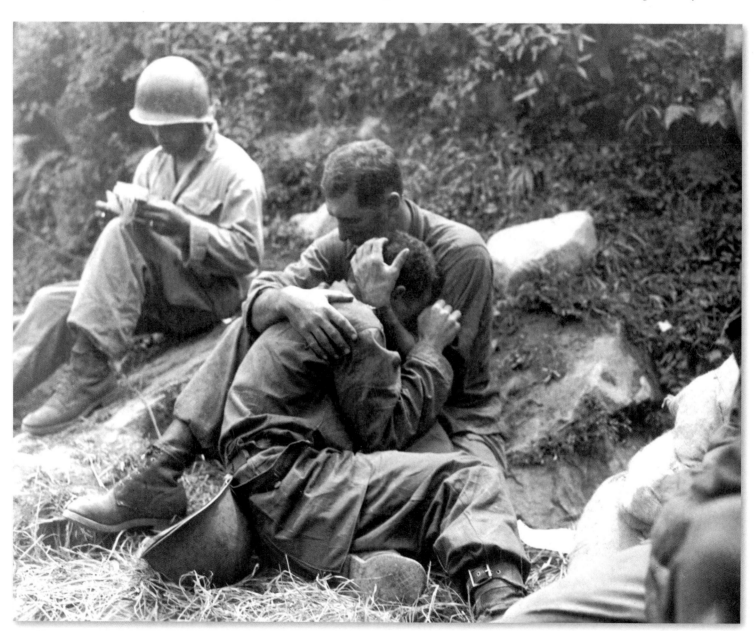

A soldier comforts a grief-stricken U.S. infantryman whose buddy has been killed in action. In the background, a corpsman methodically fills out casualty tags. Haktong-ni area, Korea, August 28, 1950. (Army)

trasts" as it depicts a corpsman in the background sifting through casualty information, detached and giving his grief-stricken comrade a moment of privacy. Chung's picture remains one of the enduring images of the Korean War, reproduced in many newspapers, magazines, books, and museum shows honoring wartime photography.

A wounded U.S. marine awaits transportation back to a field hospital after receiving first aid at the battle zone. (NARA)

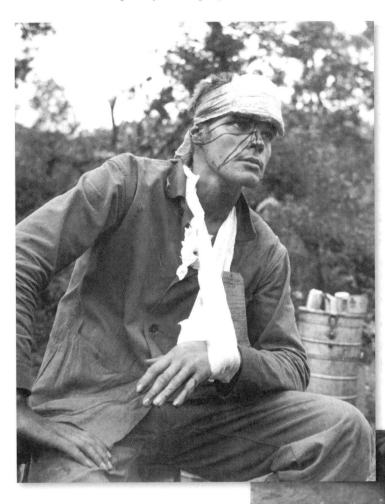

Private First Class Thomas Conlon, 21st Infantry Regiment, lies on a stretcher at a medical aid station after being wounded while crossing the Naktong River in Korea, September 19, 1950. (NARA)

BROTHER AND SISTER

At the end of World War II, the Soviet Union and the United States liberated Korea from Japanese occupation. Convinced that Koreans were not prepared for self-governance, the two emerging superpowers divided the peninsula into two temporary zones of occupation. The southern portion was politically unstable. The North became increasingly militant, supplied by the Soviet Union, and conditions were ripe for civil war. On June 25, 1950, 60,000 North Korean troops invaded the South, igniting the Korean War. The newly established United Nations asked for forces to restore peace, and the United States responded by sending its air force and navy. Shortly thereafter, President Harry S. Truman sent ground forces and ordered air strikes against the North.

With the United States providing military support to the South and the Soviets and China to the North, the Korean War quickly escalated into a proxy war between the superpowers, becoming the first armed conflict of the nascent Cold War. After three years of bloody conflict and despite the opposition from the Republic of Korea's President Syngman Rhee, delegates from North Korea, China, and the United Nations Command signed the armistice agreement on July 27, 1953.

The photograph here depicts the war weariness of the Korean population. Haengju, located in the far eastern region of Seoul across the Han River, was the site of the epic battle during the

A Korean girl with her brother on her back trudges along near a stalled M26 Pershing tank at Haengju, Korea. June 9, 1951. (Navy)

Japanese invasion of 1593 in which Korean forces repelled more than 30,000 Japanese soldiers. The tank in the background, the M26 Pershing, was named after General John J. Pershing, who commanded the American Expeditionary Force during World War I. The M26 was used at the end of World War II and briefly during the Korean War. U.S. infantry divisions fighting in Korea in June 1950 discovered that they lacked artillery capable of penetrating North Korea's T-34 tanks. Three M26 tanks in very poor condition were found in a Tokyo depot and shipped to Korea after being hastily repaired. These three were the only tanks that helped defend the town of Chinju, but they malfunctioned and stalled frequently, as this photograph depicts. American battlefield commanders did not regard Korea as good tank country because of the mountainous terrain. Coupled with the automotive deficiencies of the M26, these tanks were withdrawn from Korea during 1951 and replaced with M4A3 Shermans and M46 Pattons.

A Korean orphan dressed in oversized clothes, adopted by a motor pool battalion at Inchon, Korea, and nursed back to health. The motor pool called the boy "Number One." (NARA)

ENTERTAINING THE TROOPS

Dancer, actress, and singer Davenie Johanna "Joey" Heatherton captivated audiences during the 1960s with appearances on such popular shows as *The Andy Williams Show*, *Dean Martin Presents the Golddiggers*, *The Ed Sullivan Show*, *The Hollywood Palace*, and *The Tonight Show*. In this photograph, Heatherton performs dances that she helped popularize—the Frug, Shimmy, Watusi, and Twist. The Frug was a 1960s dance craze featuring lateral body movements and was used primarily as a change-of-pace step while doing the Twist. As they tired, Frug dancers would stand in place while moving only their hips. The Frug evolved into the Watusi, in which the dancer remained almost stationary with knees slightly bent, periodically moving forward and back in one or two small rhythmic paces; the arms were held almost straight, alternately flailing up and down.

For more than a decade Heatherton appeared in Bob Hope's United Service Organizations (USO) group of touring actors, singers, and dancers. The USO was founded in 1941 in response to President Franklin Roosevelt's request to entertain American military personnel for morale purposes. Disbanded after World War II and then reestablished during the Korean War, the first USO club opened in Vietnam in 1963. The USO ultimately had 23 centers in Vietnam and Thailand, serving almost a million service members a month. During America's long war in Southeast Asia, the USO featured more than 5,000 performances, including Heatherton's multiple appearances. The USO performers did their best to relieve the stresses of war and "to bring a little America to Vietnam." Heatherton entertained GIs with her singing, dancing, and provocative outfits. NBC televised specials excerpts from Bob Hope's series of monthly USO tours, and Heatherton's segments were regularly featured.

Bob Hope's USO camp show during the Korean War featured Marilyn Monroe. Here she poses after a performance at the U.S. Third Infantry Division area, February 17, 1954. (NARA)

"Joey" Heatherton dances on the USS *Ticonderoga* during *The Bob Hope Show*. December 27, 1965. (U.S. Navy, USIA)

LYNDON JOHNSON IN VIETNAM

On October 26, 1966, President Lyndon Johnson made a stop at Cam Ranh Bay in Vietnam. It was part of a 10-day trip that included a summit conference in the Philippines with the heads of state of Australia, South Korea, New Zealand, the Philippines, Thailand, and Vietnam, and state visits to Thailand, Malaysia, and South Korea. In this photograph, President Johnson is smiling and shaking hands with a firmness that conveyed confidence in his decision the year before to commit America's first combat troops to Vietnam. By the end of 1966, almost 400,000 U.S. troops were serving in the jungles of Southeast Asia, and approximately 6,000 combat deaths had just occurred. Yet in 1966 public opinion remained by and large behind the president, and Johnson's military commanders assured him that victory was within reach.

President Johnson would escalate U.S. involvement in the war in Vietnam. He took his role as commander in chief seriously. This photograph represented his only trip to Vietnam but not his only interaction with American troops. However, those interactions became less frequent as U.S. combat deployment levels and deaths increased. The Johnson administration employed what one historian has called a "policy of minimum candor" in its dealings with the media. Military information officers managed media coverage by emphasizing stories that portrayed progress in the war. Over time, the administration's policy damaged public trust in official pronouncements. As the media's coverage of the war and that of the Pentagon diverged, a so-called credibility gap developed.

By 1968, when he announced he would not seek a second term, Johnson would be photographed looking increasingly grim. The war in Vietnam had consumed his presidency. As early as 1966 and certainly by 1968, Vietnam touched every aspect of the Johnson administration, determining budget priorities, provoking domestic unrest and war protests, souring relations with NATO,

President Lyndon Johnson greeting U.S. troops in Vietnam, 1966. (USIA)

and complicating negotiations with the Soviet Union. President Johnson wanted to be remembered most for his commitment to civil rights and his domestic programs of progressive social reform, known collectively as the Great Society. Instead he left office with his presidency largely destroyed by the Vietnam War.

President Johnson and his advisers listen at the White House to General Creighton W. Abrams, U.S. commander in South Vietnam, as they discuss the military situation in Southeast Asia, October 29, 1968. (NARA)

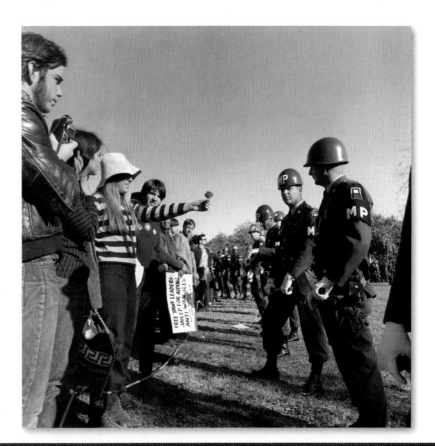

October 21, 1967: A female demonstrator offers a flower to military police on guard at the Pentagon during an anti-Vietnam demonstration in Arlington, Virginia. Nationwide protests against the Vietnam War plagued President Johnson's final two years in office and contributed to his decision not to run in 1968. (NARA)

HELICOPTER CREW CHIEF

U.S. military intervention in the Vietnam War was in its early stages when *Life* magazine featured photographer Larry Burrows's dramatic picture of an American helicopter crew chief in combat on its April 16, 1965, issue cover. Under the cover's headline, "With a Brave Crew in a Deadly Fight: Vietcong zero in on vulnerable U.S. copters," and a photo caption reading, "In a U.S. copter in thick of fight—a shouting crew chief, a dying pilot," *Life* gave the American public one of the first stark images of the escalating war's brutal reality.

Life's cover photo was highly appropriate as an early combat image of a war that became dominated by the Americans' extensive use of helicopters. In that issue, *Life* military affairs editor John Dille wrote an article titled "Good Copters But Bum Tactics," in which he explained: "In Vietnam the helicopter is indispensable. It is highly mobile and can carry troops into battle on a moment's notice over terrain where jeeps and trucks cannot go and transport planes cannot land. But if the U.S. intends to go on fighting this war in earnest—as President Johnson warned last week it would—then drastic revisions must be made in helicopter tactics." Dille recommended sound tactics for reducing heavy losses from enemy ground fire inflicted on transport helicopters at that early stage of the war. Combat aircraft and artillery must first heavily strike landing zones before transport helicopters could land—the exact tactics U.S. forces would soon adopt and use throughout the war. Larry Burrows's stunning photo essay in that issue starkly demonstrated what happened when those tactics were absent.

In Burrows's photo essay and article, "Report from Danang, Vietnam: One Ride With Yankee Papa 13," he described what took place at a heavily defended landing zone during the U.S. Marine Corps helicopter mission he accompanied. "The Vietcong," he wrote, "dug in along the tree line, were just waiting for us to come into the landing zone. We were all like sitting ducks and their raking crossfire was murderous." His cover photo shows an anguished Lance Corporal James C. Farley, crew chief of helicopter Yankee Papa 13, vainly trying to save the life of a pilot hit by that "murderous" enemy fire.

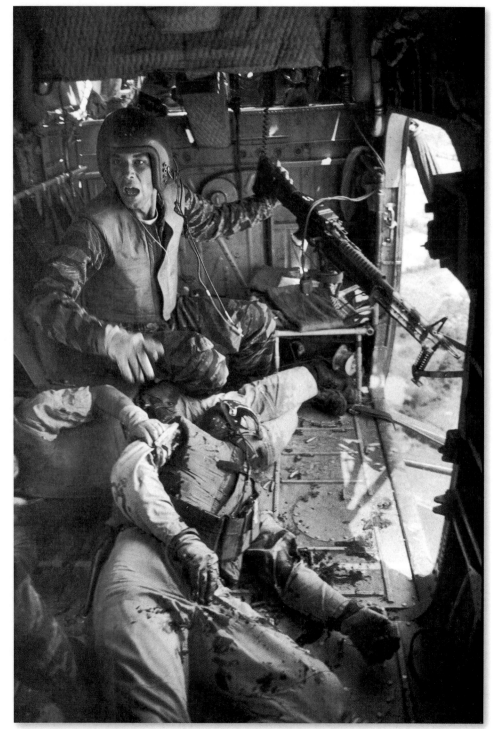

Crew Chief James Farley, with his guns jammed and two wounded comrades aboard, shouts to his gunner near Danang, Vietnam.

MARINES CARRYING COMRADE

Acclaimed photojournalist Larry Burrows's photo of anguished U.S. Marines recovering a dead comrade was published as one of his series of compelling images taken during Operation Prairie in October 1966 (see photo on page 28). Several of the dramatic photos Burrows took during the Marine operation were featured in the October 28, 1966, issue of *Life* magazine under the headline "Marines Blunt the Invasion from the North." In the text accompanying Burrows's photos, *Life* reported the photojournalist's description of the circumstances leading up to the scene: "'We were in the open approaching a 40-foot rise,' cabled photographer Larry Burrows. 'Our point man ran to the top of the hill and was shot dead.' During the fire fight, Burrows took this picture and those on the next two pages of Marine wounded being treated at the front and helped to air evacuation points. According to a ranking officer, Marines counted more than 2,000 enemy dead in the furious ground action near the DMZ."

At this stage of the U.S. military's involvement in the Vietnam War, the comment by the "ranking officer" claiming a heavy toll on the enemy was still being interpreted by the American public as an indication that the war was being won; within two years, however, such official assurances would begin to ring hollow with an increasingly skeptical home front audience. Certainly by the end of the massive 1968 Tet Offensive—and the shocking images of Tet's battlefield carnage sent home by war photographers—American public opinion had swung irreversibly against U.S. participation in a war that seemed to drag on with no end in sight. After Tet, it was no longer a question of when the U.S. would "win" the Vietnam War, but rather a question of when America's costly military involvement would finally end.

At right in Burrows's photo, moving into position to take her own picture of the Marines, is French-born photographer Catherine Leroy. Just 21 years old in 1966, Leroy covered the Vietnam War, during which she made a combat parachute jump with the U.S. 173rd Airborne Brigade and was wounded accompanying a Marine unit near the DMZ. Leroy went on to photograph other conflicts in countries ranging from Northern Ireland to Lebanon.

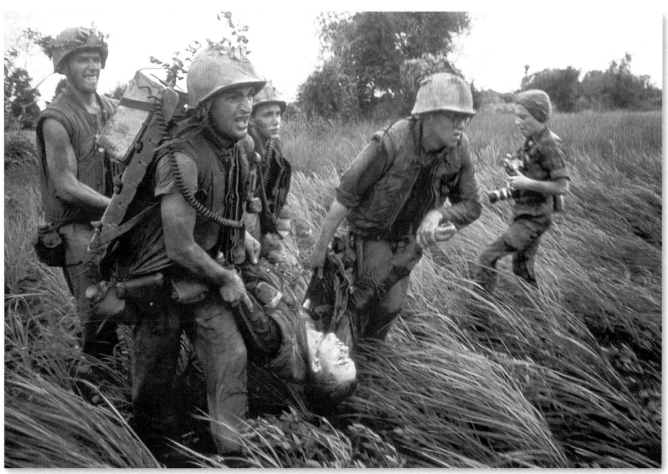

Under fire: four marines recover the body of a fifth as their company comes under fire near Hill 484. DMZ, Vietnam, 1966. Photographer: Larry Burrows.

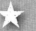

THE PENTAGON ON 9/11

Since World War II, the Pentagon has been a symbol of power and influence to the nation and the world. On September 11, 2001, due to its symbolic importance as the headquarters of the U.S. military establishment, the Pentagon was personally selected as a target for a terrorist air attack, along with the World Trade Center towers, by Osama bin Laden.

The crash occurred at 9:37 a.m. against the west side of the building near the heliport. Imagery of the impact came from two Pentagon security cameras positioned near each other. This photograph depicts the Pentagon the evening after after American Airlines Flight 77 crashed through the building. The impact proved devastating as Flight 77 still had most of its original 7,257 gallons of fuel on board. Multiple explosions occurred as the plane smashed through the building. The front part of the relatively weak fuselage disintegrated, but the midsection and tail end continued moving another fraction of a second, progressively destroying segments of the building further inward. The plane was turned inside out, with parts of the plane ending up inside the Pentagon in reverse order from entrance—the tail end of the airliner penetrated the greatest distance into the building.

All 64 people on the plane lost their lives, as did 124 people in the building. One Pentagon civilian woman who worked for the army died in the hospital six days later. Of the 125 Pentagon dead, 70 were civilians and 55 were military. The army lost the greatest number, then the navy. Most injured people were rescued in the early minutes of the catastrophe.

Secretary of Defense Donald Rumsfeld participated in the rescue, helping at one point to carry stretchers of injured workers. Despite evacuation warnings from the chief of the county fire department, who worried that carbon monoxide poisoning would render the secretary and any other occupants irrational before killing them, Rumsfeld was determined to stay, primarily because the communications network within the Pentagon enabled him to keep in touch with key government officials and military commanders.

The attack on the fortresslike structure that housed America's military command center stunned the nation and shattered its sense of security. For the U.S. government, it ushered in the beginning of the War on Terror. Five days after the attacks on U.S. soil, President George W. Bush first used the phrase in an unscripted comment to the press, declaring, "This crusade—this war on terrorism—is going to take a while."

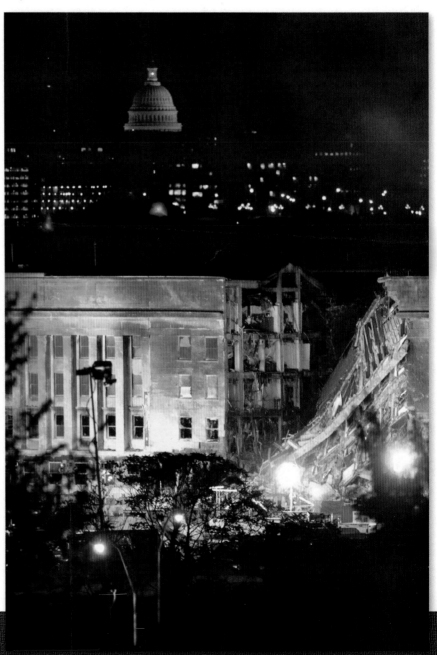

The Pentagon after it was struck by a hijacked plane on September 11, 2001.